Reminders of Invisible Light

THE ART OF BETH AMES SWARTZ

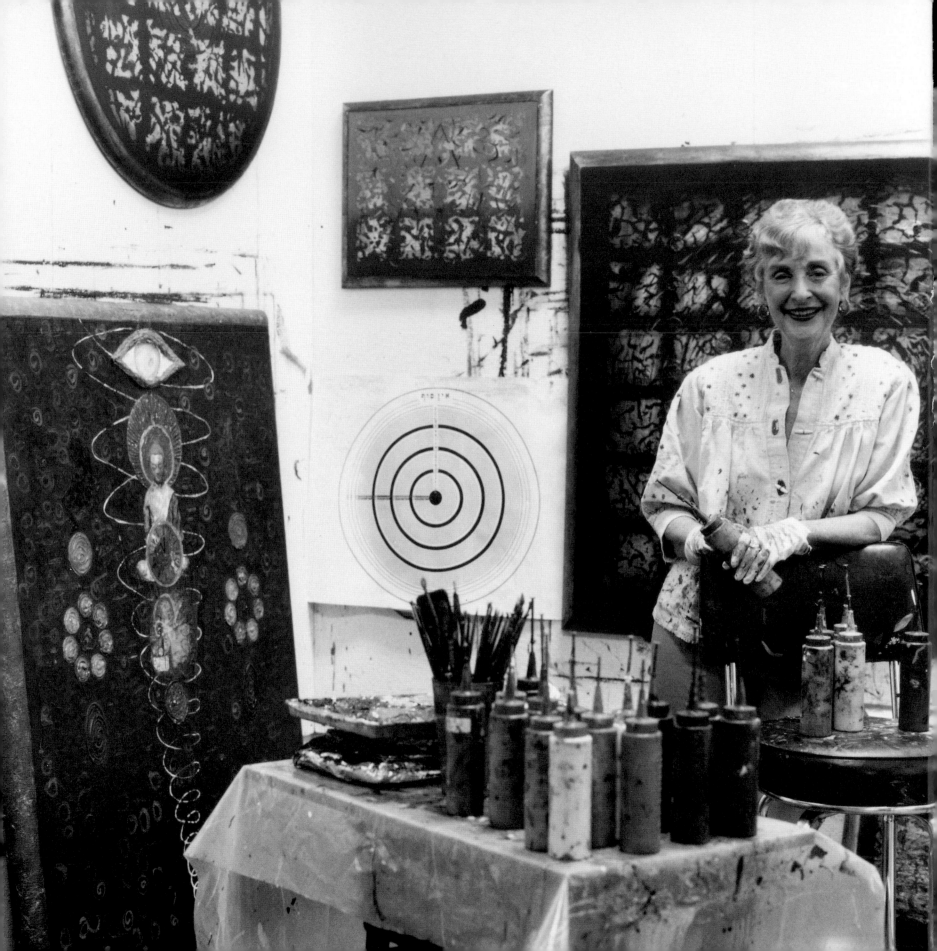

Reminders of Invisible Light

THE ART OF BETH AMES SWARTZ

Essays by

DAVID S. RUBIN

ARLENE RAVEN

Interview by

EVA S. JUNGERMANN

Foreword by

JAMES K. BALLINGER

HUDSON HILLS PRESS, NEW YORK

IN ASSOCIATION WITH PHOENIX ART MUSEUM

First Edition

© 2002 by Phoenix Art Museum.
All rights reserved under International and
Pan-American Copyright Conventions.

This volume is published in conjunction with an
exhibition shown at the Phoenix Art Museum,
February 9–May 12, 2002.

Published in the United States by
Hudson Hills Press, Inc.
1133 Broadway, Suite 1301
New York, NY 10010-8001.
Distributed in the United States, its territories
and possessions, and Canada by National Book
Network.
Distributed in the United Kingdom, Eire,
and Europe by Windsor Books International.

Editor and Publisher: Paul Anbinder
Proofreaders: Evan A. Bates, Lydia Edwards
Indexer: Karla J. Knight
Designer: David Skolkin
Composition: Angela Taormina
Manufactured in Japan by Toppan
Printing Company.

Library of Congress Cataloguing-in-Publication
Data
Swartz, Beth Ames, 1936–
 Reminders of invisible light: the art of Beth
 Ames Swartz / essays by David S. Rubin,
Arlene Raven; interview by Eva S. Jungermann;
foreword by James K. Ballinger. — 1st ed.
 p. cm.
 Published in conjunction with an exhibition
held at the Phoenix Art Museum, February 9–
May 12, 2002.
 Includes bibliographical references and index.
 ISBN 1–55595–208–9 (hardcover : alk. paper)
 1. Swartz, Beth Ames, 1936——Exhibitions.
2. Spiritual life in art—Exhibitions. I. Rubin,
David S. II. Raven, Arlene. III. Jungermann,
Eva Schlein. IV. Phoenix Art Museum. V. Title.

N6537.S97 A4 2002
709'.3—dc21 2001051458

Frontispiece: Beth Ames Swartz in her studio, 2000.

Contents

Foreword

JAMES K. BALLINGER
The Sybil Harrington Director
Phoenix Art Museum

THE DESERT PERMEATES THE LIFE AND WORK of Beth Ames Swartz. She draws from its stark powerful beauty, its quiet isolation, the spirituality of its peoples, and even from the materials on its physical surface. Upon discovering the Arizona desert in 1960, this native New Yorker was drawn into its mystery and began an artistic journey that ultimately led to a parallel appreciation of the American Southwest and Israel. These two places represent her present as well as her past. In the course of her four-decade-long career, Swartz has created an artistic autobiographical statement that has attracted national attention.

I first saw Beth at work in 1977. She had called and asked me to come see her because she was excited about a new series of "fire" works that soon would be exhibited at the Scottsdale Center for the Arts. What I found during that first visit was not the artist in her studio but rather a person outdoors who was consumed with integrating the desert itself into her pigment and with utilizing smoke illusions and the direct physical effect of fire on her paper materials. It struck me that she was using the available materials in much the same way that desert nomads of the Middle East had used the ones available to them—but in a most contemporary visual manner—to explore the spirituality of the desert. In the two decades since,

6

Beth has continued that exploration and has investigated various religious philosophies while simultaneously conducting a dialogue with her viewers about personal faith and religion.

We at the Phoenix Art Museum are pleased and honored to present *Reminders of Invisible Light: The Art of Beth Ames Swartz*. This exhibition and accompanying book celebrate the success of both an artist and an individual who has for many years contributed actively to building this city's art community. Her work has been exhibited from California to New York City, and it can be found in local museum collections as well as in those of the Brooklyn Museum, the Denver Art Museum, the San Francisco Museum of Modern Art, and the Smithsonian American Art Museum. Beth is truly an Arizona success story. Equally meaningful, to me, has been her untiring support of other artists and of our state's visual-arts institutions. She has always welcomed visiting critics, curators, and fellow artists, enthusiastically showing them the artistic riches Arizona has to offer, which include other artists' studios.

Perhaps the greatest compliment to Beth's ambassadorial commitment to Phoenix—and to her lifelong artistic commitment—is evident in the willingness of her friends and those who collect her work to help assure the success of this project. Major support for the exhibition and accompanying book was provided by Linda and Sherman Saperstein, Diane and Gary Tooker, and Carole and Jerry Vanier of Vanier Galleries, Scottsdale. Additional support came from Sandra and Harvey Belfer, Margaret S. Chester, Linda and Lee Cohn, Bruce and Jane Cole, Ted G. Decker, Dr. and Mrs. Glen Friedman, Estelle Gracer, Bill and Loraine Hawkins, Betty and Erville Hughes, the International Friends of Transformative Art, Beverly C. Johnson, Dr. and Mrs. Eric Jungermann, Ellen and Michael Korney, Mr. and Mrs. David Lieberman, The Lodestar Foundation, Doris Monicson, Joan and Carter Norris, Carolyn and Edward Parrish, Valerie Richter, John D. Rothschild, Hugh Ruddock, Sheila Schechter, Arlene and Morton Scult, Adele Seronde, Dr. and Mrs. Robert Tamis, Selma and Jerome Targovnik, Joy Tash, Ann Townsend, Dr. and Mrs. Michael Roy Treister, Jerre Lynn and Jay Vanier, and Gayle and Jay

Weiss. The Phoenix Art Museum thanks all of these individuals and organizations for their help.

The creation of a project such as this involves the efforts of many people. Beth Ames Swartz tirelessly shared her time with museum staff members, especially with Curatorial Assistant Kaytie Johnson, who organized the book and compiled the collection and exhibition histories, bibliography, and artist's chronology. The art historian Arlene Raven and David Rubin, curator of visual arts at the Contemporary Arts Center, New Orleans, are to be congratulated for their insightful essays, as is Eva S. Jungermann, who interviewed the artist for this book. Additionally, I would like to thank Anne Gully for her editorial expertise and John D. Rothschild for his help in preparing this publication. Hudson Hills Press has done an admirable job of quality control. The museum's chief preparator, David Restad and his dedicated colleagues installed the exhibition with great skill.

For more than twenty years, Beth has explained to me, in one way or another, her search for life's basic truths. Looking at this retrospective exhibition and book, it becomes clear that she has arrived at a full understanding of the special qualities that connect one human being to another.

DAVID S. RUBIN

————————

Aｃｃｏｒｄｉｎｇ ｔｏ ｔｈｅ ｐｓｙｃｈｏｌｏｇｉｓｔ Cａｒｌ Gｕｓｔａｖ Jｕｎｇ, the key to finding harmony in life is to undergo what he termed "individuation," a journey that involves confronting and accepting one's unconscious, or "shadow," until ultimately achieving wholeness. Jung professed that this progression entails the recognition of universal symbols, or "archetypes," that often appear in dreams and provide evidence of the "collective unconscious," a deeper layer than the "personal unconscious" that Sigmund Freud identified as the "id." A student of the art of many cultures, Jung observed similarities between recurring circular patterns in his patients' drawings and symbols commonly found in the art of Eastern religions, known as "mandalas."

As Frieda Fordham explained in *An Introduction to Jung's Psychology*: "Mandala is a Sanskrit word meaning magic circle, and its symbolism includes all concentrically arranged figures, all radial or spherical arrangements, and all circles or squares with a central point. It is one of the oldest religious symbols (the earliest known form being the sun wheel), and is found throughout the world."[1] For Jung, the appearance of a mandala in a patient's drawing reflected a balance of the "four parts of the human being: Body, Soul, Spirit, and Mind."[2]

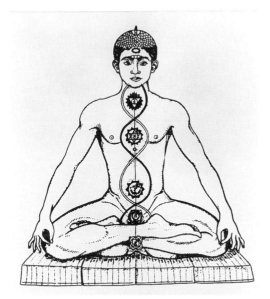

Fig. 1. Diagram of the Seven Chakras, reproduced from Joseph Campbell, The Inner Reaches of Outer Space: Metaphor as Myth as Religion *(New York: Alfred van der Marck Editions, 1985), 65.*

Beth Ames Swartz's recent painting *Ten Sefiroth #4 (pale gray)* (1999, colorplate 82) has all the properties of a mandala, which is referred to in its circular shape and also through the superimposition of symbols derived from several religious and philosophical systems. These include the Tree of Life from the Jewish Cabala, the seven Hindu chakras, an androgynous figure posed like a traditional Buddha (fig. 1), and a grid pattern of gold squares based on a Chinese healing system known as Shen Qi. A longtime admirer of Jung, Swartz shares his interest in various religions and agrees with his suggestion that if we are to address our daily anxieties with positive results, "we do not need new symbols or new religions as much as we need to find fresh personal connections to old ones."[3]

In a distinctly original manner, Swartz's art of the past forty years has developed along a Jungian course. During this evolution, she has embraced and learned from the teachings of artists, writers, philosophers, and spiritual leaders who have guided her in the creation of an art that is spiritually focused, peaceful, hopeful, and nurturing.

Born Beth Ellen Ames in 1936 in New York City and raised there, she enjoyed a culturally rich childhood. In the late 1940s, she began taking weekly lessons at the Art Students League and paying regular visits to the Museum of Modern Art. In 1949 she was accepted as a student at the High School of Music and Art and, in 1954, she entered Cornell University to study art and education in the university's College of Home Economics, focusing especially on child development. After graduating, she taught English, art, and poetry at a junior high school and, in 1959, earned a master's degree in art education from New York University. Later that year, her life as a New York City educator took an unanticipated turn when she married the attorney Melvin Swartz and moved with him to Phoenix. There, she taught full-time in the Scottsdale public school system but stopped in 1964 in order to devote more time to her art.

Initially, Swartz felt out of place in the Southwest, where the open spaces and desert rocks and vegetation contrasted sharply with the urban architecture of New York City. In an attempt to familiarize herself with her new surroundings, she worked outdoors and produced spontaneous landscapes such as *Painted Desert* (1960, colorplate 1). With mountaintops rendered as sketchy outlines and air and

sky articulated with simple washes, the work pays homage to John Marin, whose Maine seascapes the artist knew from her visits to the Museum of Modern Art. Eventually, Swartz began experimenting with an increasingly abstract vocabulary, as reflected in *View from Jerome* (1968, colorplate 3), composed entirely of color washes and devoid of literal outlines. A more rugged landscape is seen in *Dawn in the Grand Canyon* (1970, colorplate 4), a mixed-media collage she made after a rafting trip down the Colorado River. Here the artist suggested the harshness of rocks by adding a textural dimension; again influenced by Marin, Swartz simulated the topography by attaching crumpled paper to the painted surface.[4]

Swartz has always been an avid reader, and she has never hesitated to incorporate the philosophical teachings of others into her own daily routine. Growing up in New York City, she was exposed to the abstract paintings of Wassily Kandinsky, whose highly influential 1912 essay *Concerning the Spiritual in Art* has become essential reading for any student of modern art history. Kandinsky believed that art "exists and has the power to create spiritual atmosphere; and from this standpoint one judges whether it is a good work of art or a bad one."[5] Born and raised a Jew, Swartz (like many artists) practices religious expression both through her art and by observing many of Judaism's customs.

After reading Alan Watts's *The Wisdom of Insecurity* in 1968, Swartz became further encouraged to merge art and spirituality. In that book, Watts advised that "faith has no preconceptions; it is a plunge into the unknown."[6] He went on to assert that "it is surely absurd to seek God in terms of a preconceived idea of what God is."[7] He advocated the Zen notion that freedom from anxieties and insecurities can be achieved by keeping focused on the present. According to Watts, "When . . . you realize that you live in, that indeed you *are* this moment now, and no other, that apart from this there is no past and no future, you must relax and taste to the full, whether it be pleasure or pain."[8]

Inspired by Watts, Swartz soon began practicing meditation and in 1971–73 produced her *Meditation* series (colorplate 7). In these wet-on-wet, acrylic paintings on paper, desert mountains and skies appear as fluid bands of vivid color, somewhat reminiscent of the "veils" and "unfurleds" in the paintings of Morris Louis, one of the first artists to explore the new medium of acrylic paint.[9] Swartz

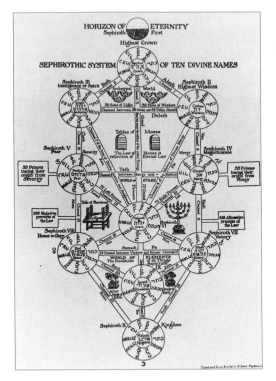

Fig. 2. *Sephirothic System of Ten Divine Names,*
reproduced from Jack Burnham, Great Western
Salt Works: Essays on the Meaning of Post-
Formalist Art *(New York: George Braziller, 1974),*
102.

Fig. 3. *The Qabbalistic Scheme of the Four*
Worlds, reproduced from Jack Burnham,
Great Western Salt Works: Essays
on the Meaning of Post-Formalist Art
(New York: George Braziller, 1974), 95.

was familiar with Louis's art in part through her association with Dorothy Fratt, an abstract painter who had come to Arizona, prior to Swartz's arrival, from Washington, D.C. Before moving to the Southwest, Fratt had been affiliated with a group of color-field painters that also included Louis.[10] In an effort to expand her understanding of the role of color in her art, Swartz studied with Fratt from 1971 to 1973.

In 1974 Swartz read another book that would significantly affect her development. Jack Burnham's *Great Western Salt Works: Essays on the Meaning of Post-Formalist Art* is a collection of writings that includes mystical and alchemical interpretations of works by Marcel Duchamp and Robert Morris. In his essay on Duchamp, Burnham identifies parallels between Duchamp's *The Bride Stripped Bare by Her Bachelors, Even* (1915–23, Philadelphia Museum of Art) and the Cabalistic Tree of Life.[11] According to that age-old mystical Jewish system of Scriptural interpretation, the Tree of Life is a symbol of creation that contains spheres or vessels, known as Sephiroth, through which the light of God shines down on humankind.[12] Burnham illustrates his book with diagrams of the Cabalistic Tree of Life (fig. 2) and the Scheme of the Four Worlds (fig. 3), a subdivision of the Sephirothic system. In his explanation of the latter, he notes that the sphere at the center of the diagram symbolizes the four chemical elements of the earth: fire, air, water, and earth.[13] Similarly, the essay on Robert Morris interprets a sculptural installation as symbolizing the four elements.[14] In reading about relationships between twentieth-century art and the Cabala, Swartz recognized the possibility of connecting her own art to her Jewish heritage and, subsequently, began investigating the natural elements. This move would eventually determine the tone and direction of her identity as an artist.

Swartz began her exploration of the elements by relating her medium to her subject. To depict air, for example, she applied paint with an airbrush to portray abstract sections of sky, as in *Air, #3* (1974, colorplate 12). While spending the summer of 1974 at the beaches in San Diego, she turned her attention to water, an element that had also interested Alan Watts. In *The Wisdom of Insecurity*, Watts praised the Chinese Taoists for recognizing the dual nature of water, noting that "the Chinese philosophy of which *judo* itself is an expression—Taoism—drew

attention to the power of water to overcome all obstacles by its gentleness and pliability."[15] In her acrylic paintings of water (colorplates 10, 11), Swartz simulated the effects of ocean waves, splashes, and foam by working with a variety of tools, including large brushes, her hands and fingers, paper towels, and a serrated knife for scraping into the paint. Because she considered these works to refer to essences of water, as opposed to landscape, and because making them involved a Zen-like concentration, Swartz entitled the series *Umi,* the Japanese word for water. Upon returning to Arizona, the artist shifted her focus to the earth and translated topography into fluid streams of color that were even more abstract than her earlier landscapes. In *Earth Flow, #21* (1975, colorplate 13), sinuous contours of broad fields of color suggest the curvature of the planet itself.

In 1976 Swartz's mother, Dorothy Ames, suffered a heart attack, a crisis that prompted the artist to confront her fear of death and her relationship with her mother. In dealing with these issues, she began to accept the darker, destructive side of her psyche (what Jung called the "shadow") and channeled her anger into her art. In a series dedicated to her mother, Swartz "took a large piece of watercolor paper, scratched 'fear of dying' on it and ripped an opening in it with a screwdriver."[16] Later the same year, as her mother recovered, Swartz traveled to Israel and visited Yad Vashem, the Holocaust-memorial museum in Jerusalem, where an eternal flame burns to honor the six million Jews who perished in the Nazi death camps. Profoundly moved, the artist recognized the symbolic significance of the final element to be explored—fire—which provided yet another link to her Jewish heritage.

Swartz's inquiry into fire involved several new procedures and marked a turning point in the evolution of her methodology. She made the earliest works in the series by drawing on paper with smoke from a candle, a technique that was popular in the 1930s among Surrealist artists who called the process *fumage*[17] (fig. 4). In 1977 Swartz created about fifty such drawings by holding paper over a candle and tracing out patterns of smoke. The artworks born from this process, such as *Smoke Imagery, #4* (1977, colorplates 17a, 17b) and *Fire and Ice, #2* (1977, fig. 5), are alchemically produced abstractions that suggest topography as well as withered, ancient artifacts that could have their own religious histories.

Fig. 4. Beth Ames Swartz, smoke drawing experiment, 1976.

Fig. 5. Beth Ames Swartz
Fire and Ice, #2, 1977
fire, ice, and mixed media on paper
28 × 44 in.
Private collection

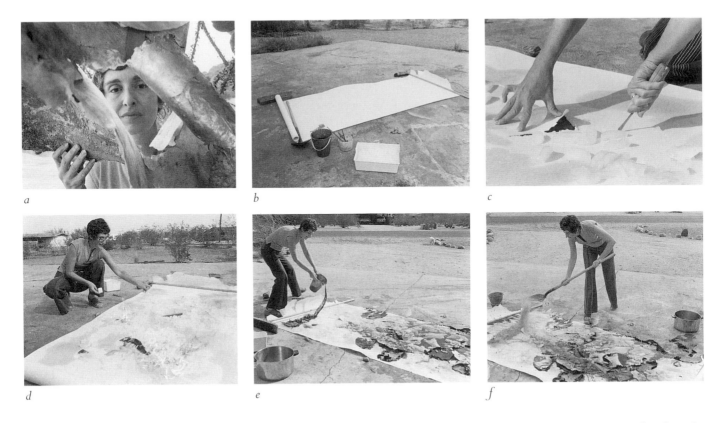

a

b

c

d

e

f

Fig. 6. The ritualized process Swartz used in creating her fire works:

a. Emptying mind (ordering)

b. White paper rolled out (ordering)

c. Mutilation with screwdriver (disordering)

d. Burning of mutilations (disordering)

e. Mixed media applied (reordering)

f. Earth, rain, sunlight, tearing, fire, and mixed media applied as needed (reordering)

As she continued to experiment with making art by fire, Swartz developed a ritualistic mode of working. The ritual began with meditation and entailed unfurling large rolls of watercolor paper on the ground, mutilating it with a screwdriver, burning it with a candle or matches, and adding glue, colored pigments, and earth. She would repeat the sequence by adding three or four layers of paper to each work and pouring water or ice over it to contain the fire (figs. 6 a–f). Conscious of the religious connotations of her new process, Swartz began using Hebrew terms such as *Cabala* and *Torah* in her titles and exploring various stylistic devices to reinforce these associations. *Cabala, Tayet #9* (1977, colorplate 19), for example, is a vertical triptych shaped to resemble the ark that houses the Torah; its three divisions also suggest a Christian altarpiece. In *Torah Scroll, #4* (1977, colorplate 22) sumptuous shades of red and blue, airbrushed onto the surface of what appears to be a scroll fragment, evoke the radiant surface of a precious religious object.

Swartz achieved a similar effect in *Mica Transformation, #3* (1977, colorplate 20) by burning handmade paper lined with silver leaf and adding mica to the smoke-

formed imagery. The title of this work reflects the influence of George T. Lock Land, author of *Grow or Die: The Unifying Principle of Transformation.* Swartz had attended creativity workshops led by Land, who argues in his book that transformation results from "mutual growth" involving the interplay between order and disorder. According to Land: "We constantly take our physical world apart so we can reformulate it into new levels of organized material. Local cultures dissolve as they bring their differences into new cultural organizations. In all of this we see the process of transformation as we disorganize in order to reorganize at higher levels."[18]

During the same period when Swartz was creating her first fire series, several southern California artists also were exploring spiritual aspects of the natural elements. By the time she exhibited her fire works at the Scottsdale Center for the Arts in 1978 (fig. 7), she was aware of these developments on the West Coast and invited artists working with fire to contribute documentation of their work to her exhibition. The Los Angeles artist Jay McCafferty, for example, was experimenting with solar-burning, making drawings from sunlight penetrating through a magnifying glass.[19] He was one of several young artists who viewed art as a spiritual endeavor. Robert Irwin, a leader of the "light and space" movement, had by this time made a national impact with a Zen-influenced approach. Irwin's sculptures and installations used light and shadow to heighten viewer perception of a gallery's surrounding space (fig. 8).[20] The late Wallace Berman, who had been involved in the West Coast Beat movement in the 1950s and 1960s, shared Swartz's fascination with the Cabala and used an obsolete Verifax photocopying machine to create photographic grids filled with provocative symbols about the mysteries of the universe (fig. 9).[21]

The pioneering feminist artist Judy Chicago also contributed to the documentary section of Swartz's 1978 exhibition, submitting a photograph and an explanation of a performance-art event in which several women created the outline of a female butterfly from two hundred road flares.[22] The feminist movement was in full force by the late 1970s, and Swartz learned about its early milestones when she attended a lecture by the art critic Lucy Lippard in 1976.[23] Although steeped in Jewish tradition, Swartz's fire ritual had many of the same properties as the early

Fig. 7. Installation view, Inquiry into Fire, *Scottsdale Center for the Arts, 1978.*

Fig. 8. Robert Irwin (American, b. 1928)
Untitled, *1969*
acrylic paint on cast acrylic
diam.: 21⅞ × 46¹/₁₆ in.
Phoenix Art Museum,
Gift of Mr. and Mrs. Alvin N. Haas

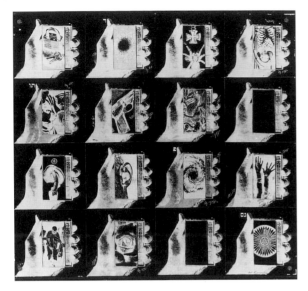

Fig. 9. Wallace Berman (American, 1926 –1976)
Untitled, 1965
Verifax collage
26¹/₁₆ × 24¹/₈ in.
Phoenix Art Museum, with funds provided by
Contemporary Forum, William S. Woodward,
Steven Woodward and the Media Foundation

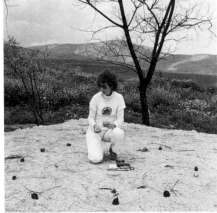

Fig. 10. Swartz at work on Hazor #1, her
homage to the Palestinian scholar Beruriah.

1970s performance-art ceremonies by the Cuban-born Ana Mendieta, who is credited with having played "an influential role in formulating a connection between temporal earth works, feminist body art, and the ritual forms and symbols of her Cuban Santeria heritage."[24]

Swartz's interest in working with earth itself accelerated in 1978–79. A great admirer of Robert Smithson, whose well-known earth work *Spiral Jetty* (1970, fig. 11) graced the cover of her copy of Jack Burnham's collected essays, Swartz traveled to several locations to collect soil of varying colors.[25] The red rocks of Sedona provided both the material and palette for *Sedona, #6* (1978, colorplate 23), while the sands of Hawaiian beaches are incorporated in *Green Sand Beach, #1* (1979, colorplate 25) and *Black Sand Beach, #12* (1979, colorplate 26).

In the spring of 1980 Swartz traveled again to Israel. It was this trip that was to result in the first defining body of work in her career. In the group of works that would be exhibited the following year under the heading *Israel Revisited*, Swartz blended aspects of Judaism, feminism, and transformation to create a ritualistic form of earth art that was distinctly her own. While reading about the Cabala, she conceived the idea of returning to Israel to perform her ritual at several historic sites. In researching which sites to visit, she discovered that the stories associated with many of them were patriarchal, a perspective to which she related with difficulty. Consequently, she looked for sites that involved stories of biblical or historical women and ultimately selected ten. Swartz's studies of Cabala had introduced her to the concept of the Shekinah, which one scholar has interpreted as "a divine entity, a portion of God himself, but as a feminine power."[26] Already familiar with the Jungian division of the human psyche into male and female aspects, known as *animus* and *anima*,[27] Swartz instantly embraced the idea that, as she expressed it, "God has many names and can speak through women as well as men and that feminine energy is part of everyone's heritage."[28]

From April 9 to 18, 1980, Swartz worked her way from northern to southern Israel, beginning at Mount Tabor, where she dedicated her ritual to the prophetess Deborah, and culminating at Solomon's Pillars (near Eliat) with a ceremony honoring the Queen of Sheba, known for her great wisdom. On the advice of a

Cabalist teacher, Swartz wore white clothing bearing the seal of Solomon for protection. Also, at the suggestion of a rabbi, she began each ritual by drawing a circle in the soil as an act of consecration. Working now with up to twenty layers of paper at a time, she burned and buried her materials in the soil and then rescued the charred fragments that formed the skeletons for three bodies of work that would later be completed in the studio. These include the *Buried Scroll* series (colorplate 34), which resembles remnants of ancient religious scriptures; the *Illuminated Manuscript* series (colorplate 33), in which each work is based on a letter of the Hebrew alphabet; and the most complex group, the *Ten Sites Series*, in which biblical heroines are distinguished by different colors and linked symbolically to the ten Sephiroth, or vessels, of the Cabalistic Tree of Life.

Hazor #1 (1980, colorplate 31; see also fig. 10), for example, is dedicated to Beruriah, a second-century scholar and teacher of Judaic law.[29] Because Beruriah "possessed a precise and clear mind, remarkable memory and formidable wit," Swartz associated her with the ninth sephirah, Yesod, which contains the divine attribute "foundation."[30] Appropriately, *The Red Sea #1* (1980, colorplate 28) honors Miriam, whose brother Moses led the Children of Israel out of Egypt when God parted the waters of the Red Sea. Because Miriam, along with Moses, "encouraged her people to abandon the worship of graven images," the artist identified her with the eighth sephirah, Hod, whose attribute is "intelligence."[31] In shaping works such as *Hazor #1* and *The Red Sea #1* in the studio, Swartz ripped and tore her paper fragments intuitively and reworked them with glue, pigments, and other materials such as gold or silver leaf. Today, she views the entire process—from drawing a circle in the earth to the completion of each object—as a symbolic form of transformation. According to Swartz, her art-making journey through Israel was essentially "a ritual of life, death, and rebirth, with fire as the integrating link."[32]

Swartz continued making fire pieces for about two years following her second trip to Israel, abandoning the process in 1983. An unanticipated consequence of working with alchemical materials was that exposure to fumes began jeopardizing her health; in late 1980 Swartz was operated on for the removal of a benign tumor. Seeking to improve her health and recover from a state of exhaustion, she began

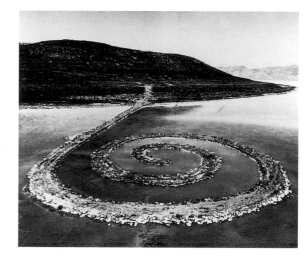

Fig. 11. Robert Smithson
Spiral Jetty, April 1970
Great Salt Lake, Utah
Black rock, salt crystals, earth, and red water (algae)
3 1/2 × 15 × 1500 ft.
Estate of Robert Smithson,
Courtesy James Cohan Gallery, New York
Collection DIA Center for the Arts, New York

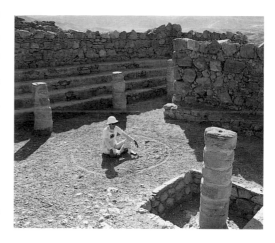

Fig. 12. Swartz at Masada, above the western shore of the Dead Sea, 1980.

studying Native American healing practices and in 1981 participated in a medicine-wheel ceremony led by a Navajo medicine man.[33] Around the same time, she was reading about the Hindu chakra system, a belief that physical health can be regulated by the flow of energy through seven points of entry in the human body, called chakras. This Sanskrit term, meaning wheel, refers to a vortex, or "force-center," where spiritual energy and physical matter unite. The concept was attractive to Swartz because she recognized a parallel with the Cabalistic Sephiroth through which humankind receives God's energy.

Another feature of the chakra system is its emphasis on color, something that naturally appealed to Swartz as an artist. According to the system, spiritual energy enters the body through the first chakra, located at the base of the spine and associated with the color red, and moves upward through the other chakras until it reaches the seventh one, located at the crown of the head and identified with violet. No longer able to work with fire, Swartz decided to return to painting and chose to study the chakras by working with each individually. She began her investigation in 1982 by concentrating on the color red. Continuing her interest in sacred sites, she decided to perform a ritual focused on the color red at the Anasazi Sun Clan site in Snowflake, Arizona, a location associated with healing in Native American culture.

In Snowflake, Swartz devised a ceremony involving red foods, a lit red candle, and indigenous rocks, which she arranged to form a Navajo medicine wheel. Seated at the center of the circle, she began applying paint to an earlier fire piece, but the process was interrupted by rain. What followed was an unexpected experience that Swartz later learned was the equivalent of a Native American "vision quest."[34] When she discovered her car was stuck in the mud, she found refuge from the rain in an abandoned shack, where she had a vision of two horses, one black and the other white; they made her feel protected. The following morning, she found assistance and was able to return home safely. Swartz's vision instilled in her an interest in the symbolic power of animals that was reinforced the following year when she viewed prehistoric cave paintings at Grotte de Font de Gaume in Les Eyzies de Tayac, France.

From 1983 to 1985 Swartz worked on a series of paintings based on the seven chakras. Seeking to charge each painting symbolically with references to organic life and healing, she incorporated figurative images of body parts associated with the chakras, animals, medicine wheels, and floral forms. Inspired by a workshop on shamanistic healing that she attended in 1983 at the Esalen Institute in Big Sur, California, she also began mixing her paint with metal leaf, crushed crystals and microglitter, believing that the optical effects of these light-reflective materials could "produce the inner radiance of the chakra energies."[35] While working on the chakra paintings, Swartz visited the Rothko Chapel in Houston; the impact of viewing Mark Rothko's art in a public, architectural environment lingered, and upon returning to Arizona, she decided to present her chakra paintings in an installation format. The ultimate result was *A Moving Point of Balance*, a participatory installation that was designed to be a healing environment based on the chakra system. It debuted in Canada in 1985 and toured the United States until 1990.

In *A Moving Point of Balance*, Swartz's seven chakra paintings were part of a multi-sensory environment that included carefully orchestrated light and sound. Viewers entering the exhibition received a brochure with instructions on how to walk through the installation and interact with the paintings. First, they encountered a Navajo medicine wheel, similar to the one that Swartz created at Snowflake and at six other sites where she conducted rituals as ceremonial preludes to producing each of the chakra paintings (fig. 13). Moving farther into a darkened interior, they stood in seven altarlike installations, each consisting of a chakra painting, with a circle of colored light reflected several feet in front of it. The brochure encouraged viewers to meditate as they stood in the circular color baths and faced the paintings, listening to soothing music composed by Frank Smith. Swartz sequenced the installations to follow the order of the chakras. Viewers of *Chakra #1 (base of the spine)* (1983, colorplate 40) stood in a circular bath of red light; in orange light for *Chakra #2 (reproduction)* (1983, colorplate 41); in yellow light for *Chakra #3 (solar plexus)* (1984, colorplate 42); and so on until they reached the circle of purple light accompanying *Chakra #7 (crown)* (1985, colorplate 46). At the end of this circuit was an environ-

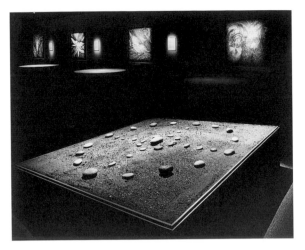

Fig. 13. *Medicine wheel, installation view,* A Moving Point of Balance, *Nickle Arts Museum, University of Calgary, Alberta, Canada, 1985.*

ment called the "Balancing Room," where projections of white light helped viewers stabilize their perceptual and emotional responses.[36]

A Moving Point of Balance was meant to function as an environment in which the senses could serve as points of transition for healing—or, at least, for feeling uplifted. To gauge the impact of the work, Swartz solicited viewers' reactions using computer-coded cards and questionnaires. The great majority of the 1,468 respondents from the first three venues to which the installation traveled reported feeling "relaxed, uplifted, stimulated or spiritually moved."[37] Encouraged by this reaction, Swartz became interested in transformative art, which the art historian John Perreault has defined as

> any visual or performing art that expresses or evokes spiritual truths or higher states of consciousness that lead to a greater understanding of oneself, humanity, nature, the cosmos and their interdependence. Transformative art is intended to directly affect or heal the body, mind and spirit of the artist through the creative process and of the receptive viewer/audience through the experience of the art itself."[38]

In 1988 Swartz co-founded the International Friends of Transformative Art, a philanthropic organization that provided grants for artists involved in spiritual and ecological endeavors.[39] Swartz met artists who shared these interests and became immersed in a kind of community dialogue with them. She also read books such as Riane Eisler's *The Chalice and the Blade: Our History, Our Future* (1987) and Thomas Berry's *The Dream of the Earth* (1988), which introduced her to various models for universal harmony based on symbolic narratives, and began incorporating relevant symbols into her paintings. In the triptych *Choice: Love or Fear #1* (1991, colorplate 55), for example, a plea for healing the planet is expressed through symbols of angelic deities flanking the womb of the earth (in the center panel), which is depicted as a vaginal form. Taking the sentiment of this work a step further, Swartz decided in the early 1990s to develop a series of paintings in which she would create her own mythology for a better world.

Swartz's *A Story for the Eleventh Hour* presents a psychological, cosmological, and spiritual journey that moves sequentially from personal considerations to universal

ones. The fifteen paintings making up the series combine to tell a story of enlightenment in which the "I" of the ego is transformed into the "eye" of seeing and then, finally, into the "aye" of affirmation. These multiple meanings are alluded to in all the paintings by the repeated symbol of a human eye. The series commences, appropriately, with *A Story for the Eleventh Hour, Beginning* (1993, colorplate 59), in which creation is represented by a dark void filled with a spark of light. Next is *A Story for the Eleventh Hour, Coalescence* (1993, colorplate 60), which portrays the Big Bang theory of creation with three open eyes and abstracted galaxies. The third through ninth paintings are collectively known as *A Story for the Eleventh Hour, A Personal Story* (1993, colorplates 61 a–c, 62 a–d); this grouping corresponds to the seven-chakra system and represents the artist's personal growth. In each of these paintings, Swartz has incorporated a photograph of herself, combined with Hindu and Buddhist symbols. In the tenth painting of the overall sequence, *A Story for the Eleventh Hour, And the lotos rose, quietly, quietly* (1993, colorplate 63), a Buddha figure cradles the world. Presented as an androgynous universal symbol, the Buddha represents the attainment of serenity. In the thirteenth segment, *A Story for the Eleventh Hour, The Return: Charging the Species at the Eleventh Hour* (1993, colorplate 66), the Buddha is busy at work, healing humanity with love and compassion. Images affixed to the surface of this painting include an undernourished Biafran, an aged woman, and the text from an article about overpopulation. In the final painting, *A Story for the Eleventh Hour, Shantih shantih shantih* (1993, colorplate 68), the Buddha presides over the galaxies but has diminished in scale because the world is now awakened. The title of this painting, the last line of T. S. Eliot's *The Waste Land*, is Sanskrit for "the peace which passeth understanding."[40]

With *A Moving Point of Balance* and *A Story for the Eleventh Hour*, Swartz had shifted her artistic direction from healing herself to healing others. Another bout with personal illness, however, forced her to concentrate on her own well-being. Diagnosed in 1995 with chronic fatigue immune deficiency syndrome (CFIDS), a debilitating disease that can last for months or even years, she again faced her situation by turning to ritual. This time, she attended classes on healing and meditation rooted in Qi Gong, a Chinese system of physical training, philosophy, and preventive and therapeutic health care. In the meditation group to which Swartz be-

longed, participants practiced Shen Qi, a form of relaxing and bonding spiritually through community. According to one writer, Shen Qi is "the energy from which the universe is formed; it is the force that gives us spirit, creativity, health, happiness, life itself."[41]

During the late 1990s Swartz began referring to Shen Qi in her paintings. In applying layers of gold leaf, she found a vivid metaphor for the inner glow that accompanies good health. In *Tetragrammaton #2 (with ultramarine line)* (1997, colorplate 72), for example, Swartz immersed the top triangular section of a Star of David in a field of radiant gold leaf, thereby drawing a visual analogy between the spiritual energies associated with Shen Qi and the Cabala. In *Ten Sefiroth #4 (pale gray)* (1999, colorplate 82), a shimmering gold surface sheathes a cosmological composite that fuses the Cabalistic Tree of Life, the Hindu chakras, and the androgynous Buddha. According to Swartz, "the images that are underneath the gold need to be sought after and discovered, just as the Cabala is a slowly revealed body of knowledge. On one hand, the shine of the gold draws us in, but we are asked to go beneath the illusion into another reality."[42]

Swartz also has commented that "the painstakingly slow process of painting in between all the negative areas and building up layer after layer of surface" in her recent paintings is time-consuming and meditative; she is certain that it has contributed to her recovery from CFIDS.[43] Yet just as she has been healed by making the paintings and nurtured by the other members of her Shen Qi meditation group, she believes that viewers, too, will have similar experiences as they connect, consciously or unconsciously, with the symbolism and visual splendor of her recent art. Still a devoted student of Kandinsky, Swartz continues to develop new and expressive ways to fulfill his dictum that art "must be directed to the improvement and refinement of the human soul."[44]

NOTES

1. Frieda Fordham, *An Introduction to Jung's Psychology* (Harmondsworth, England: Penguin Books, 1953), 65.

2. Robin Robertson, *C. G. Jung and the Archetypes of the Collective Unconscious* (New York: Peter Lang Publishing, 1987), 125. See also Fordham, *An Introduction to Jung's Psychology* and Carl G. Jung and M.-L. von Franz, *Man and His Symbols* (London: Aldus Books, 1964).

3. Ann Belford Ulanov, *Religion and the Spiritual in Carl Jung* (Mahwah, N.J.: Paulist Press, 1999), 11. The quotation is by Ulanov.

4. During a 1970 visit to the Los Angeles County Museum of Art, Swartz had seen a work by John Marin in which a cutout was collaged to paper. See Mary Carroll Nelson, *Connecting: The Art of Beth Ames Swartz* (Flagstaff, Ariz.: Northland Press, 1984), 123. Swartz believes the Marin work was *Red Sun, Brooklyn Bridge* (1922, Art Institute of Chicago). Swartz, e-mail to author, June 5, 2001.

5. Wassily Kandinsky, *Concerning the Spiritual in Art* (1912; reprint, New York: Dover Publications, 1977), 53.

6. Alan W. Watts, *The Wisdom of Insecurity* (New York: Pantheon Books, 1951), 24.

7. Ibid., 103.

8. Ibid., 115–16.

9. Louis exploited the fluidity of the medium by pouring liquid acrylic directly onto canvas. See John Elderfield, *Morris Louis*, exh. cat. (New York: Museum of Modern Art, 1988).

10. Nelson, *Connecting*, 40. Louis, Gene Davis, and Kenneth Noland are the best-known members of this group.

11. Jack Burnham, *Great Western Salt Works: Essays on the Meaning of Post-Formalist Art* (New York: George Braziller, 1974), 89–117.

12. Henrietta Bernstein, *Cabalah Primer: Introduction to English/Hebrew Cabalah* (Marina Del Rey, Calif.: De Vorss, 1984).

13. Burnham, *Great Western Salt Works*, 95, 115.

14. Ibid., 119–23.

15. Watts, *Wisdom of Insecurity*, 95.

16. Swartz, quoted in Mary Lou Reed, "Beth Ames Swartz's Stylistic Development, 1960–1980," master's thesis, Arizona State University, 1981, 30.

17. A good example is Wolfgang Paalen, *Fumage* (1938, smoke painting on canvas), reproduced in Gustav Regler, *Wolfgang Paalen* (New York: Nierendorf Editions, 1946), 29.

18. George T. Lock Land, *Grow or Die: The Unifying Principle of Transformation* (New York: Random House, 1973), 186–87.

19. McCafferty explained his process in his statement for the exhibition, quoted in *Beth Ames Swartz: Inquiry into Fire*, exh. cat. (Scottsdale, Ariz.: Scottsdale Center for the Arts, 1978), 18. He wrote, "I have been using the sun, a magnifying glass and the wind to focus the sun's energy to change paper."

20. See Klaus Kertess, "The Architecture of Perception," in Richard Koshalek and Kerry Brougher, *Robert Irwin*, exh. cat. (Los Angeles: Museum of Contemporary Art, 1993), 113–27.

21. See Tosh Berman, *Wallace Berman: Support the Revolution* (Amsterdam: Institute of Contemporary Art, 1992).

22. *Inquiry into Fire*, 17.

23. Nelson, *Connecting*, 124.

24. Robyn Brentano and Olivia Georgia, *Outside the Frame: Performance and the Object*, exh. cat. (Cleveland: Cleveland Center for Contemporary Art, 1994), 178.

25. Burnham, *Great Western Salt Works*, cover illustration. Smithson constructed *Spiral Jetty* by moving rocks into the Great Salt Lake, Utah, to form a spiral.

26. Bernstein, *Cabalah Primer*, 146.

27. Fordham, *Introduction to Jung's Psychology*, 52–58.

28. Swartz, quoted in *Israel Revisited*, exh. cat. (Scottsdale, Ariz.: Beth Ames Swartz, 1981), 12.

29. Ibid., 32.

30. Ibid.

31. Ibid., 29.

32. Swartz, conversation with author, Paradise Valley, Arizona, September 7, 2000.

33. Margret Carde, "Interview with Beth Ames Swartz," in *Beth Ames Swartz, 1982–1988*, exh. cat. for *A Moving Point of Balance* (Scottsdale, Ariz.: A Moving Point of Balance, Inc., 1988), 28.

34. Nelson, *Connecting*, 108. In 1983 Michael Harner, author of *The Way of the Shaman* (1980), explained to Swartz that she had experienced a typical vision quest in which powerful animals had come to protect her, likening them to the totem animals of ancient cultures that lent their survival energy to chosen humans. Swartz, e-mail to author, June 3, 2001.

35. Swartz, quoted in Carde, "Interview," *Beth Ames Swartz*, 34.

36. Research and development for the "Balancing Room" and color baths are ©1985 by Steinberg-Evans-Finch.

37. John Perreault, quoted in Beth Ames Swartz, *Research Study of "A Moving Point of Balance"* (New York: First International Medical Arts Conference, 1991), n.p.

38. Ibid.

39. The International Friends of Transformative Art was active from 1988 to 1998.

40. John D. Rothschild, "A Story for the Eleventh Hour," in *A Story for the Eleventh Hour*, exh. cat. (New York: E. M. Donahue, 1994), 20.

41. John D. Rothschild, "Beth Ames Swartz: States of Change," essay in exh. cat. (Scottsdale, Ariz.: Vanier Galleries on Marshall, 2000), 7.

42. Swartz, e-mail to author, September 27, 2000.

43. Ibid.

44. Kandinsky, *Concerning the Spiritual in Art*, 54.

Wounding and Healing

A STORY

Prologue

1905

Berne, Switzerland

ARLENE RAVEN

Albert Einstein,

a young patent clerk,

bends over his desk

and closes his eyes.

He is flying,

 straddling a single beam

 and moving at the speed of light.

 At this velocity,

 all change stops and everything changes.

 The present swells to embrace past and future.

 "Now" becomes so big

 that it can hold

 the whole of time.

Einstein's vision

of the new nature of the universe

is prophetic.

Soon his theory of relativity,

a four-dimensional world view,

will replace all Euclidean notions of space and time.*

2000

New York City

Tiny transparencies sparkle across my light table. A retrospective collection of the works of Beth Ames Swartz, these miniatures span more than forty years.

Many are images I have seen, on both U.S. coasts and at sites between, over the course of the three decades I have known Swartz and followed her work.

The entirety of her oeuvre tells an unfolding tale—as process, theme, and meaning. Swartz's paintings and environments are abundant in analogs, metaphors, and references—associations with and materials from places and events in this artist's life story and through the longer chronicle of global history.

Classify, collate, sort, and assemble the pictures, I look for the story.

Swartz's configurations contain multiple narratives that are layered and heterogeneous. Diary and autobiography redouble as parable and saga.

Telling the tall tale that enfolds Swartz's smaller story into its totality requires binocular vision and double entendre.

Eyes, for instance. Singular. Wide open and all-seeing in paintings for *A Story for the Eleventh Hour* (1993) such as *Coalescence* (colorplate 60) and *Shantih shantih shantih* (colorplate 68). Eyes everywhere in *The Return: Charging the Species at the Eleventh Hour* (colorplate 66).

Organs of the body, yes. And manifold in meanings. Eye schemas hiding among the lotus leaves in *The Lotus as Metaphor: Twenty-two Petaled Lotus* (1994, colorplate 70), spiral back decades to recurring radiating circles and ellipses of previous efforts.

*Adapted from Alan Lightman, *Einstein's Dreams* (New York: Warner Books, 1993).

For artists and shamans, seeing can be psychic; insight, conceptual; vision, supernal. Swartz, the art dealer and writer John D. Rothschild has written, views the eye as a metaphorical verbal and visual reminder of a "double, double entendre":

The "I" of ego
The "eye" of seeing
The "aye" of affirmation[1]

Or the heart. Crux of will, love, and of all healing as the axis of the circulation of lifeblood and animating, rose-colored energy. Even pluck.

Shape of *The Red Sea #1* (1980, colorplate 28) in *Israel Revisited* (1980). A valentine at the "heart" chakra—*Chakra #4 (heart)* (1984, colorplate 43) (one element of the 1983–85 multimedia installation *A Moving Point of Balance* [colorplates 39–46]).

This artist not only depicts the heart but also follows its path—a passionate practice in which the infinite and divine are perceived through a detailed personal lens, rendered infinitesimal enough to enter from aperture to nucleus.

Although the way of the heart (in which blood, bone, home, and spirit dynamically coexist and intermingle) is part of the Torah path integral to ancient Jewish mysticism, Swartz finds the sensual and emotional quest for the spirit in the mystical environments of every faith.

This core of Jewish Cabalism harmonizes with Swartz's own central concerns. But ciphers profane and sacred are gleaned from far-ranging sources—exhaustively absorbed and rendered uniquely visible in her work. Through changing the fundamental route of her life journey, the artist freely employs and interfaces concepts and icons associated with systems for understanding the sacred—from Buddhism, Hinduism, Christianity, and Taoism to current secular spiritualities and many other roots.

States of Change (1999–2001, colorplates 80–84), for example, combines "the chakra system of body knowledge and the Cabalistic Tree of Life" (in fact, seven chakras and seven sacraments; five states of change, five forces, five cardinal points, five seasons, and more) to underline their similarities.[2]

Swartz's symbolism names, in multiples, markers in the unbroken cycles of wounding and healing that create transformation. The dynamic structure of the world, as her art portrays it, interprets earthly life as, by definition, in need of continuous repair.

The repairing (or healing) of the world, *tikkun olam*, is intrinsic to Jewish spiritual practice, a basic obligation. Healing embodies bruised ruins and riddling restorations in order to "make well." And healing here—as the artist's action, in the face of impossibility and of possibility—means most essentially "elevating the task or condition at hand."[3]

Here also, time and timelessness can coexist in constant contradiction. In Swartz's world, as in Einstein's:

> There are two times. . . . The first is . . . rigid and metallic. . . . The second squirms and wriggles like a bluefish in a bay. The first is unyielding, predetermined. The second makes up its mind as it goes along.[4]

States of Change is the artist's most recent series. Vibrant gold, silver, cobalt, and ruby hues; rich in rendered archetypes and emblematic signs, the compositions are also charged with crucial antitheses. Anchored, still; these paintings move.

Swartz's titles exemplify the artist's dualistic complexity. "State" and "change" can maintain or tip over the equilibrium offered by "of" at any moment.

The Wounded Healer (1991–92, colorplates 54–56) alludes to the inborn hurt and renewal of the shaman.

A Moving Point of Balance expresses both being and doing. Monikers for concrete geometric objects with crusty homogeneous surfaces, these series, as well as whole bodies of works between, aspire to depict the immaterial. The designations Swartz has chosen to name them contain contemporary truths in knots characteristic of the koan.

The thirteenth-century Zen master Kigen Dogen offered this paradoxical meditation: "It is believed by most that time passes; in actual fact, it stays where it is."[5]

The sage is no trickster. Rather, he presents in poetic form a thesis and antithesis from which the fresh system of thought necessary to confront and understand

any new picture will emerge. Swartz has reached such a point more than once. For her, these states require change.

Einstein's dream of time ticking at rest, a symbiosis of scenes from the invisible inner eye and, equally, the ordinary realm of things, also was a meditation and, incontrovertibly, all in his mind. Imagination, delusion, or insight, the paradoxes of perception that he embraced opened possibilities previously considered contrary to reason.

Sigmund Freud also dreamed. Night visions, he theorized in his *Interpretation of Dreams* (1900), are as keenly true-to-life as waking encounters. Quantum physics fused the formerly incongruent properties of light, blurring the boundaries between natural philosophy and art.[6]

Piet Mondrian, František Kupka, Wassily Kandinsky, and Sonia Delaunay were moved to actualize in material terms a world behind and beyond the eye.

The separate intricacies and transposability of the interior and external cosmos—as set forth in the fine arts, physical sciences, and theosophies East and West during the first years of the twentieth century—were to shape the sensibilities of the next hundred years and serve as principles governing the deepest reaches of Swartz's art.

Ten Sefiroth #1 (alizarin crimson) (colorplate 81), a 1999 tondo painting forty inches in diameter, demonstrates the state of change that binds perpetuation and permutation into a timeless present. Ten spheres mark a schematic body at rest in the lotus meditation posture. The figure is a triangle, delineated by its energy and position rather than by the appearance or placement of its features. Centered, frontal, and iconic, the tricorn is secured inside the gridded circumference.

But the stasis, once attained, shimmies and shakes. The circle is rimmed in a gold halo that frames a viewer's gaze to the inside and locks eyes with the source peering out. The yarn is already a conversation, mirroring the spinner and the listener.

I see red.

Fuming and flaring; inflamed, kindled, explosive.

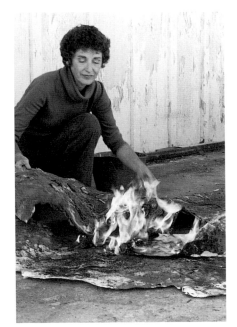

Fig. 1. *Swartz working with fire, part of the process she used in creating her fire works, ca. 1977.*

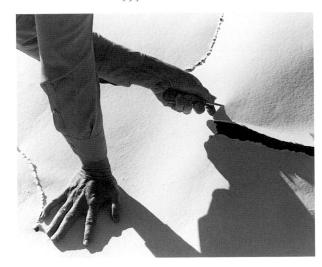

Fig. 2. *Swartz ripping paper with a screwdriver, ca. 1976.*

Swartz is, after all, a feminist, a seeker, and an earth lover. She understands fury as a fire that can burn out the heart or spur revolutionary action.

Passion sizzles. And catalyzes her art.

The red eyes of the dragon.

Jacob's biblical stew and ritual wine.

The sacrificial red heifer.

Alizarin crimson moves from vermilion to claret, to mingle yet never truly merge, suggesting the edgy collision of fire and blood.

In the year 2000, with Einstein's enlightenment (and postmodern permission), Swartz's story might start anytime, anywhere. But a story of healing always begins in the wound.

1976

Paradise Valley, Arizona

Suddenly Swartz is playing with fire (fig. 1).

She tears and torches her paper.

After painting in a lyrical abstract style for two decades, the artist is now mercurial, dangerous.

Her mother's 1976 heart attack had been the cardinal event that fueled the artist's apprehensions about her own inevitable death. Swartz's state of mind and emotion "precipitated a moment in [her] studio when she grabbed a screwdriver and stabbed and ripped at the paper in front of her"[7] (fig. 2).

A decade later, *Celestial Visitations* (1987–88, colorplates 50, 51) would act "as a harbinger to take my mother to heaven," Swartz recently wrote me. "I didn't know at the time that was why I was doing these strange, huge headless figures, but that is the way it turned out."[8]

Whether as grief or explosion, Swartz used the potent animation of anger as the spine of healing. She explored the relationship between rage and love—not as incompatible but as liberating.

The critic Margret Carde writes about the artist's "destructive acts" on her painting surfaces.[9] Through these actions, private rituals of ravagement, she would create an entirely different methodology of expression over the next year.

Swartz would no longer represent in her paintings, even abstractly. Instead, she was to make objects of virtual size and actual scale. They were not to be conventional canvases in mass, format, or materials but site works including scrolls, altars, and environments. As the critic Harry Rand claims, the "flames burnt away old assumptions and conceptions, and in the process, Phoenix-like, her new work emerged."[10]

Swartz's inspired epiphany would ignite, then transfigure, the artist and her art. Such a "breakthrough" event is inherent to American modernism, inaugurating mature or signature work. Four decades earlier, Jackson Pollock had abruptly abandoned his easel to spread much larger canvases on the floor and drip house paint onto their surfaces with a stick.

A few years after Pollock's revelation, Morris Louis also took his canvases off their stretchers. He began spilling a different kind of paint—an experimental oil-based acrylic—in very thin veils of color onto unsized material draped over a trough. As Louis's personal self-images jumped, his internal forms enlarged and altered. His painting formats became colossal. The fabric is so voluminous that he must roll out a portion at a time to fit into his garage studio. He never sees a whole work—from top to bottom or side to side—there.

1982

Paradise Valley, Arizona

Nineteen eighty-two was not an expansive year for many. The Vietnam Veterans Memorial, designed by Maya Lin and dedicated on November 13 in Washington, D.C., recorded the names of 57,692 Americans who had been killed or were missing as a result of that war. Helen Gurley Brown published *Having It All*, yet seemed to be eating almost nothing at all. The Jane Fonda workout tapes had become best-selling videos. If that didn't do the trick, American plastic surgeons made 1982 the year liposuction was introduced.[11]

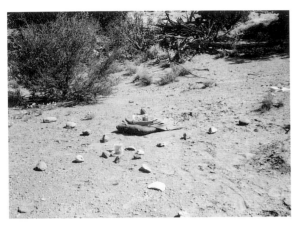

Fig. 3. *Medicine wheel built at an Anasazi Sun Clan sacred site near Snowflake, Arizona, where* Chakra #1 (base of the spine) *from* A Moving Point of Balance *was created, ca. 1982.*

But Swartz had expanded—beyond the capabilities of her working space.

She builds a new, larger studio that year.

Pollock, Louis, and Swartz were compelled to make profound changes in their art by personal experiences that they could hardly have explained at the time. Their insights required a high level of risk and a leap of faith.

They would now undertake untraveled spiritual journeys into their processes and visions.

They would improvise.

And make up their minds along the way.

In this same way, Ad Reinhardt arrived at his "minimal" black squares—insistently material imageless images—in his search for a likeness of the "breathless, timeless, styleless, lifeless, deathless, endless" Buddha.[12]

Just like that, Swartz caught fire.

A symbol of God's presence and power, flames were closely related to Old Testament worship and religious life as well as critical to secular existence as light at night, heat for cooking and warmth, forge for tools and weapons.

The artist chose the "Way of Flame," and her blood boiled.[13]

Red served Swartz's zeal and colored her story.

Seven years after making her first fire works, Swartz set *A Moving Point of Balance* in motion with red: "She started with the red chakra because it was the first. . . . To connect the work more closely with healing, she chose to paint at a site [Moon Rock, near Snowflake, Arizona] considered to be both sacred and healing."

> I worked with red foods; I lit a red candle and built an Indian medicine wheel in a northeast, southwest direction using thirty-two rocks. Within the circle of rocks, I meditated and then painted a fire piece. I didn't know what kind of art I would do[14] (fig. 3).

1980

The Red Sea, Israel

In April Swartz traveled to Israel to make pilgrimages to ten biblical sites (fig. 4). To select the locations for works in what would become *Israel Revisited*, she had "studied Biblical history . . . [and] searched for accounts related to specific areas in the Holy Land." The artist, writes Mary Carroll Nelson, "felt the need to find, acknowledge, and honor women," focusing on heroines of the Old Testament who had incited change.

Accompanying this study and as a natural outgrowth of her interest in unseen coincidences and the great philosophical questions of birth, life, death, and rebirth, Swartz was attracted to the Cabala and began a systematic study of it (fig. 5). By taking this step, she precipitated the most dramatic transformations she had yet experienced in both her art and her view of the cosmos.[15]

The study of ancient texts would inform confirmation as well as substance: some of the objects Swartz made during 1980 model illuminated manuscripts and scrolls.

Contemporary writing that articulates current spiritual trends also inspired Swartz. *Return of the Chalice, #2* (1988, colorplate 52) emerged from the artist's reading of Riane Eisler's *The Chalice and the Blade: Our History, Our Future* (1987). *Dreams for the Earth, #6* (1989, colorplate 53) was a response to *The Dream of the Earth* (1988) by Thomas Berry. Her series *The Wounded Healer* (1991–92, colorplates 54–56) takes its title from a concept discussed by Jean Houston in her book *The Search for the Beloved* (1987).

Cabalists speak of the Lightening Flash of Divine Energy that emanates from Kether [the first Sephirah of the Tree of Life, according to the Cabala] and streaks through all the higher worlds to illuminate the earth. Swartz had an intimation of the sudden nature of an illuminating inspiration when she connected her proposed trip to holy sites in Israel with the Tree of Life and great women of the Bible. The character of her project deepened into a quest, a spiritual journey to rediscover the Shekinah.[16]

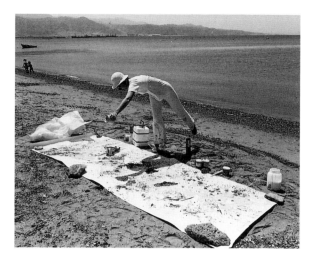

Fig. 4. Swartz at work on Red Sea #1, *from the series* Israel Revisited, *1980.*

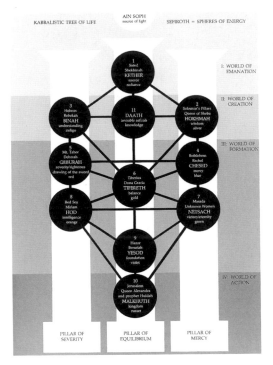

Fig. 5. Cabalistic Tree of Life diagram by Beth Ames Swartz.

At ten sites, Swartz's ten totems honor biblical women in a powerful private language built from the layering, overlapping, and overhanging of fragments of urgent visual speech.[17]

The Red Sea #1 (1980, colorplate 28) is a jewel, liquefied, catching the light. A tribute to Miriam, this ruby red piece reveals Swartz's approach to *Israel Revisited*. Because no gem deposits existed in the ancient land of Israel, such stones were sought after and secured from surrounding nations.

And in the Old Testament, the ruby is called the rarest of these exotic imports. Rubies serve in the Bible as a standard of comparison for that which may be even more precious. The price of wisdom or a good wife, for instance, was considered "far above rubies."[18]

Miriam, along with Aaron, dared to challenge their brother Moses' plan to marry a Cushite woman. As punishment, she was struck with leprosy, turning her skin "white as snow" (Numbers 12:10). Today she is celebrated as an artist by many biblical scholars and feminist readers for her song of victory after the Israelites' miraculous crossing of the Red Sea (Exodus 15:20–21), one of the earliest poems in the written record.

Red Sea #1's suggestion of female viscera brings to mind other early feminist expressions of in-your-face rage through the female body, such as Judy Chicago's "cunt art" and Carolee Schneeman's naked self-portraits in film and on paper as a hot-tempered, bloodthirsty goddess.

But Swartz's approach to the body is in the end not anatomical. Nor does her perspective concur with the worldly ambition of the Renaissance to mirror flesh or the stylistic collaging of postmodernism. Swartz's interpretation is most clearly opposed to modern and contemporary versions of woman put forth by (as examples) Marcel Duchamp, Man Ray, Pablo Picasso, Richard Serra, Jeff Koons, or Cindy Sherman. Not a geometric map or a stack of bricks, an assemblage of levers and pulleys, or a deliberate distortion of female features, *Red Sea #1* is another kind of portrait entirely.

Swartz faithfully represents the female through the emotional geography, conflicts, and energies therein. Corporeal terrain is Swartz's macrocosm and microcosm. In configuring the body as a universe, the artist neither forgets nor assumes but vigorously asserts the paramount presence of the soul.

The popular writer Deepak Chopra echoes the spatial connections in Swartz's synthesis when he describes what he calls the "quantum mechanical human body":

> *No* part of the body lives apart from the rest. There are no wires holding together the molecules of your arteries, just as there are no visible connections binding together the stars in a galaxy. Yet arteries and galaxies are both securely held together, in a seamless, perfect design. The invisible bonds that you cannot examine under a microscope are quantum in nature; without this "hidden physiology," your visible physiology could not exist. It would have never been more than a random collection of molecules.[19]

Red emblem of *la mer*, Swartz's "likeness" of Miriam, as an incarnation of Shekinah, embodies the sea as a corporeal and symbolic body that becomes a gateway through the fourth chakra to the fourth dimension.

Fig. 6. Swartz at work on Jerusalem #1, *her homage to Queen Alexandra and the prophetess Huldah, 1980.*

1989

Staten Island, New York

A circle of red light bathes my feet. Stepping into the cryptic dusk of *A Moving Point of Balance* at the Newhouse Center for Contemporary Art has already dimmed the world outside, and I am back at the beginning. The pleasing hue evokes the energy center at the base of my spine.

A Moving Point of Balance, a testament of and witness to survival, is an ethereal monument to the inner spirit as well as to the physical body. A quiet place, the environment encourages equilibrium. Seven sequential colored lights, music, and a medicine wheel prepare the viewer for a participatory relationship with the paintings. Microglitter, gold leaf, broken glass, and crystals occupy the panels.[20]

Standing in each of the color baths, four feet away from the seven-foot-square paintings, I find myself at the center—times seven—of the work (colorplate 39).

Like Jonah swallowed by a whale, I am inside a larger body. Square edges are softened, unfocused. At such close range, only one area can be seen at a time. I must turn my head or deliberately shift from direct to peripheral vision to see the whole. The point of balance moves as I stay still; rebalances, continuing its rest, when I move.

In the release and catharsis that this peace provides, I see that I, too, am torn. Everyone, in fact, begins broken.

"Wounding represents the first chakra and the first ray," Swartz told Mary Emma Harris in an interview. "We're in paradise in the womb. To come out of that beautiful watery place is a shock, the first wound we bear."[21] *A Moving Point of Balance* charts a way through and back.

Still, healing hurts.

1994

New York City

In fifteen paintings, *A Story for the Eleventh Hour* (colorplates 59–68) presents a sequenced narrative that describes the state of the wound at the last possible moment.

As the clock struck the eleventh hour of the twentieth century, Swartz was moved to remind us of our choices: change or die.

A Personal Story (colorplates 61a–c, 62a–d) is a seven-work subset within this series that chronicles the artist's response to affliction and parallels the morphogenic phases of the biological and spiritual development of any person. *Wounding* (61a) is first.

Swartz's narratives at the brink—in the process of construction as well for the audience of completed work—blend small and larger stories from the start. Her strategy incites interactivity with the life events of others; it merges the many details of individual accounts to multiply and generalize their meanings.

The feminist poet Susan Griffin's book *What Her Body Thought: A Journey into the Shadows* (1999) weaves her struggle with a chronic illness into that of Marie Duplessis, whom Alexandre Dumas *fils* popularized in his 1848 novel *La Dame aux camélias* as the fictional Camille, a courtesan whose life was ended by tuberculosis.

Griffin explains the originating insight that also drives and inaugurates the process that the two artists share: "And now, just as you prepare to tell your own story, you hear another story, one you know will be with you as you make your descent."[22]

The final painting in *A Story for the Eleventh Hour*, *Shantih shantih shantih* (colorplate 68)—Sanskrit for "the peace that passeth understanding"—is the final line of T. S. Eliot's "The Waste Land." The orb, delicately delineated at the center of *Shantih shantih shantih*, is a globe and galaxy at once. All forms ride the wind. None touches the framing edge.

A tiny Buddha sits below the eye that sees the whole.

1995

Scottsdale, Arizona

"When the lotus blossom is open and viewed directly into the open flower, the lotus appears circular," John D. Rothschild writes. Surrounding petals are spokes of a wheel—a circular emblem like the wheel of Dharma or Bhava-chakra, "typifying the doctrine of perpetual cycles of existence."[23]

The initial works in *The Lotus as Metaphor* series, such as *Twenty-two Petaled Lotus* (1994, colorplate 70), issue directly from *A Story for the Eleventh Hour*. Both series foreground the eye. Both use indigo blue as serene backgrounds. Most significant, the former series proposes a new healing myth, based on collective history, and a value system rooted in self-transcendence.[24]

Flattening the circles and floating the ellipses of paintings of the previous year on a pond, Swartz plays with the magic performed by representational artists in portraying three dimensions on a two-dimensional ground. Her canvas surfaces are newly full of painterly brushstrokes that cannot but evoke the water-lily images Claude Monet produced late in his career. Since *lotus* is synonymous with *water lily*,

Swartz acknowledges in these works a conscious connection with this phase of the French artist's work.

Anonymous "lady" flower painters of all periods, who exemplify the lost history of women artists for feminists working since the 1970s, receive tribute in these works. Georgia O'Keeffe's up-close, intimate renderings of orchids and irises, seen by many artists and art historians as references to female sexuality, became principles of the hidden meanings of flowers and provided Swartz's generation with the permission to use flowers as subjects without fear of appearing trivial.

For O'Keeffe, an important feature of her flower works was their spellbinding effect. She sought to stop even busy New Yorkers in their tracks and entice them to take the time to see and dream. Similarly, Swartz invites us to meditate.

For their use of photography and printing in the creative process, Swartz's paper pieces in this series recall those of Andy Warhol. Swartz pastes laser copies of photographs of her beloved New York City lotus pond upon a pool of varied hand-made papers. In some works, an entire rectangular photograph is applied to the paper; in other works, she strips the photographs into a grid, creatively judging where to leave images in and where to omit them.

Next, Swartz practices "the trick of maya": she uses acrylic (and/or pastel) to expand the image outside the rectangular confines of the photograph or to complete the image in the gaps of information between missing parts of the photographic grid.[25]

The lotus flower opens every morning and closes every night. Come to the lily at the same time each day, and see an identical picture. Stay for a whole day and see an evolution that repeats itself—over and over, identically, daily. Thus Swartz evokes linear and circular time, allowing the eternal to move through the temporal.

1999
New York City
The Cabalistic Scheme of the Four Worlds #1 (1997, colorplate 75), one work from the *Shen Qi* series, runs in concentric circles.
Large all-seeing eyes claiming the divine origin of the body and its parts.[26]

Enclosed cycles of continuous rebirth. Shimmering within a rosy golden atmosphere whose extreme beauty quiets their facts of life and death without denying their truths. Standing monoliths at Stonehenge. People in a ring gathered for community and celebration.

The many unified in the one.

The snake biting its tail.

Full circle.

With the *Shen Qi* series (1996–99, colorplates 71–78) we see Swartz playing with a different kind of fire. The grids of gold leaf arrayed across the surfaces of these recent paintings confront us with the fire within, the inner light displayed. These works initiate a new chapter in this artist's ongoing translation of her own spiritual journey through her evolving art process.[27]

2000

New York City

"Suppose time is a circle, bending back on itself."[28]

Swartz wants to add an element to Elisabeth Kubler-Ross's five stages in the journey toward death. Acceptance as an end is not enough. "I like to think there is a sixth stage, transformation."[29]

In *States of Change, Eternity #2 (Three Aspects)* (1999, colorplate 83), Swartz visualizes the gold of the human soul caught between the silver of heaven and the copper of earth against a background field depicting the Chinese character for eternity.[30]

Time alone does not heal wounds. Regeneration is action and reflection, chosen with commitment and dedication.

In this calling, again and again,

Beth Ames Swartz triumphs.

NOTES

1. John D. Rothschild, "The Lotus as Metaphor: New Works by Beth Ames Swartz" (Scottsdale, Ariz.: Joy Tash Gallery, 1995), 4.

2. John D. Rothschild, "Beth Ames Swartz: States of Change" (Scottsdale, Ariz.: Vanier Galleries on Marshall, 2000), 4. See also Barbara Ann Brennan, *Light Emerging: The Journey of Personal Healing* (New York: Bantam Books, 1993), esp. 26ff.: "Chakras are the configurations in the structure of the energy field with which healers work. *Chakra* is the Sanskrit word for 'wheel.'. . . Chakras look much more like vortices, or funnels, of energy. . . . Chakras function as intake organs for energy from the universal life energy."

3. Avram Davis, *The Way of Flame: A Guide to the Forgotten Mystical Tradition of Jewish Meditation* (Woodstock, Vt.: Jewish Lights Publishing, 1999), 55.

4. Alan Lightman, *Einstein's Dreams* (New York: Warner Books, 1993), 23–24.

5. Quoted in Michael Crichton, *Jasper Johns* (New York: Harry N. Abrams in association with the Whitney Museum of American Art, 1977), 91.

6. Leonard Shlain, *Art and Physics: Parallel Visions in Space, Time and Light* (New York: Quill/William Morrow, 1991), 22.

7. Margret Carde, "Balancing Act: Latest Work of Beth Ames Swartz Set in Quiet, Healing Environment," *Phoenix Metro Magazine*, May 1987, 68.

8. Swartz, letter to author, June 27, 2000.

9. Carde, "Balancing Act," 68.

10. Harry Rand, Introduction to Mary Carroll Nelson, *Connecting: The Art of Beth Ames Swartz* (Flagstaff, Ariz.: Northland Press, 1984), 1.

11. James Trager, *The Women's Chronology* (New York: Henry Holt, 1994), 674–78.

12. David Piper, *The Random House Library of Painting and Sculpture* (New York: Random House, 1981), 2: 89.

13. Davis, *The Way of Flame*, identifies the mystical tradition of Jewish meditation by using the term that gives his book its title.

14. Nelson, *Connecting*, 106–7.

15. Ibid., 81.

16. Ibid., 84. In Swartz's work, Nelson writes, the Shekinah developed "because humankind includes both man and woman, and Scripture declares that man is made in God's image, Kabbalists theorize that God must be androgynous. As a consequence, they pay honor to the Skekhinah, or feminine aspect of God. . . . Swartz believes in a balanced image of God for the good of men as well as of women."

17. Ibid., 88.

18. *Nelson's New Illustrated Bible Dictionary* (Nashville, Tenn.: Thomas Nelson Publishers, 1995), n.p.

19. Deepak Chopra, *Perfect Health* (New York: Harmony Books, 1991), 9.

20. Carde, "Balancing Act," 69–70.

21. Swartz, interview with Mary Emma Harris, New York City, January 1994.

22. Susan Griffin, *What Her Body Thought: A Journey into the Shadows* (San Francisco: Harper San Francisco, 1999), 6.

23. Rothschild, "The Lotus as Metaphor," 4–5.

24. John D. Rothschild, *Beth Ames Swartz: The Lotus as Metaphor*, exh. cat. (Scottsdale, Ariz.: Joy Tash Gallery, 1994), n.p.

25. Rothschild, "Lotus as Metaphor," 3. There, Rothschild also cites *The Shambhala Dictionary of Buddhism and Zen* (Boston: Shambhala Publications, 1991), 141–42: "Maya. Sanskrit, literally 'deception, illusion, appearance': The continually changing, impermanent phenomenal world of appearance and forms, of illusion or deception, which an unenlightened mind takes as the only reality."

26. Marija Gimbutas, *The Language of the Goddess* (San Francisco: Harper San Francisco, 1989), 51.

27. Miriam Seidel, *Beth Ames Swartz: The Shen Qi Series*, exh. cat. (New York: Donahue/Sosinski Art, 1997), n.p.

28. Lightman, *Einstein's Dreams*, 8.

29. Swartz, Harris interview.

30. Rothschild, *States of Change*, 5.

EVA S. JUNGERMANN

REFLECTING ON THE LIFE AND WORK OF AN ARTIST is not an easy task. There are visions to be revealed, and there are secrets to be kept. Beth Ames Swartz is an artist and a seeker. She is also a mother, a feminist, and a community activist. I conducted a two-session interview with Swartz in her Paradise Valley, Arizona, home and studio during the summer of 2000. "My work has been a chronicle and a residue of my life," Swartz said as we began talking. "Philosophic threads link theories, yet I take great leaps aesthetically because I find it exciting to explore new painting issues that I had not previously resolved."

Swartz's works articulate the fundamental concerns of mankind and man's relationship with the environment. After years of searching, she has devised an approach that fuses the ideas and customs of various philosophies. She is fond of a dictum by the philosopher and educator John Dewey: "You, plus the painting, equals experience." Swartz sees the artist as an agent of change and a force for good. Her lyrical early watercolors have given way to richly textured canvases that emphasize creation, beauty, and reverence. Her colors and textures have become more opulent. Her art incorporates a search for spiritual truth and is based on the belief that art can transform the human experience.

I live my life in growing orbits
Which move out over the things of the world.
Perhaps I can never achieve the last,
But that will be my attempt.

I am circling around God, around the ancient tower,
And I have been circling for a thousand years,
And I still don't know if I am a falcon,
Or a storm, or a great song.

—Rainer Maria Rilke[1]

Beth Ellen Ames was born in New York City on February 5, 1936, the youngest of three children. "My father, Maurice Ames, was the son of Jewish immigrants. He rose to the position of assistant superintendent of schools in New York City. He taught science before he became an administrator and wrote a series of textbooks called Science for Progress. He also earned a law degree. My mother, Dorothy, worked as a secretary at P.S. 187 in New York. We lived high up in an apartment building in Washington Heights, with a view of the city. Some of my earliest drawings were cityscapes that I drew looking out the window."

"As a child, I had an active imagination," the artist recalled. "When I was five years old, I started showing an interest in art, music, and dance. My mother noticed and encouraged these interests. At twelve, I started taking weekly lessons at the Art Students League, where I had an opportunity to work from live models. Listening to classical music was an important influence in my early years. I often attended concerts conducted by Leonard Bernstein and visited the Museum of Modern Art, where I was especially fascinated by Picasso's *Guernica* and the primitive art of Henri Rousseau.

"I was a lonely child," she went on. "We were not allowed to talk back or be aggressive in any way. Writing poetry and drawing became my sanctuary from the sternness of my parents' home. Getting into the High School of Music and Art in New York focused the direction my life was to take. In addition to a regular academic program, there were two hours of studio art every day. Art became a second language for me."

In 1954 Swartz entered Cornell University, enrolling in the College of Home Economics. "Frances Wilson Schwartz, a professor in the Child Development department, became my friend and mentor. I participated in her Family Art Classes course and became interested in the relationship between art and healing. She was the first person who understood my nature and saw my potential. She died shortly after I left Cornell, leaving me her library. When I flew back to Ithaca to pick up her books, her husband showed me a mobile she had just completed with light and dark disks. Synchronistically, I had just finished a portrait of her in which a mobilelike shape appeared in the background."

Swartz continued: "I read voraciously, including Viktor Lowenfeld and W. Lambert Brittain's *Creative and Mental Growth* [1947]. That and other related books influenced me tremendously, prompting me to ponder the role of creativity in my life and in the life of communities generally. Although I had majored in child development and design, I enrolled in many art history, philosophy, and painting classes, which inspired me to express myself aesthetically. I continued my schooling at New York University and graduated in 1959 with an M.A. in art education. After that, I started teaching several subjects, primarily art and poetry."

At the end of 1959, the twenty-three-year-old Beth Ames married Melvin Swartz, an attorney, and soon moved with him to Phoenix. "He courted me with *Arizona Highways* under his arm," she recalled with a smile. "While my husband clerked in a law office and studied for the Arizona bar exam, I taught in the Scottsdale public school system and continued painting." In 1967 the couple's daughter, Julianne, was born. A son, Jonathan, was born in 1970, completing the family.

Accustomed to the green foliage of the East, Swartz initially found the western landscape harsh and alien. Yet before long, she saw that the new surroundings had sharpened her sensibilities and stimulated her sense of connection with nature. During this period, her art became lyrical and abstract, reminiscent of the works of Helen Frankenthaler and Paul Jenkins. "When I moved to Arizona, I was doing mostly conventional landscapes," she stated. "Gradually my landscapes became more abstract as I searched for ways to make the work more powerful." At that time, the artist started to combine collage and watercolor.

During the 1970s, Swartz had three experiences that catapulted her in a new direction and ultimately led to the development of her "fire works." A rafting trip down the Colorado River into the Grand Canyon in 1970 enhanced her fascination with the Arizona landscape. "I felt the power of the rocks that existed for millions of years. They gave me a new feeling for the continuity of life. I wanted to be able to penetrate these rocks, enter into their soul and assimilate myself into them. In 1974 I met George T. Lock Land. His book *Grow or Die: The Unifying Principle of Transformation* [1973] significantly influenced me. He believed there were two forces in the universe, the force of ordering and the force of disordering, or chaos.

I realized the existence of a third force, called reordering. For me, Land's thesis offered a new way of looking at the thermodynamic concept of entropy. In 1976 my mother had her first heart attack, after which I did a series called *I Love Mommy*. In my next series, *Red Banner*, I ripped the paper with a screwdriver. On one of the works in this series I scratched the words 'fear of dying.' I started to weep. I knew that I had hit upon something deep. I learned that I could translate that emotion into my art. Thinking about my river trip, Land's book, and my mother's illness generated a new way of working, a process-ritual that built upon the idea of life, death, and rebirth. The early fire works have no color. I was just doing smoke-imaging pieces, trying to capture the flow of smoke. It was only later that color developed."

To Swartz, life, death, and rebirth constitute a logical progression. The acts of tearing and breaking up pieces of paper, scarifying, and then reassembling the pieces gave her the feeling that she was creating a new order out of chaos. Making these works stirred in her the desire to gather earth from various sacred sites and incorporate it in her art.

Over the years, Swartz became involved in the feminist movement. "My interest in fire and earth led me to explore and champion feminism. I read books such as Betty Friedan's *The Feminine Mystique* [1963] and, early in 1980, Carol Christ's *Diving Deep and Surfacing: Women Writers on Spiritual Quests*, which had just come out. I realized that 'women's stories' had not been told. These books galvanized me and showed me that my own direction was part of a bigger movement. I felt empowered. When I had my children I was aware that there was a larger context for this. I began to see that feminist ideas had a large historical context, and I started thinking about ways to explore these ideas down to their roots while at the same time pursuing the origins of mystical philosophy."

Through a series of works conceived on a 1980 trip to Israel during which she visited various holy and historic sites, Swartz sought to connect her feminist perspective with aspects of her Jewish heritage. "I conducted extensive research to honor the women of biblical Israel and explore the spiritual significance of each site, emphasizing the Cabalistic tradition of Jewish mysticism. *Israel Revisited* honors ten women, including Rachel and Miriam."

Swartz received permission from Israeli officials to use soil from the sites. "I conducted rituals. I felt the sacredness of the earth and in my paintings used earth from these sites as pigments. Working at the holy sites changed my life. It led me to discover ancient role models. It helped me explore my feminine side, but it also led me to see that in order to be whole, we have to develop both our feminine and masculine sides. My most important discovery during this period was the Shekinah, a term that Cabalists identify as the feminine aspect of God.[2] Another discovery was the Tree of Life with its Feminine Pillar." The works in this series were presented in the pioneering exhibition *Israel Revisited,* which received critical acclaim when it opened at the Jewish Museum in New York City in 1981.

Several years before producing *Israel Revisited,* Swartz had been inspired by a visit to the Rothko Chapel in Houston. "The feeling of wanting to create a contemplative atmosphere or environment came to me during that visit. I conceived my next major series, *A Moving Point of Balance*, as a contemplative environment." Swartz described the work: "Concepts related to spirituality, shamanism, and healing were woven together to create a complex installation consisting of paintings, light projections, music, and a medicine wheel. The installation's principal paintings depict the seven chakras, which are points located along the spine through which universal energy flows into the body. In this work, each multilayered canvas fulfills a specific function and purpose. Viewers were encouraged to participate and interact with the installation." The work was first exhibited at the Nickle Arts Museum, University of Calgary, Alberta, in 1985 and appeared in nine U.S. venues over the next five years. As of this writing, *A Moving Point of Balance* is on long-term loan at the Arizona Cancer Center, Tucson.

Inspired by *A Moving Point of Balance,* a group of collectors and artists formed an organization called the International Friends of Transformative Art (IFTA). One of its objectives was to find space where Swartz's work could be permanently exhibited. The group had broader goals as well. "We had a noble vision that included other cultural activities," Swartz said, "but this proved too ambitious to accomplish. Instead, we focused on raising money and giving grants and exhibitions to artists doing environmental and experimental work." IFTA was officially dissolved in 2000, though the organization had then been inactive for more than a year.

In 1987 Swartz began work on a new series, *Celestial Visitations,* consisting of fifteen paintings inspired by her mother's earlier heart attack and deteriorating health due to Parkinson's disease. Adin Steinsaltz's book *The Thirteen Petalled Rose* (1980) struck a sympathetic chord in Swartz, especially his discussion of the role of angels in the Cabala. "Angels began appearing in my paintings, and I was not sure why I was doing them. Then I thought their presence might help my mother go to heaven. The angels announced death and eternal life at the same time. There is a legend in Cabalistic thought that good deeds done in our lifetime create angels in the next. I said, 'Mother, you have done so many good deeds in your lifetime. When you are ready, all you have to do is put out your arms and say, "I am ready, take me," and all the angels that we have both created will take you to heaven.'" Dorothy Ames passed away peacefully in March 1988, a day after her daughter completed *Celestial Visitations, #5 (The Angel of Deliverance)*.

A serious lover of poetry since her college days, Swartz immersed herself in the works of e. e. cummings, T. S. Eliot, and William Butler Yeats and has incorporated some of their poetry into her paintings. "In 1992 and 1993," she recounted, "I created a series of six works entitled *A Verse for the Eleventh Hour.* Each of the works visualized a portion of Yeats's 'The Second Coming,' and I incorporated individual lines or verses from this poem into the images. The whole poem appears, collectively, in these six paintings." She likes to quote a line from Eliot's "East Coker," in *Four Quartets*: "So the darkness shall be the light, and the stillness the dancing." Swartz elaborated: "I have gone through dark periods in my life, but eventually my art comes into the light. With every new series there is the excitement of a new beginning. One of the most incredible aspects of being an artist is allowing for those voids. You do not know what is going to happen next. You have to trust the process that the new work will come. It is almost like a miracle. With time, each series begins to evolve, and I let it evolve. I try not to get locked in."

In 1992 Swartz moved back to New York City. "I wanted to expose myself to new and stimulating ideas and felt ready to test my concepts in a demanding environment," she explained. Several successful Manhattan exhibitions followed and gave her art and vision greater exposure. In 1993 she produced A *Story for the*

Eleventh Hour, a series of paintings that formulated a myth in which mankind and the planet come near to extinction but finally are saved through human enlightenment.

Swartz's next quest was to find, acknowledge, and record instances of individual goodness, an endeavor that led to her Sacred Souls Project. Support for the project was provided by the Flow Fund of the Rockefeller Family Fund with the stipulation that all grant money be distributed. The search that ensued provides a record of both the vulnerability and resilience of the human spirit. In our interview, Swartz defined Sacred Souls as individuals who had, over a twenty-five-year period, demonstrated compassionate and exemplary behavior toward others and had served as role models both for their own culture and other societies. "I enlisted the help of several United Nations ambassadors in my search," she elaborated. "These diplomats nominated outstanding individuals who met the various criteria established to qualify as Sacred Souls. Interviews, written materials, and commendations were considered before selecting candidates. I made two trips to Indonesia in September and December 1994. The project recognized the achievements of four women from India, Japan, Thailand, and Malaysia at an awards ceremony held in Djakarta, Indonesia, in December 1994. The woman from Thailand had spent twenty-five years rescuing more than thirty-five thousand women who had been sold into prostitution. The project helped me make sense of life. Sacred Souls was life as art."

Eventually her travels in Southeast Asia adversely affected Swartz's health. "I still owned my Arizona home," she said, " and longed to return to it, to renew my roots and regain my strength. I felt again the need to connect with the desert landscape."

Swartz has struggled with a number of illnesses during her adult life and believes that these experiences have strengthened her as an individual. Meditation has helped her master the dark periods of her life. "I have assimilated the healing symbols from various cultures and religions, and I believe in their magic and curative powers. I practice Shen Qi. It is a system of philosophy that emphasizes relaxing and bonding spiritually through community. Through Shen Qi, I found my equilibrium and regained my strength."

In 1996, the year she was introduced to Shen Qi, she began the series of paintings bearing that title. "I wanted these new paintings to infuse the viewer with a

quiet tranquility," she explained. "I began using gold leaf, which has metaphoric associations for me. Painting archetypal under-images and superimposing a gold grid became a kind of meditation. Mutilating the gold by scratching into it echoed the deformations that I had made in paper with the screwdriver twenty years before. After all these years, I am still dealing with life, death, and rebirth and making order out of chaos."

I concluded the interview by asking Swartz what she thought the future holds for her. "I relate to Hermann Hesse's novel *Siddartha* and its focus on the inevitability of change and the yearning for wholeness. Siddartha glimpsed the essential oneness and simultaneity of all things, as symbolized by the river and its whispered syllable *om*. I am an incorrigible optimist. I compare myself to a person rowing along in a narrow stream. I keep on rowing because I must. I haven't felt myself part of the main stream, but I'm certain that my narrow stream will connect to the larger stream. I want to live the 'magical life' by being open to those chance events that the universe places in my path.[3] Years ago, I asked an old man what was the secret of his longevity. He responded, 'Keep moving.' Somehow, my physical pilgrimages to sacred sites began a process of inner movement—or maybe the inner stirrings were what prompted the outward search. Anyhow, I am still moving."

NOTES

I would like to thank Valerie Vadala Homer for her editorial advice and helpful suggestions and my husband, Eric Jungermann, for his support, advice, and patience.

1. Robert Bly, trans. *Selected Poems of Rainer Maria Rilke* (New York: Harper and Row, 1981), 13.

2. Gershom Scholem, *On the Kabbalah and Its Symbolism*, trans. Ralph Manheim (New York: Schocken, 1965), 104–9.

3. Suzi Gablik, *Living the Magical Life* (Grand Rapids, Mich.: Phanes Press, forthcoming).

Color Plates

All works are by Beth Ames Swartz. For each work, the series title is presented in *italic* and precedes the **boldfaced** title of the individual piece. Works not otherwise credited are in the collection of the artist. In dimensions, height precedes width.

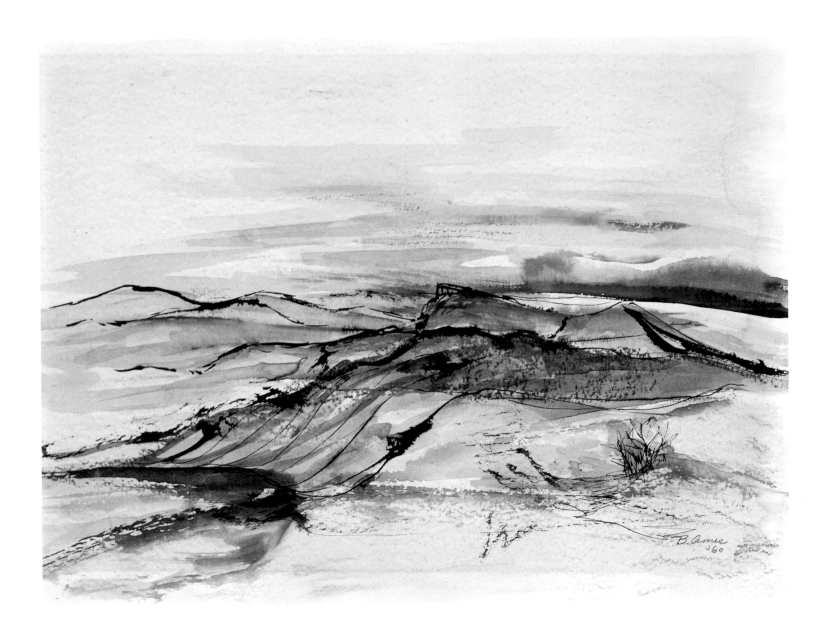

PLATE I
Abstracted Landscape, **Painted Desert**, 1960
watercolor and pastel on rice paper
15 × 19¾ in.

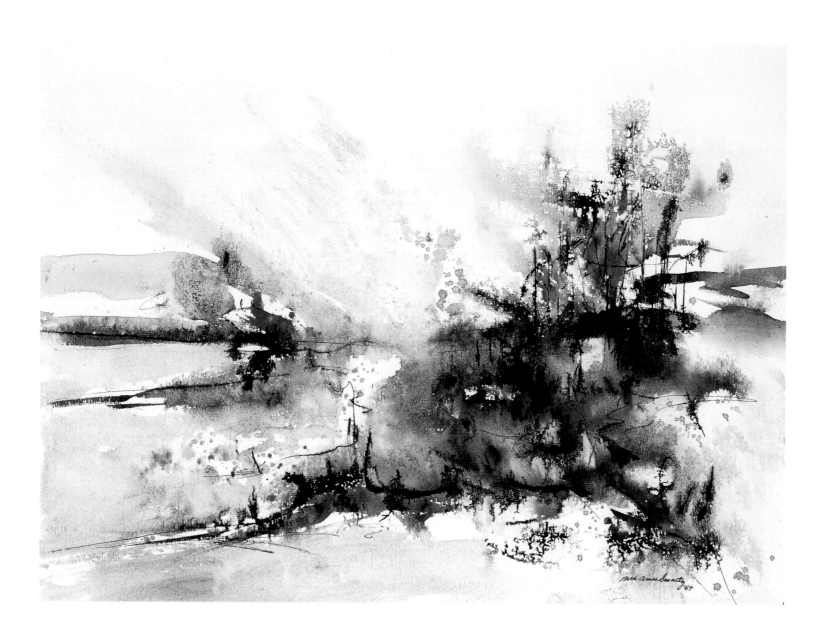

PLATE 2
Abstracted Landscape, **Dust Storm at Saguaro Lake**, 1967
watercolor and ink on paper
18 × 24 in.

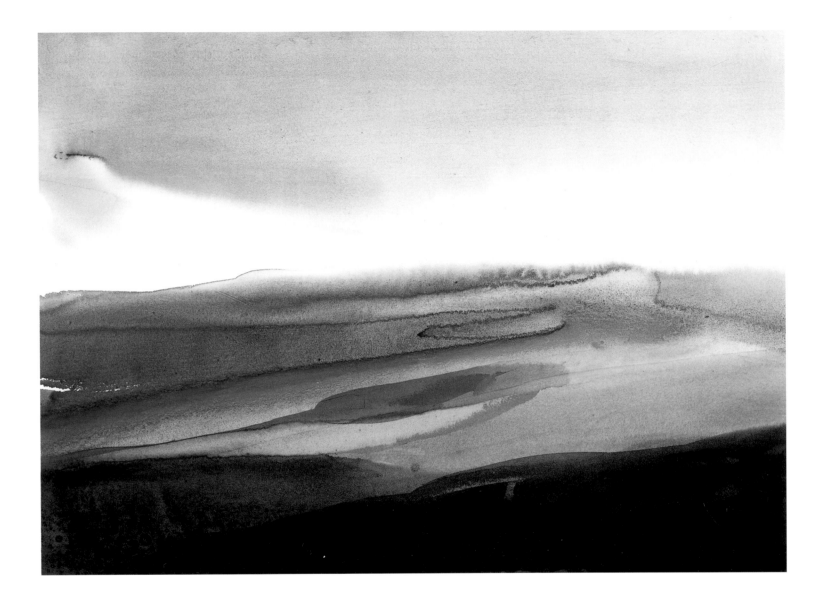

PLATE 3
Abstracted Landscape, **View from Jerome**, 1968
acrylic on paper
18 × 24 in.

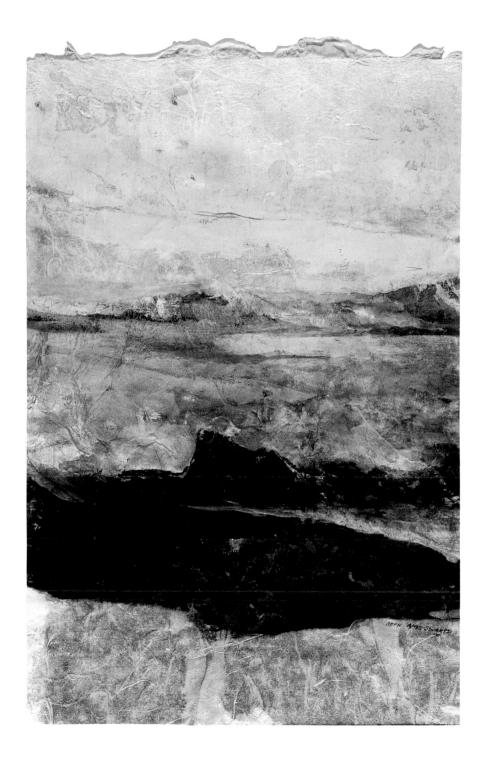

PLATE 4

Abstracted Landscape, **Dawn in the Grand Canyon**, 1970

acrylic and mixed media on paper

18 × 11½ in.

Collection of Sylvia Levin, Santa Monica, California

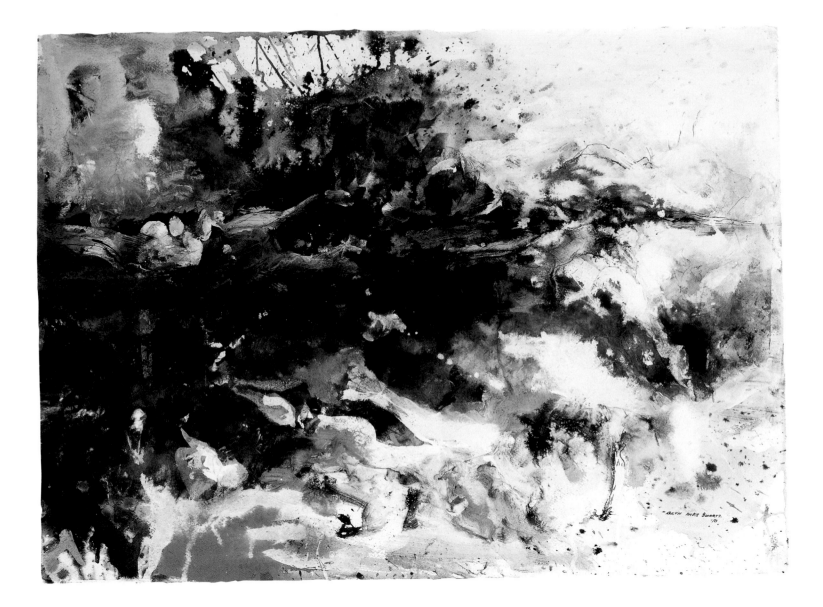

PLATE 5
Abstracted Landscape, **The Twilight between Birth and Dying**, 1970
acrylic and mixed media on paper
22 × 29¾ in.
Collection of Betty Barber Hughes, Paradise Valley, Arizona

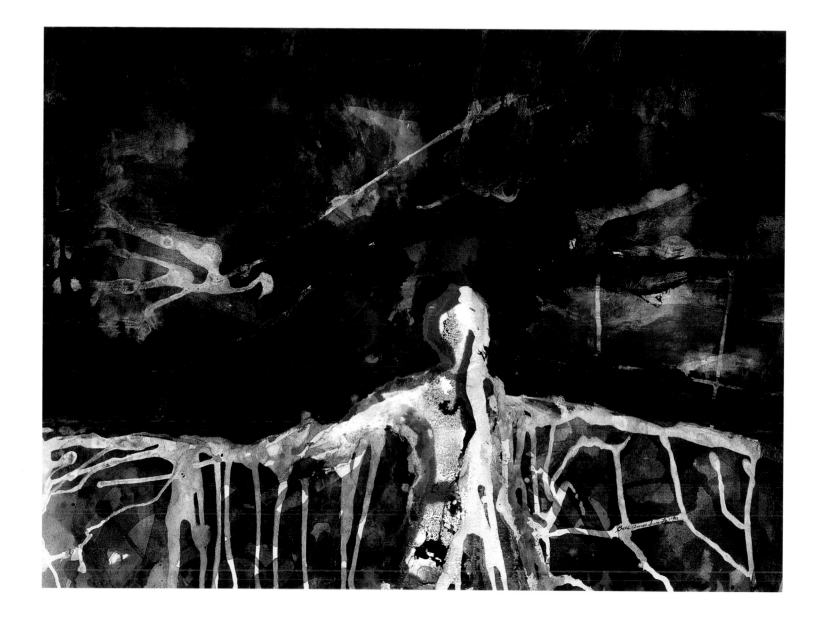

PLATE 6
Abstracted Landscape, **Opening Her New Wings at Dusk**, 1971
acrylic on paper
22 × 30 in.

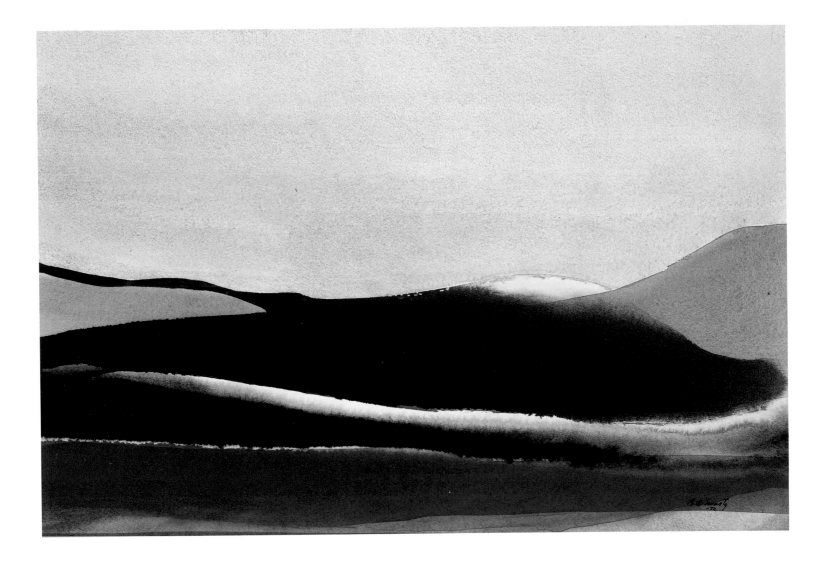

PLATE 7
Meditation, #15, 1972
acrylic on paper
20 × 24 in.

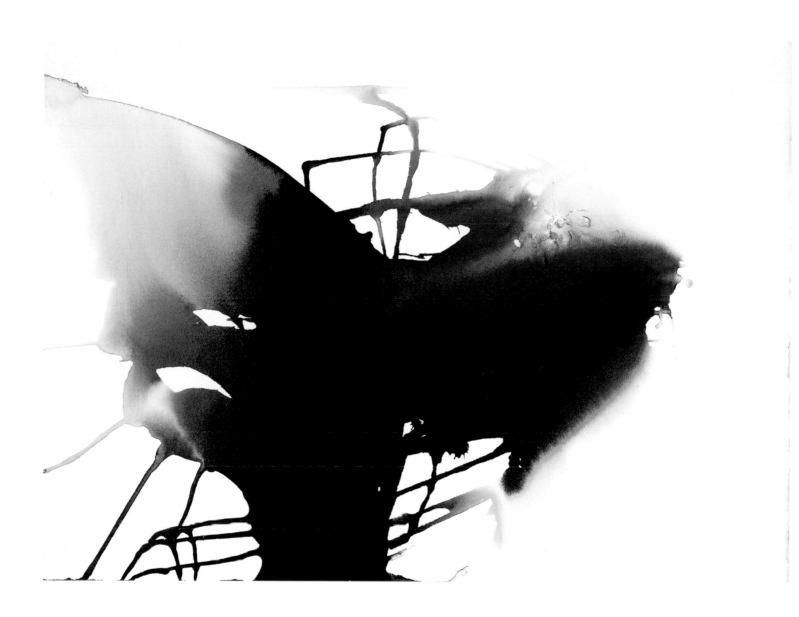

PLATE 8
Restless Oral Darkness, #2, 1973
acrylic on paper
22 × 30 in.
Private collection

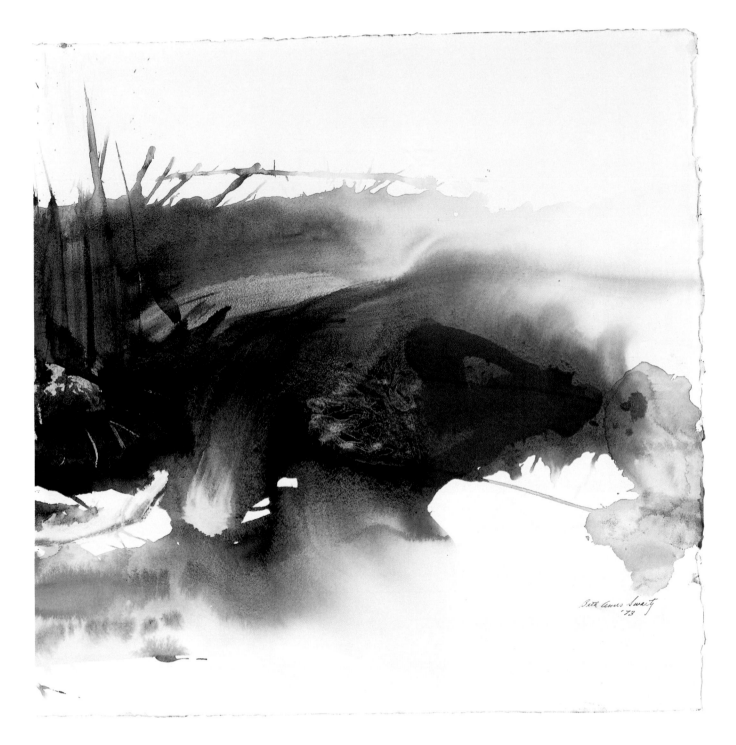

PLATE 9
Projected Power, **The Magic Thrust**, 1973
acrylic on paper
22 × 22 in.

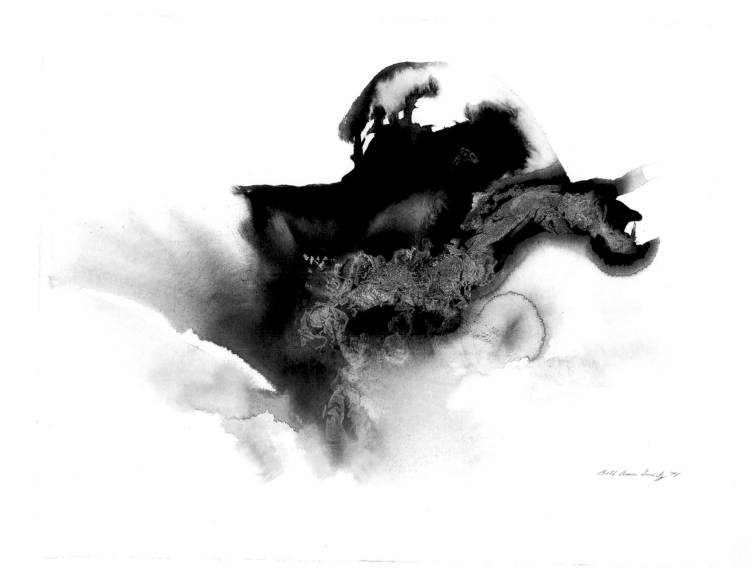

PLATE 10
Umi, #1, 1974
acrylic on paper
22 × 30 in.
Collection of Melvin J. Swartz

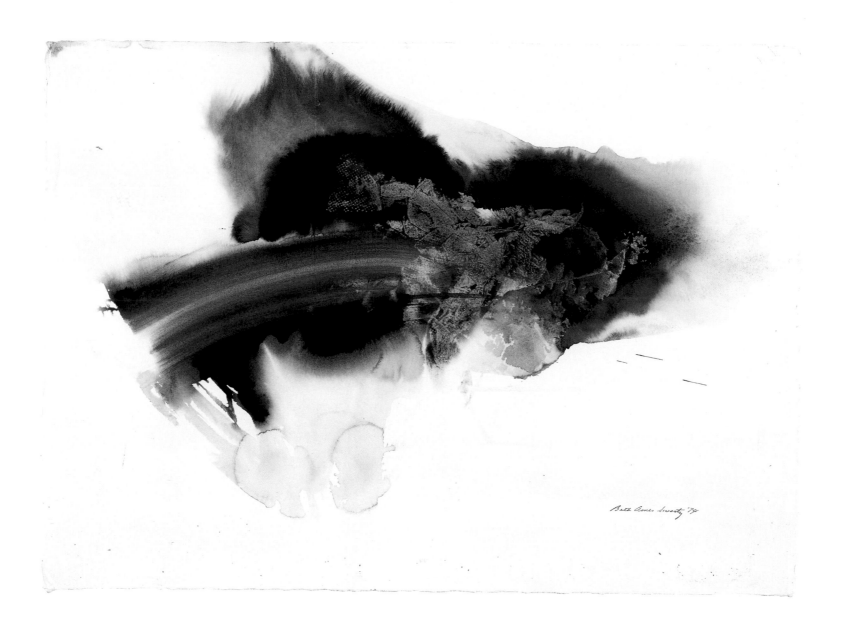

PLATE 11
Umi, **#2**, 1974
acrylic on paper
22 × 30 in.
Collection of Melvin J. Swartz

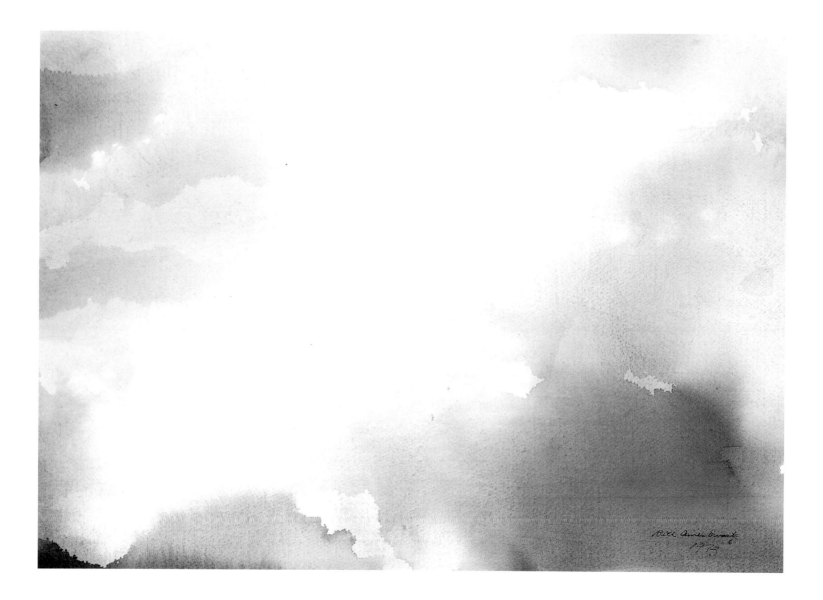

PLATE 12
*Air, **#3**, 1974
acrylic with airbrush on paper
13½ × 18½ in.
Collection of Loraine and William Hawkins, Paradise Valley, Arizona

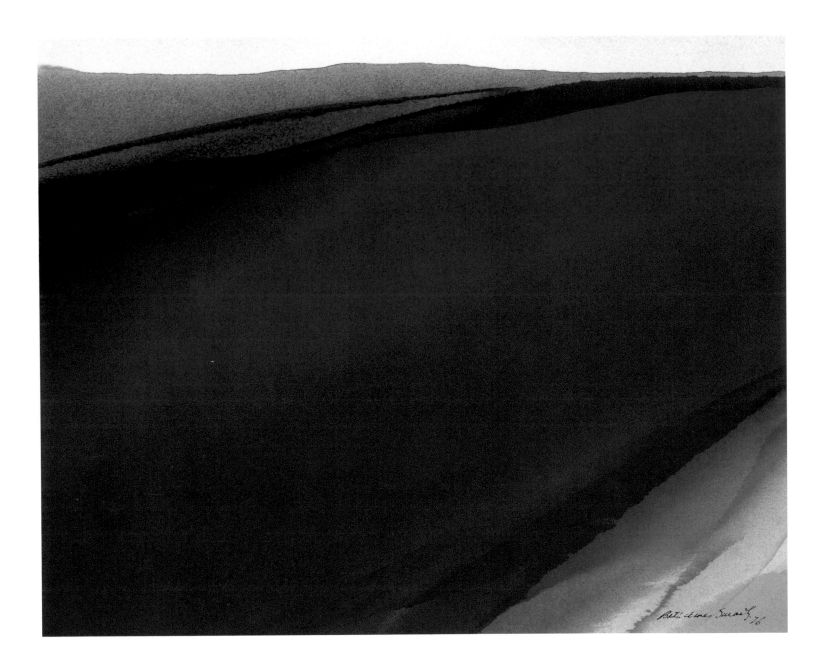

PLATE 13
*Earthflow, **#21***, 1975
acrylic on paper
11 x 13 in.
Collection of Carol and Lorin Swagel, Paradise Valley, Arizona

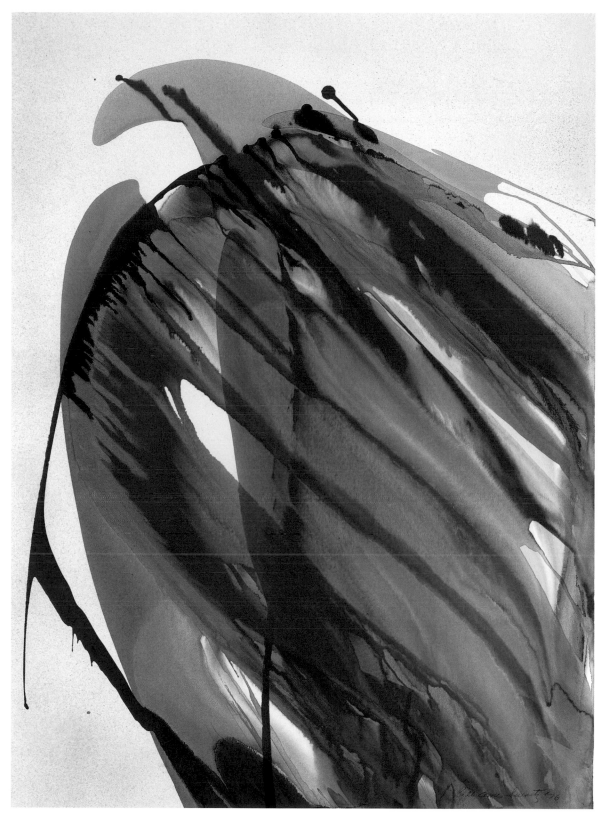

PLATE 14
Earthflow, **#40**, 1976
acrylic on paper
30 × 22 in.

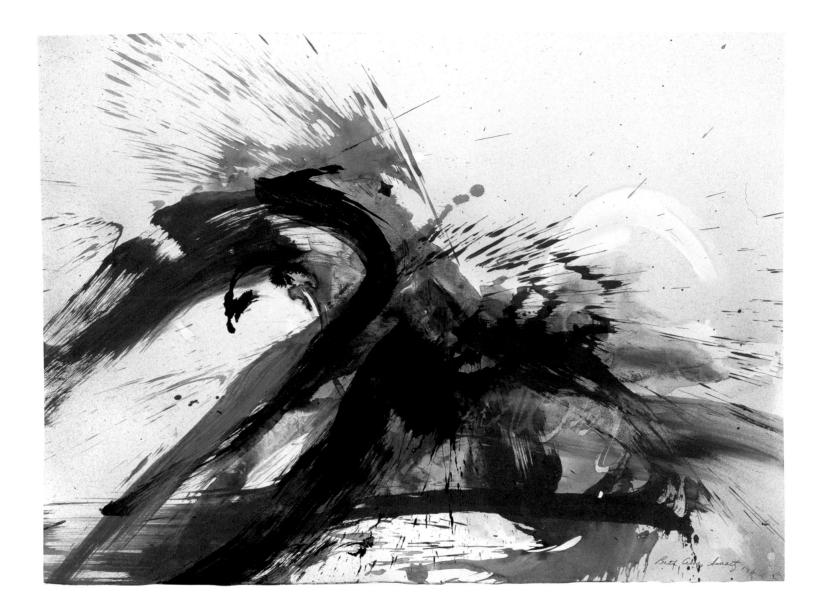

PLATE 15
*I Love Mommy, **#2**,* 1976
acrylic on paper
22 × 30 in.
Private collection

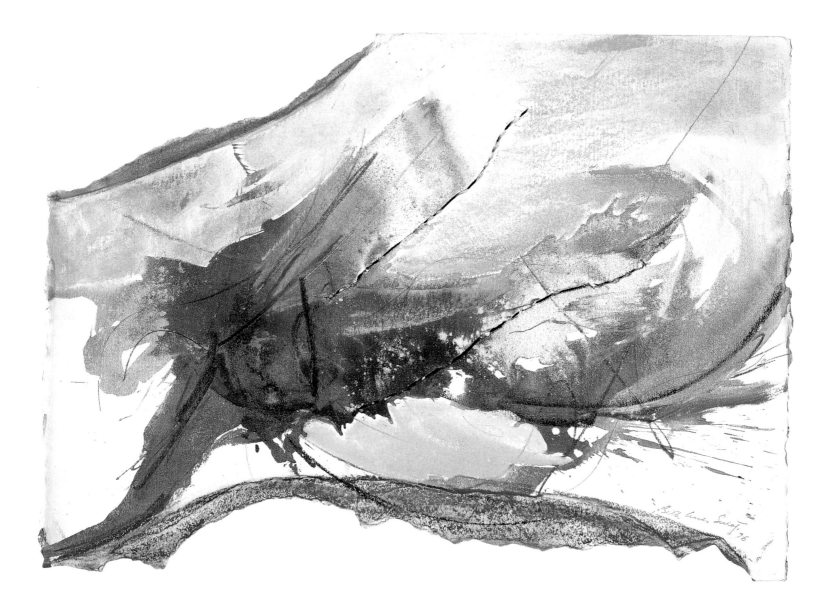

PLATE 16
*Red Banner, **Inside Out**,* 1976
acrylic on mutilated paper
24 × 30 in.
Private collection

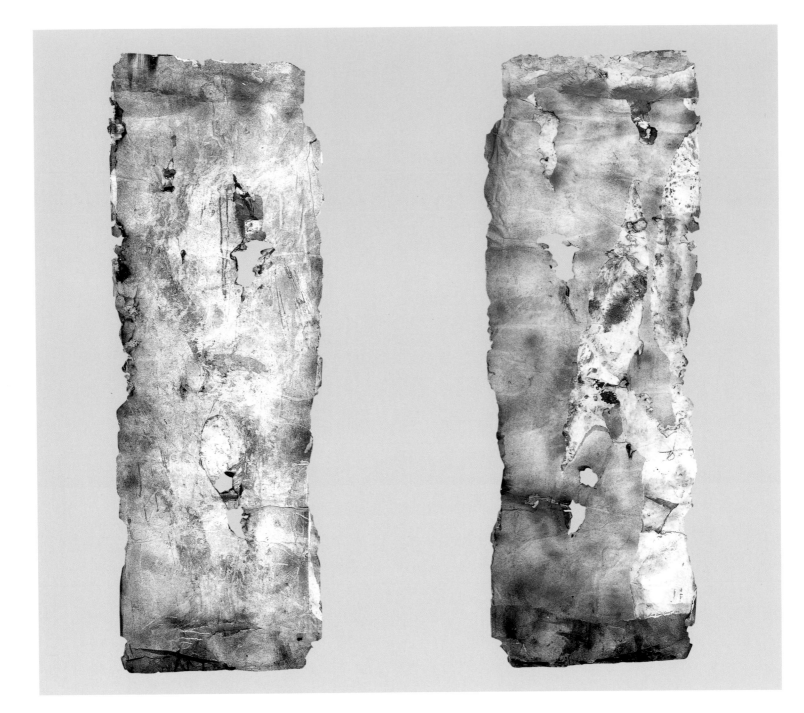

PLATE 17a
Smoke Imagery, #4, 1977 (front view)
smoke, fire, ash, acrylic, and dripped candle wax on layered rice paper
75 × 28½ in.

PLATE 17b
Smoke Imagery, #4, 1977 (back view)
smoke, fire, ash, acrylic, and dripped candle wax on layered rice paper
75 × 28½ in.

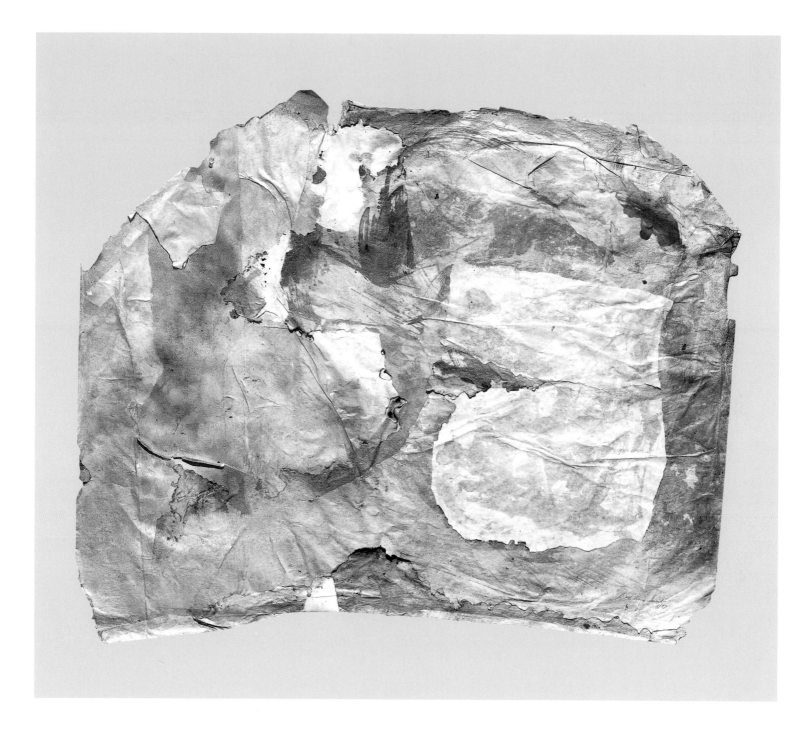

PLATE 18
Cabala, **Bayet #2**, 1977
fire, acrylic, and mixed media on layered rice paper
43 × 53 in.
Collection of The Jewish Museum, New York

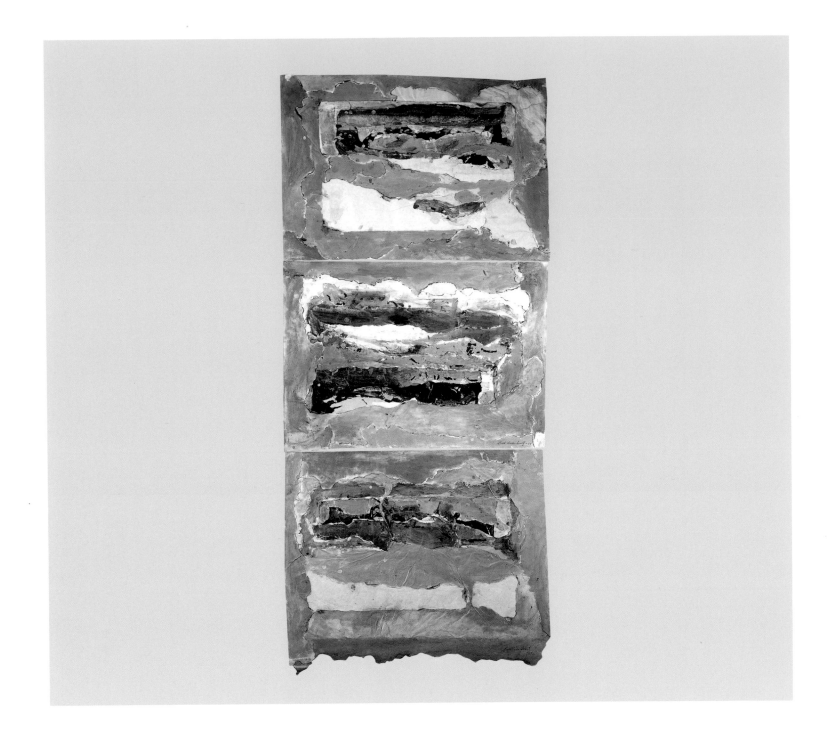

PLATE 19
*Cabala, **Tayet #9**,* 1977
fire, acrylic, gold leaf, silver leaf, metallic thread, dripped candle wax, and mixed media on layered rice paper (triptych)
60 × 28 in.

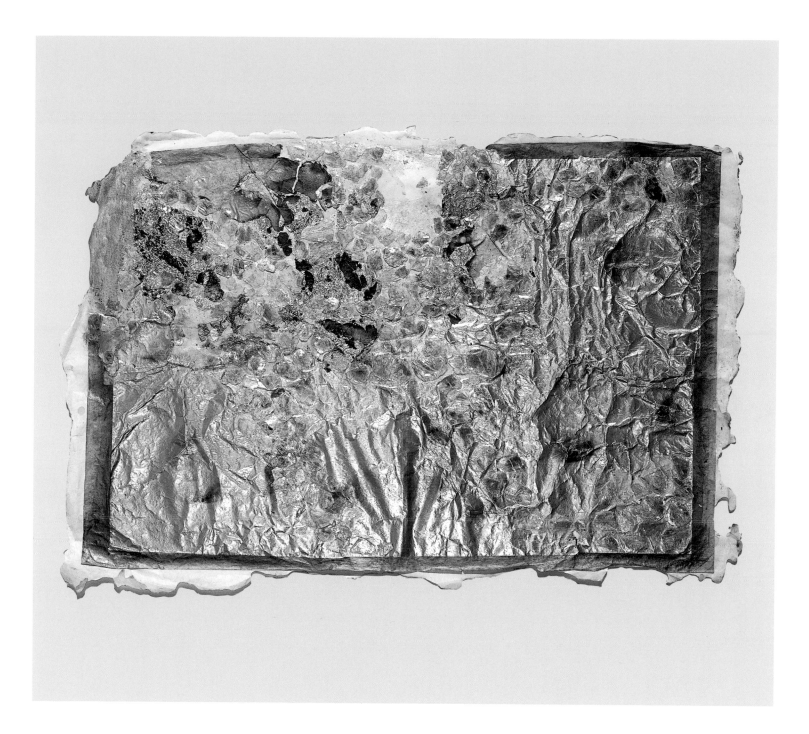

PLATE 20
Mica Transformation, #3, 1977
mica, fire, ash, acrylic, silver leaf, and mixed media on layered rice paper
23 × 32 in.

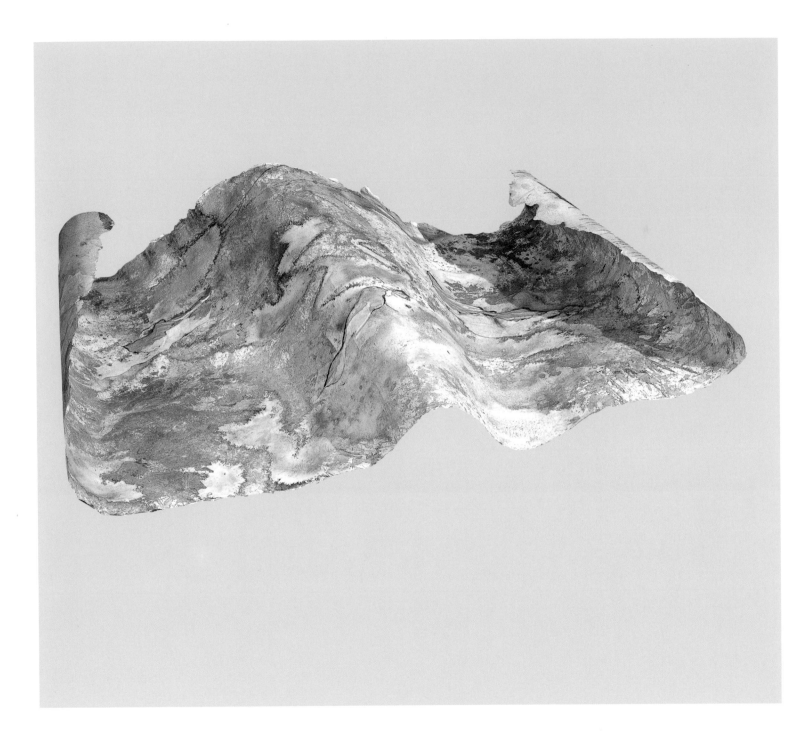

PLATE 21
Torah Scroll, **#2**, 1977
fire, acrylic, metallic silver paint, and mixed media on layered paper
42 × 72 in.

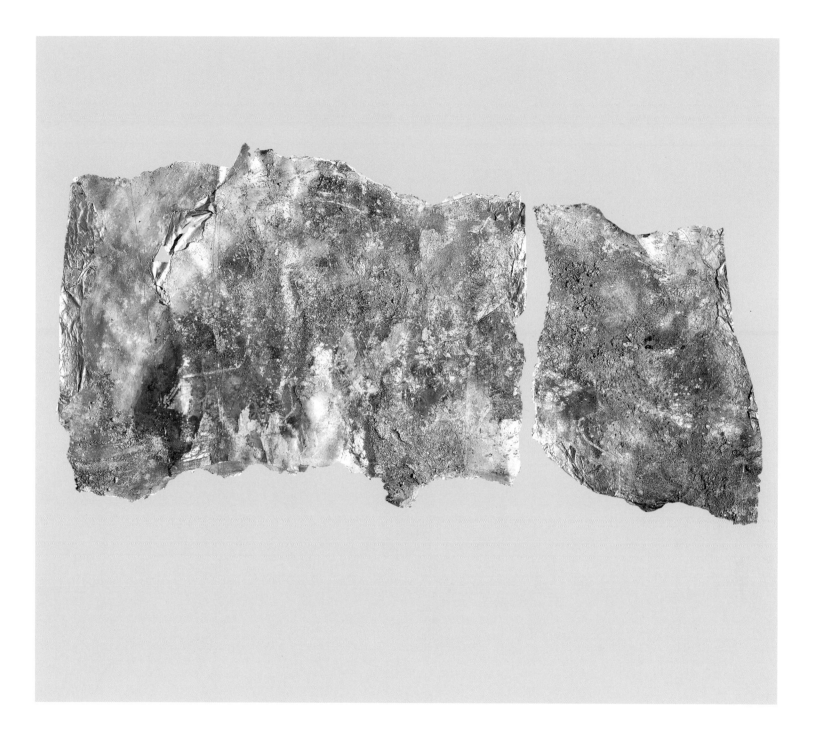

PLATE 22
Torah Scroll, #4, 1977
fire, earth, acrylic, variegated gold leaf, and mixed media on layered paper
44 × 112 in.

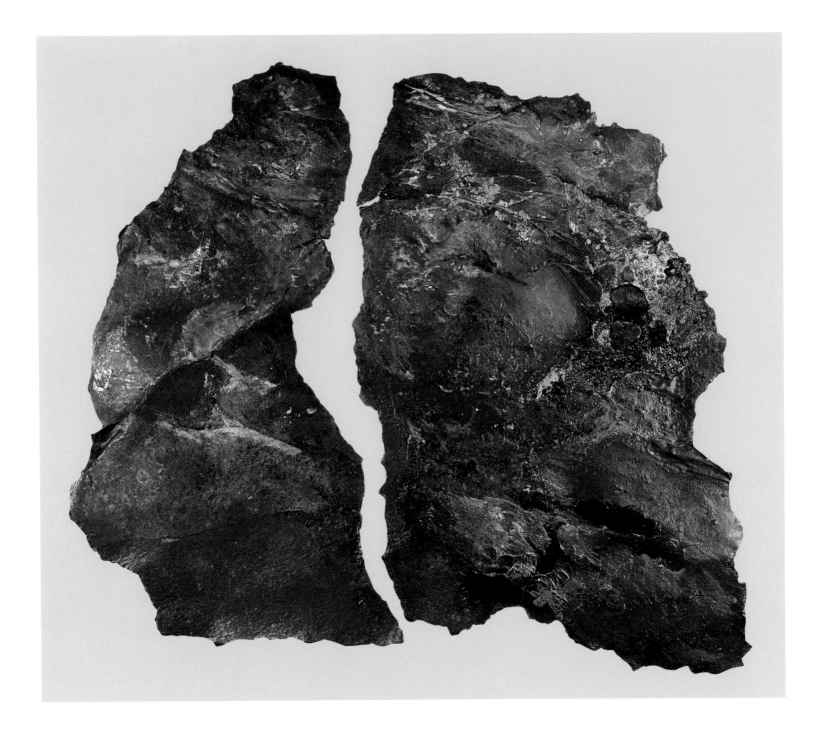

PLATE 23
Sedona, **#6**, 1978
fire, earth, acrylic, variegated gold leaf, and mixed media on layered paper
29 × 36 in.
Collection of Mr. and Mrs. Bertram Broer, Johannesburg, South Africa

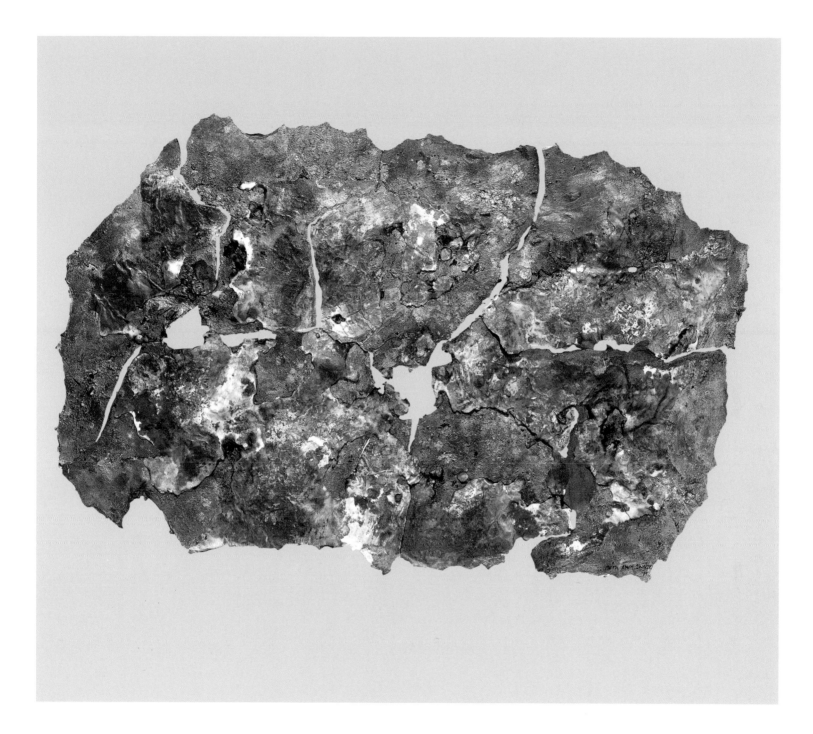

PLATE 24
*Sedona, **#30**,* 1979
fire, earth, acrylic, variegated gold leaf, and mixed media on layered paper
27 × 40 in.
Collection of Diane and Gary Tooker, Paradise Valley, Arizona

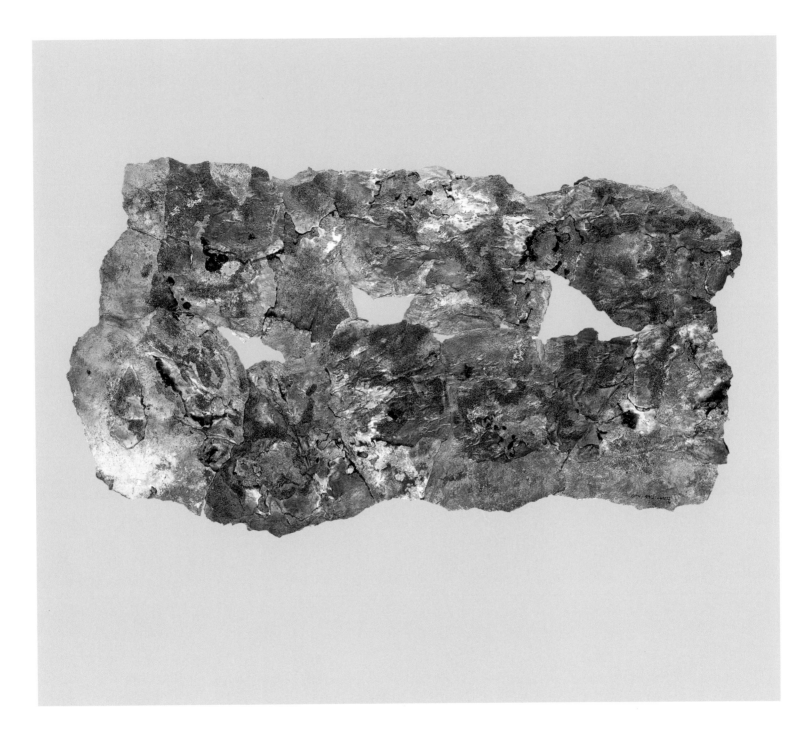

PLATE 25
Green Sand Beach, #1, 1979
fire, sand, acrylic, variegated gold leaf, and mixed media on layered paper
40 × 65 in.
Private collection

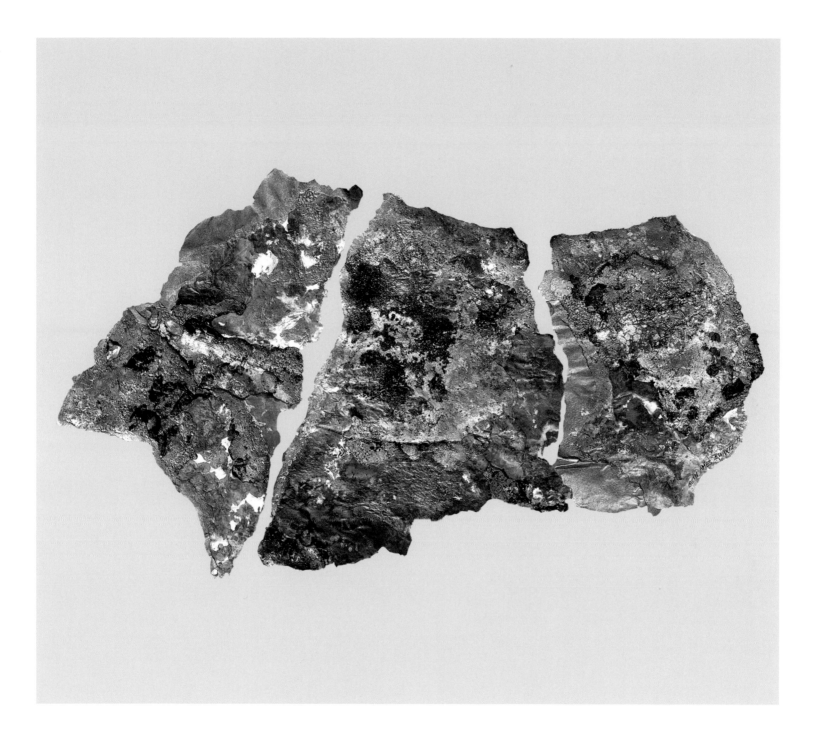

PLATE 26
Black Sand Beach, #12, 1979
fire, sand, acrylic, variegated gold leaf, and mixed media on layered paper
24 × 40 in.
Collection of Mr. and Mrs. Ron Sackheim, Highland Park, Illinois

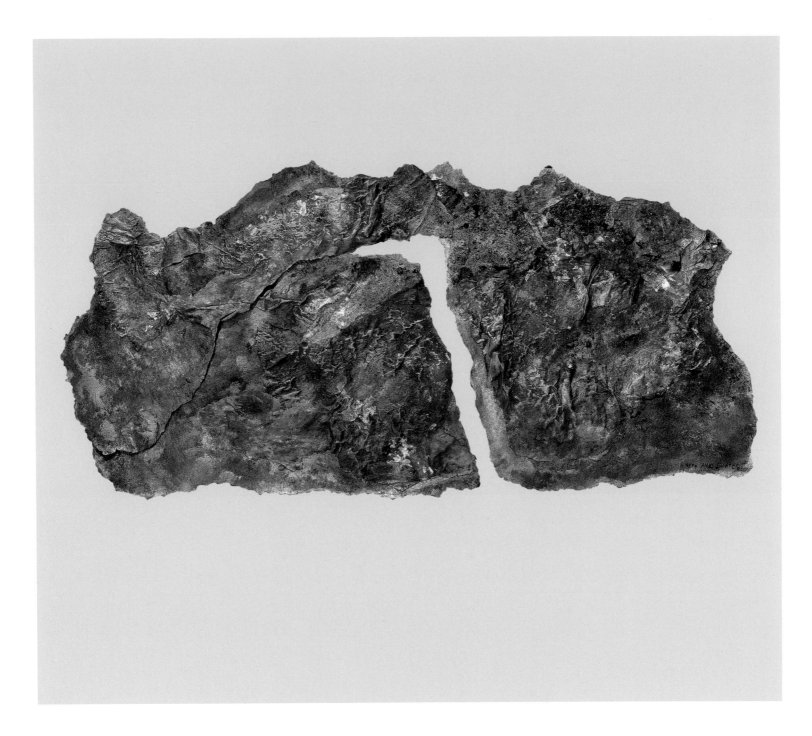

PLATE 27
Monument Valley, #12, 1980
fire, earth, acrylic, variegated gold leaf, and mixed media on layered paper
24 × 36 in.
Private collection

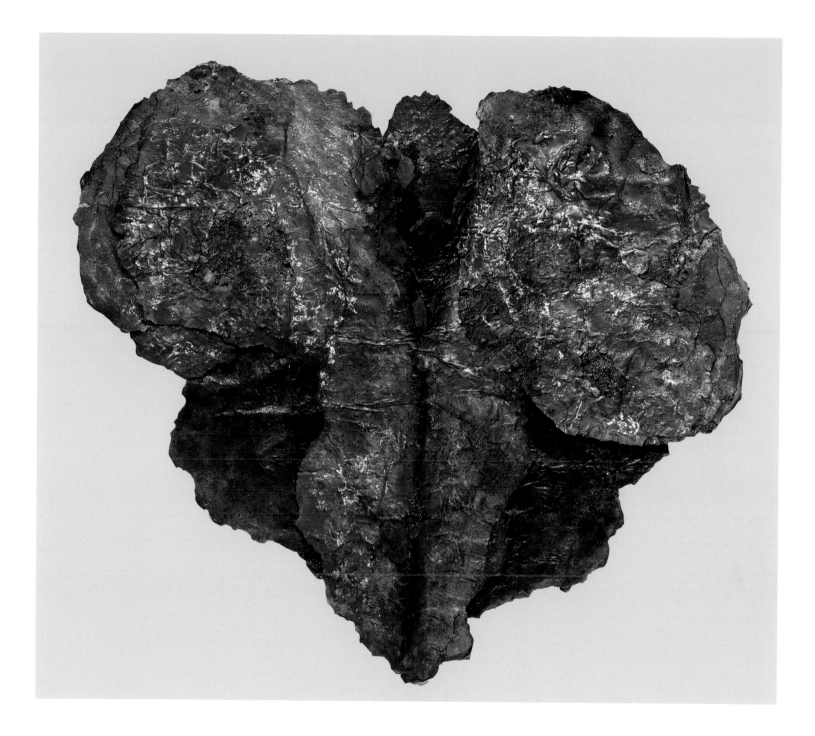

PLATE 28
Israel Revisited, **The Red Sea #1**, 1980
fire, earth, acrylic, variegated gold leaf, and mixed media on layered paper
41 × 46½ in.
Collection of Diane and Gary Tooker, Paradise Valley, Arizona

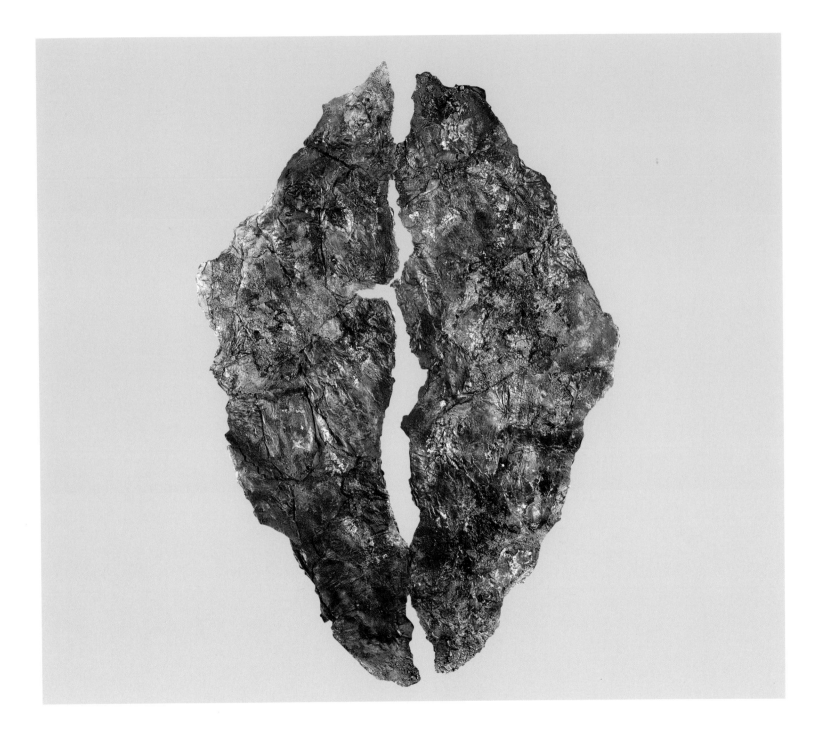

PLATE 29
Israel Revisited, **Mount Tabor #1**, 1980
fire, earth, variegated gold leaf, and mixed media on layered paper
51 × 35 in.
Collection of Mr. and Mrs. Merle E. Roberts, Columbus, Ohio

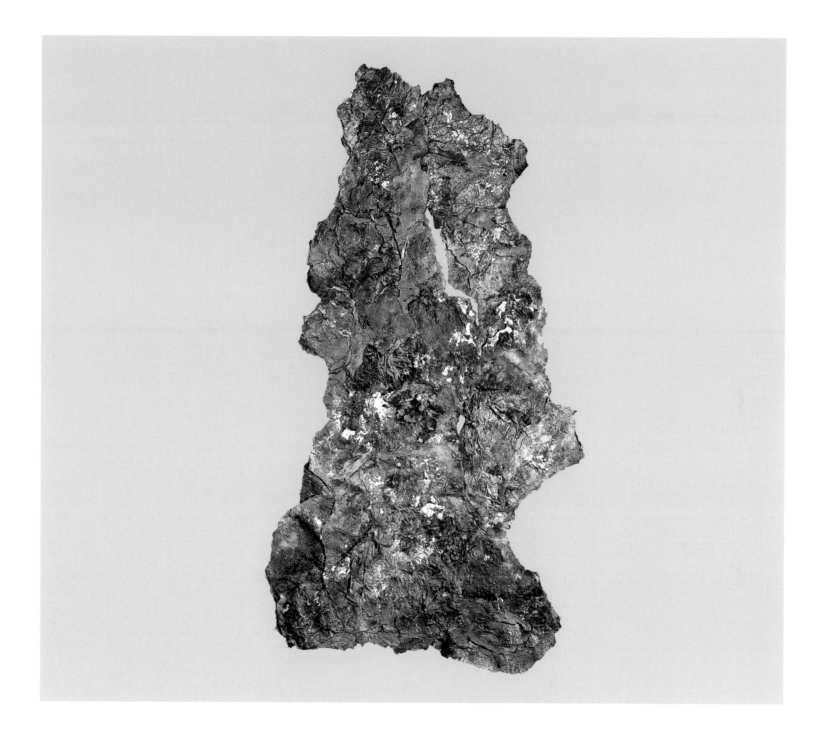

PLATE 30
Israel Revisited, **Solomon's Pillars #1**, 1980
fire, earth, acrylic, silver leaf, and mixed media on layered paper
59½ × 31½ in.
Collection of Sylvia Levin, Santa Monica, California

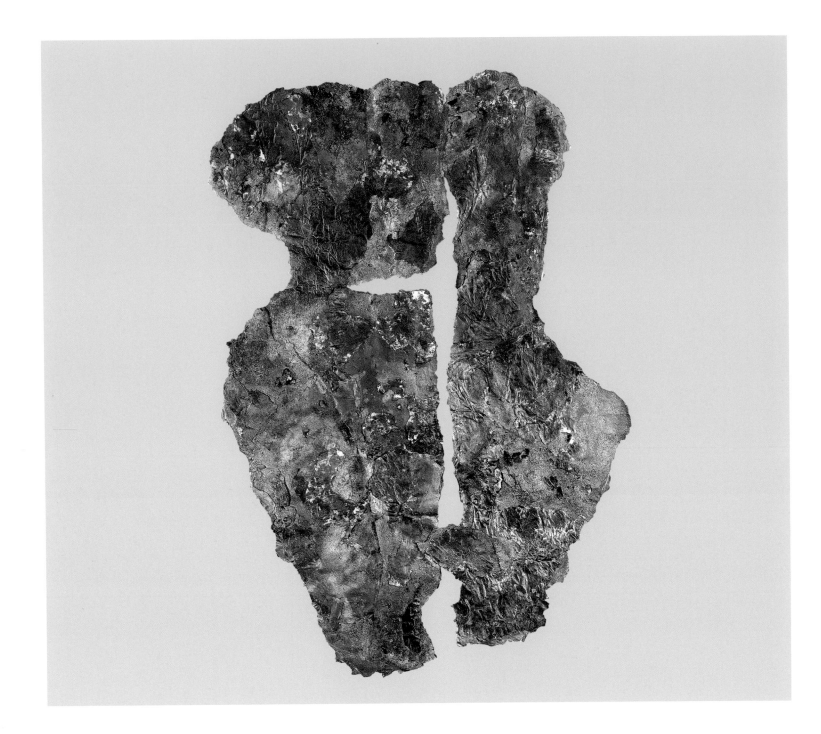

PLATE 31
Israel Revisited, **Hazor #1**, 1980
fire, earth, acrylic, variegated gold leaf, and mixed media on layered paper
51 × 35 in.
Collection of Phoenix Art Museum

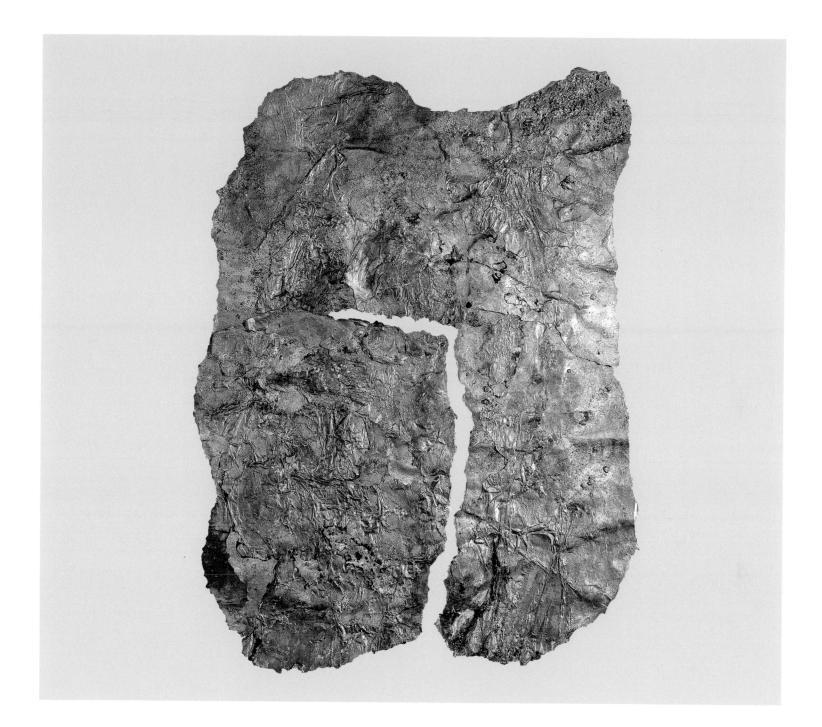

PLATE 32
Israel Revisited, **Tiberius #1**, 1980
fire, earth, acrylic, variegated gold leaf, and mixed media on layered paper
50½ × 38 in.
Collection of Herbert F. Johnson Museum of Art, Cornell University, Ithaca, New York

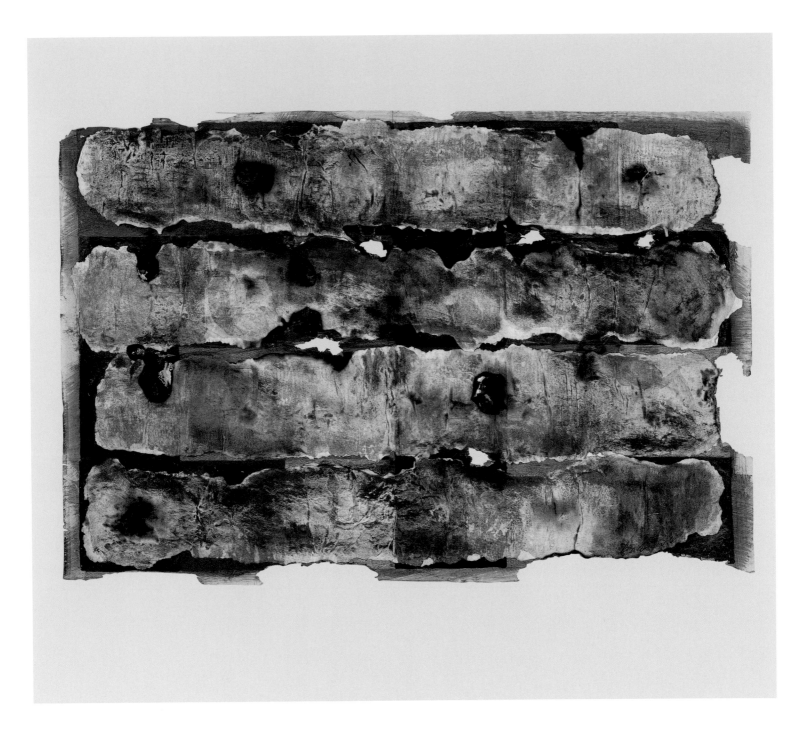

PLATE 33
Israel Revisited, **Illuminated Manuscript #2,** 1980
fire, acrylic, and mixed media on silver-leaf rice paper
21 × 32 in.
Collection of University of Arizona Museum of Art, Tucson

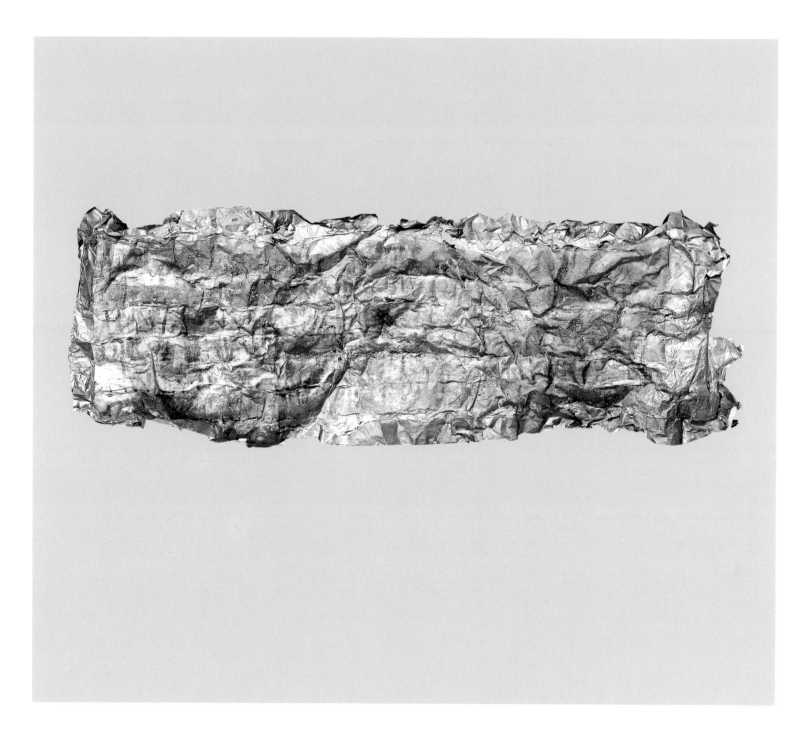

PLATE 34
Israel Revisited, **Buried Scroll #1**, 1980
fire, earth, acrylic, and mixed media on silver-leaf rice paper
14½ × 42 in.
Private collection

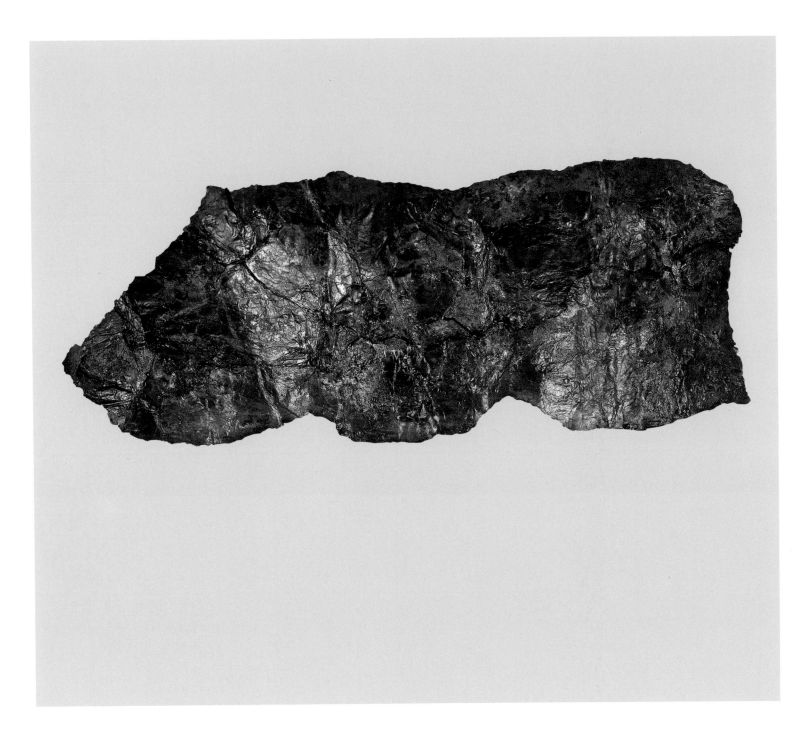

PLATE 35
Arizona Fault Line, #2, 1981
fire, earth, acrylic, variegated gold leaf, and mixed media on layered paper
45 × 113 in.

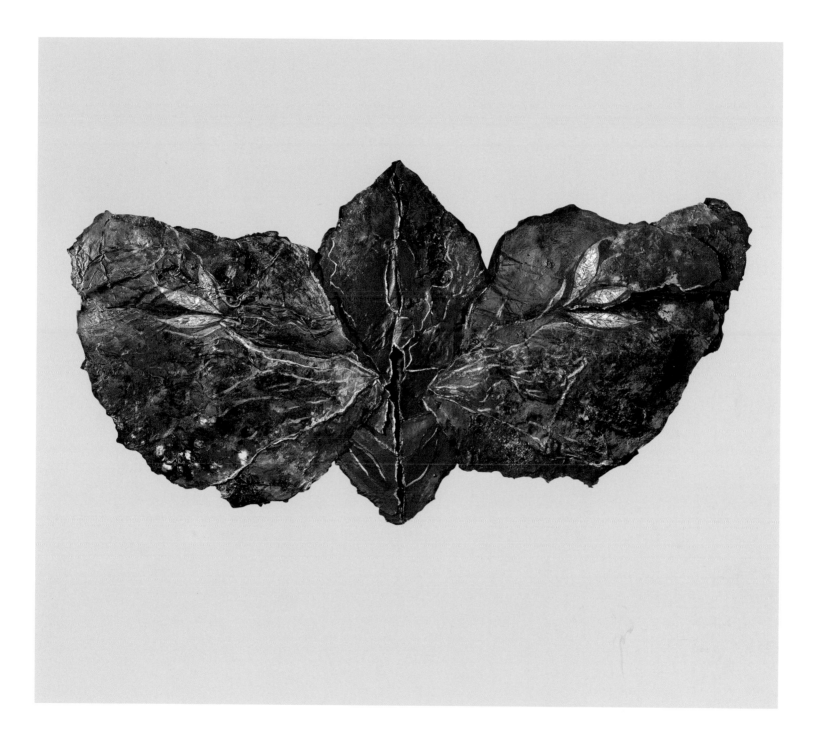

PLATE 36
Colly's Dream, #1, 1982
fire, earth, acrylic, variegated gold leaf, and mixed media on layered paper
30 × 60 in.
Collection of Dr. and Mrs. Ronald W. Barnet, Paradise Valley, Arizona

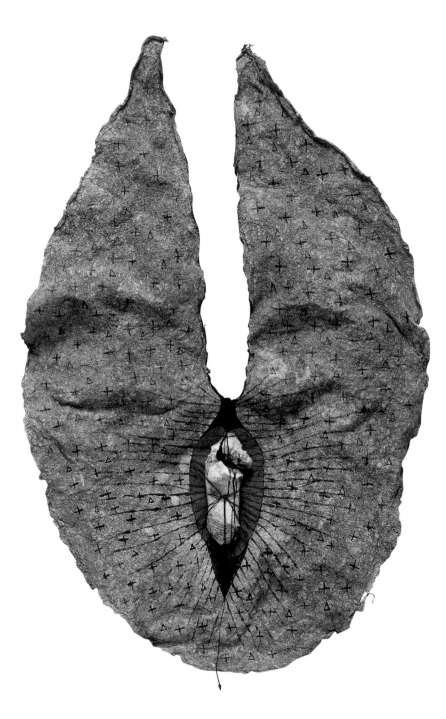

PLATE 37
Healing Icon, **#2**, 1982
acrylic, bone, and string on handmade raw flax
30 × 20 in.
Collection of Myrna and Robert Zuckerman, Englewood Cliffs, New Jersey

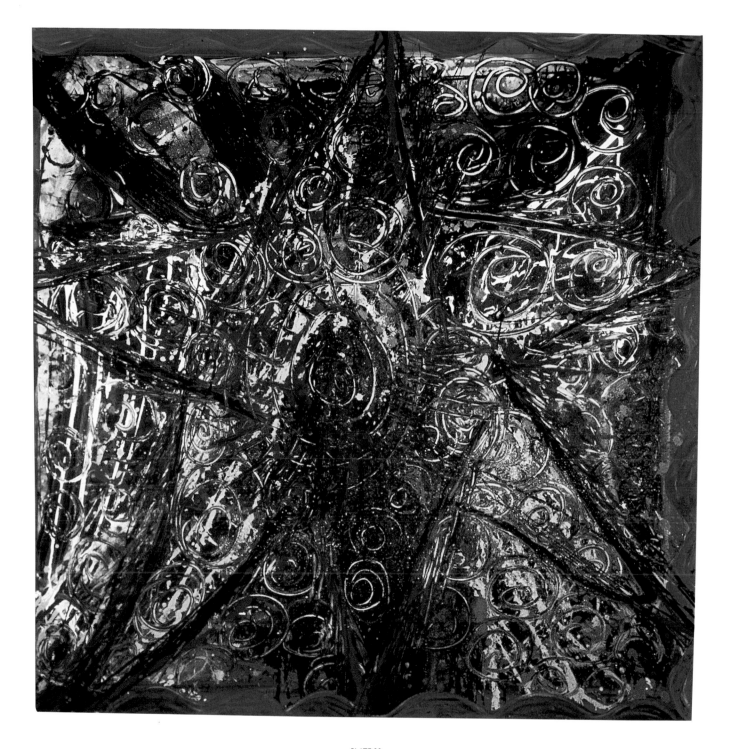

PLATE 38
Aurora Borealis, #4, 1983
acrylic and microglitter on linen
60 × 60 in.
Collection of Muriel Siebert, New York

PLATE 39
Installation view, *A Moving Point of Balance*, Nickle Art Museum, University of Calgary, Alberta, 1985

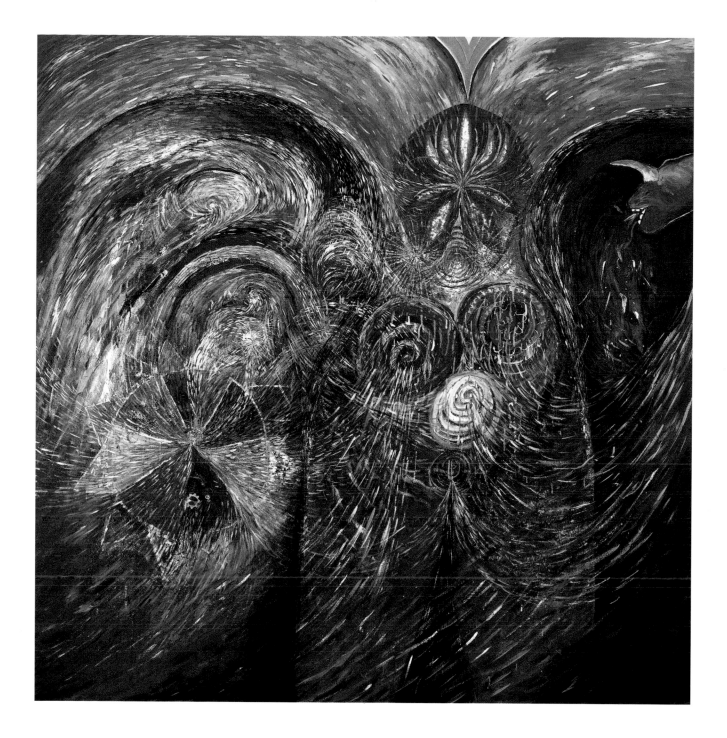

PLATE 40
A Moving Point of Balance, **Chakra #1 (base of the spine)**, 1983
acrylic, gold leaf, and mixed media on linen
84 × 84 in.
Collection of Kelley and Stanton Perry, Laguna Niguel, California

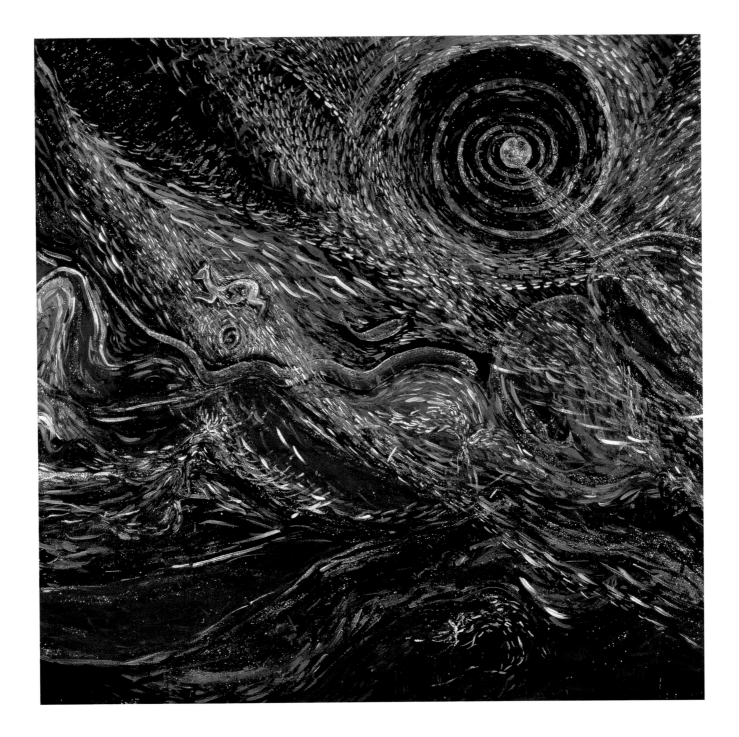

PLATE 41
A Moving Point of Balance, ***Chakra #2 (reproduction)***, 1983
acrylic, microglitter, gold leaf, and mixed media on linen
84 × 84 in.
Collection of Kelley and Stanton Perry, Laguna Niguel, California

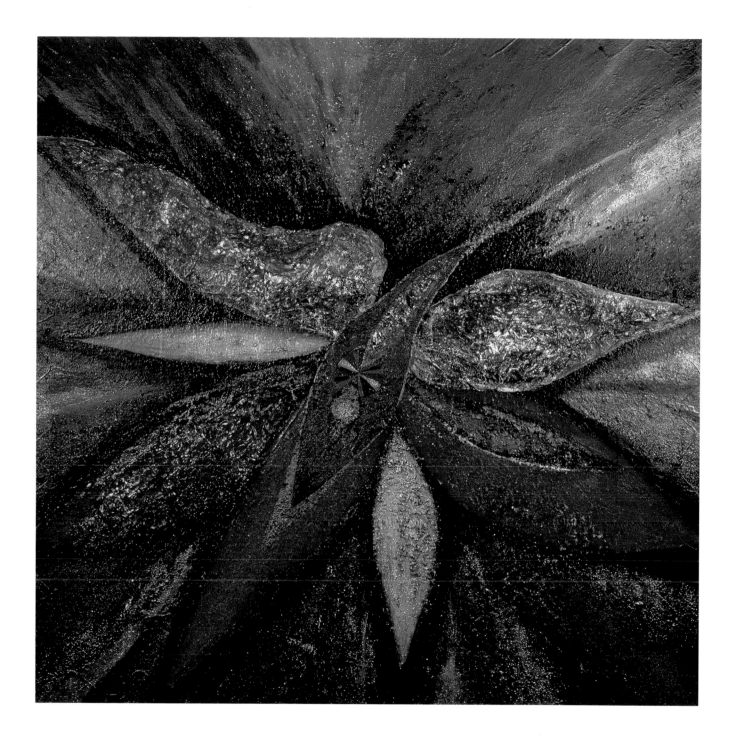

PLATE 42
A Moving Point of Balance, **Chakra #3 (solar plexus)**, 1984
acrylic, microglitter, gold leaf, broken glass, foil, and mixed media on linen
84 × 84 in.
Collection of Kelley and Stanton Perry, Laguna Niguel, California

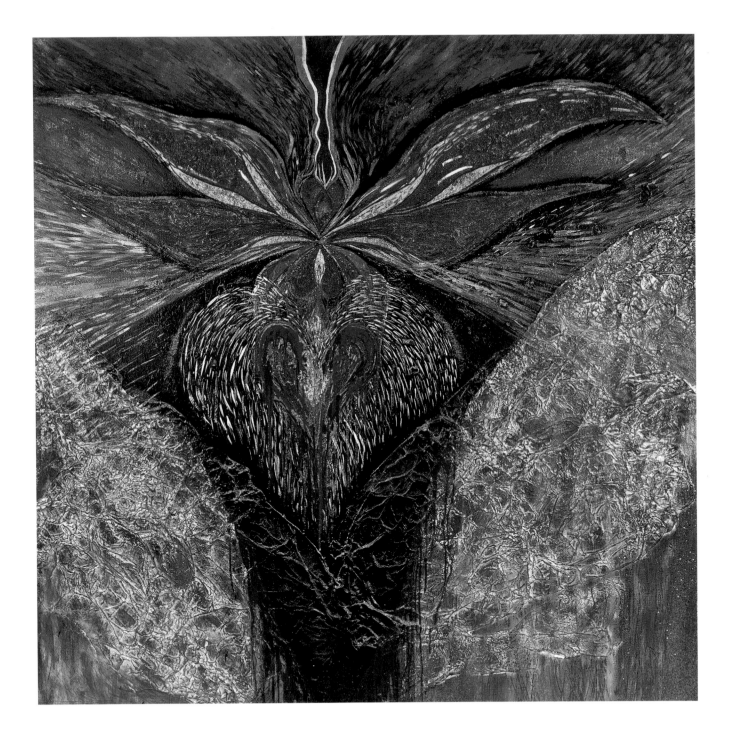

PLATE 43
A Moving Point of Balance, **Chakra #4 (heart)**, 1984
acrylic, microglitter, gold leaf, broken glass, foil, and mixed media on linen
84 × 84 in.
Collection of Kelley and Stanton Perry, Laguna Niguel, California

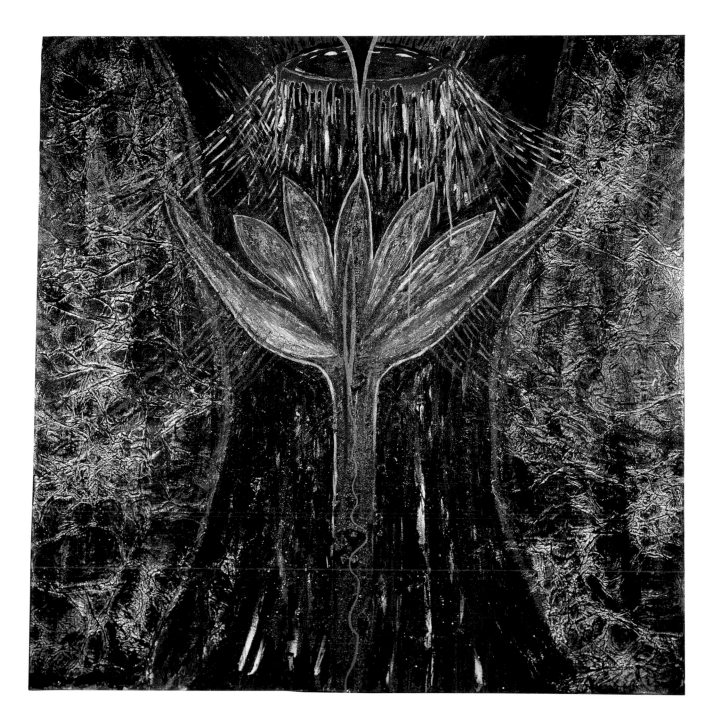

PLATE 44
A Moving Point of Balance, **Chakra #5 (throat)**, 1985
acrylic, microglitter, gold leaf, broken glass, foil, fabric, and mixed media on linen
84 × 84 in.
Collection of Kelley and Stanton Perry, Laguna Niguel, California

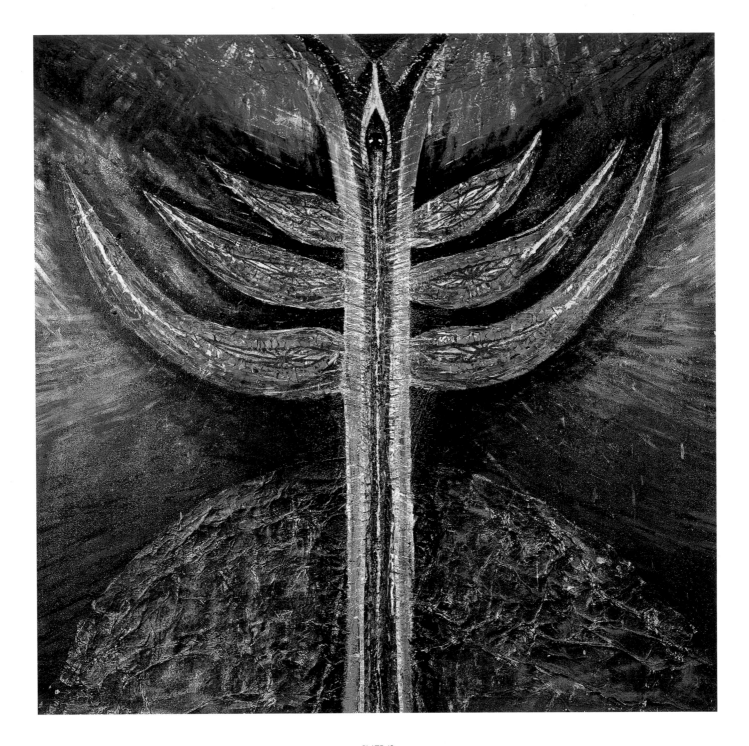

PLATE 45
A Moving Point of Balance, ***Chakra #6 (third eye)***, 1985
acrylic, microglitter, gold leaf, broken glass, foil, fabric, and mixed media on linen
84 × 84 in.
Collection of Kelley and Stanton Perry, Laguna Niguel, California

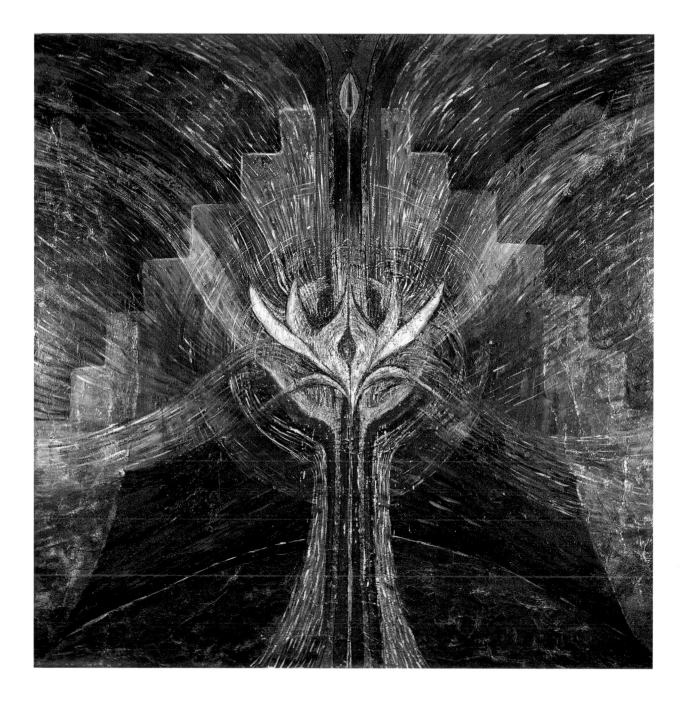

PLATE 46
A Moving Point of Balance, **Chakra #7 (crown)**, 1985
acrylic, microglitter, gold leaf, broken glass, foil, quartz crystals, and mixed media on linen
84 × 84 in.
Collection of Kelley and Stanton Perry, Laguna Niguel, California

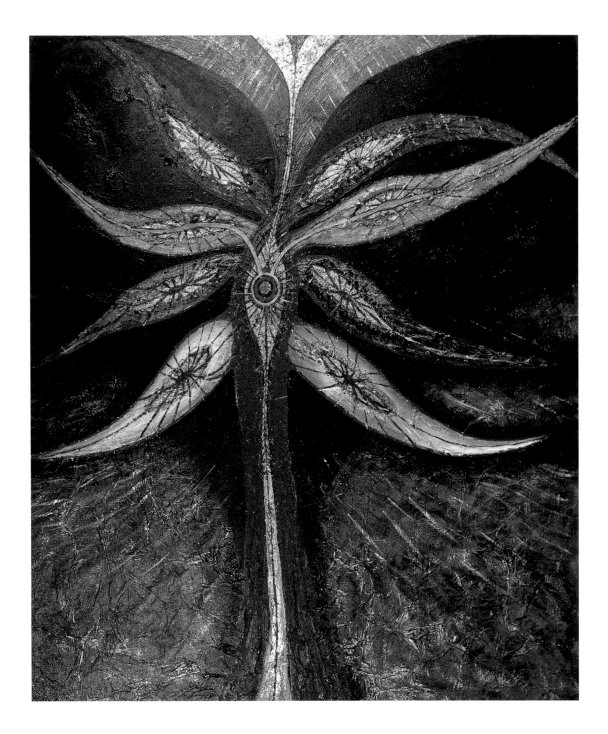

PLATE 47
*Night Vision, **#8**,* 1985
acrylic, mica, glass, and gold leaf on canvas
72 × 60 in.
Collection of Diane and Gary Tooker, Paradise Valley, Arizona

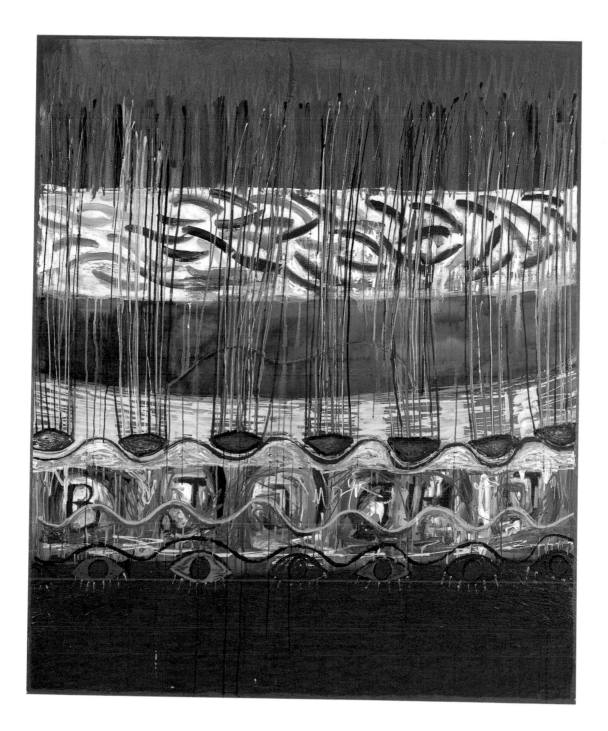

PLATE 48
Trans-Illumination, **Healing Portrait #2 (Joanne Norris)**, 1986
acrylic on canvas
60 × 48 in.
Collection of Joanne and Carter Norris, Paradise Valley, Arizona

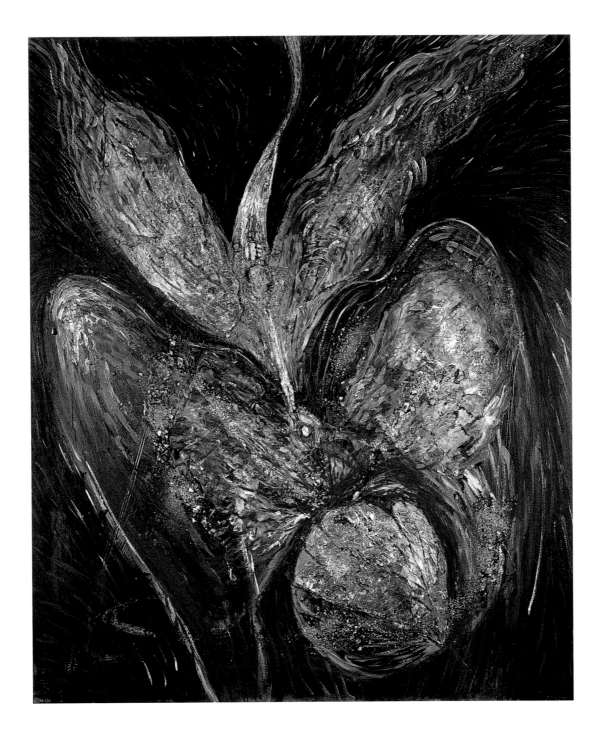

PLATE 49
Alchemy, #5, 1987
acrylic, quartz crystals, gold leaf, silver leaf, mica, amethyst, azurite, chrysocolla, and mixed media on canvas
72 × 60 in.
Collection of Cinda and Tom Cole, Casa Grande, Arizona

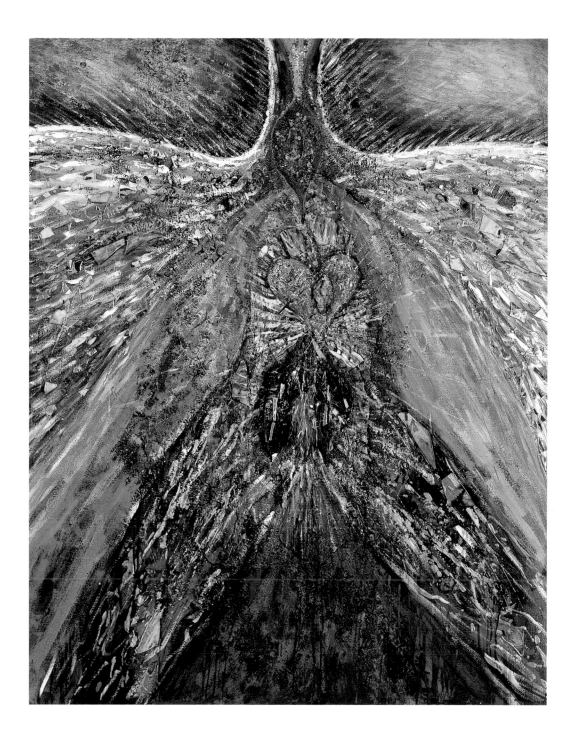

PLATE 50
Celestial Visitations, **#4 (The Angel of Irrevocable Choice)**, 1987–88
acrylic, quartz crystals, gold leaf, silver leaf, mica, broken mirror, amethyst, azurite, chrysocolla, dead bird, and mixed media on canvas
60 × 48 in.
Collection of Joy Tash, Paradise Valley, Arizona

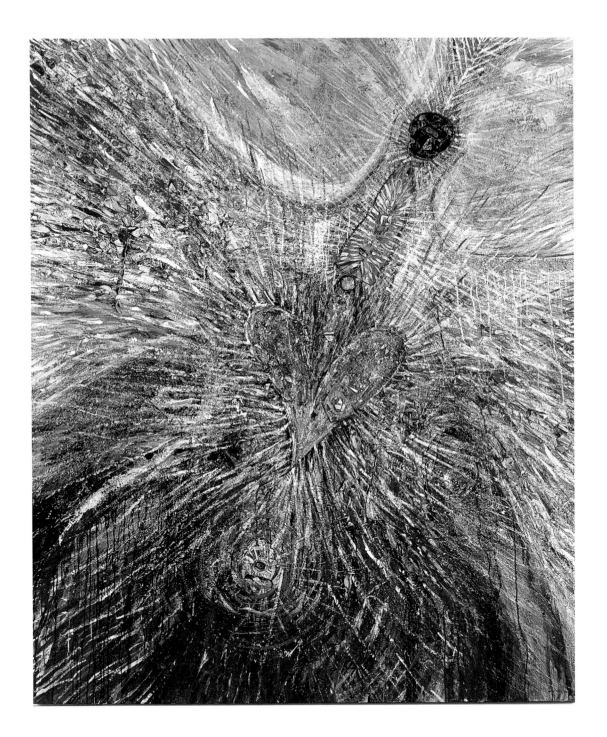

PLATE 51
Celestial Visitations, **#5 (The Angel of Deliverance)**, 1988
acrylic, quartz crystals, gold leaf, silver leaf, mica, broken mirror, amethyst, azurite, chrysocolla, and mixed media on canvas
72 × 60 in.

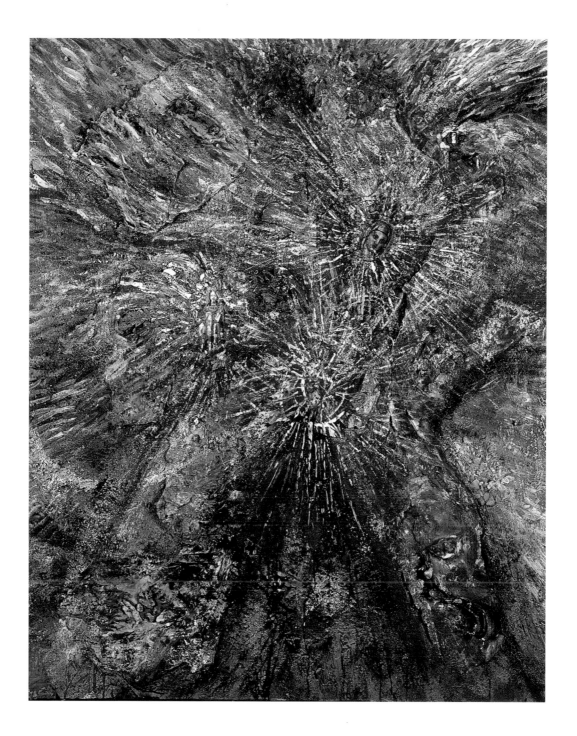

PLATE 52
Return of the Chalice, **#2**, 1988
acrylic, gold leaf, and mixed media on canvas
60 × 48 in.

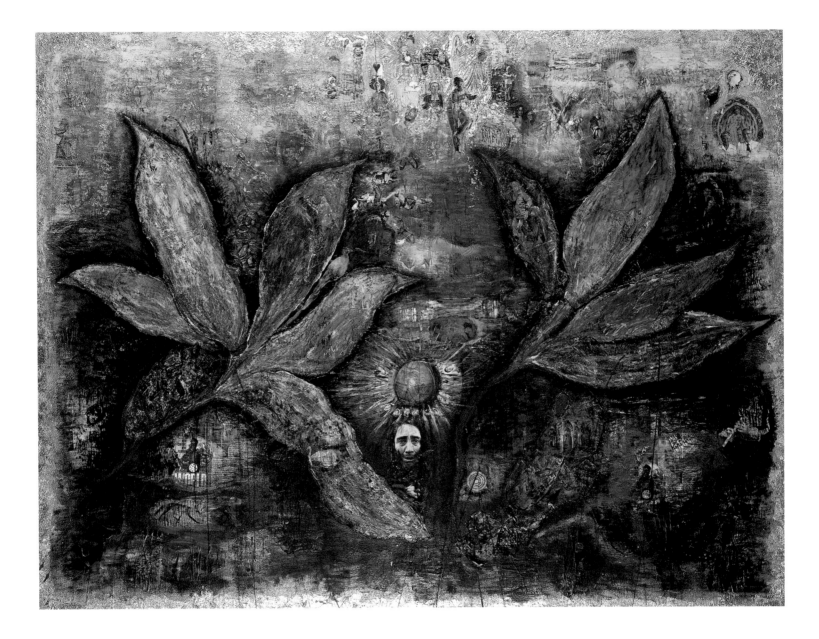

PLATE 53
Dreams for the Earth, **#6**
(So the darkness shall be the light and the stillness the dancing), 1989
acrylic, gold leaf, silver leaf, and mixed media on canvas
66 × 84 in.

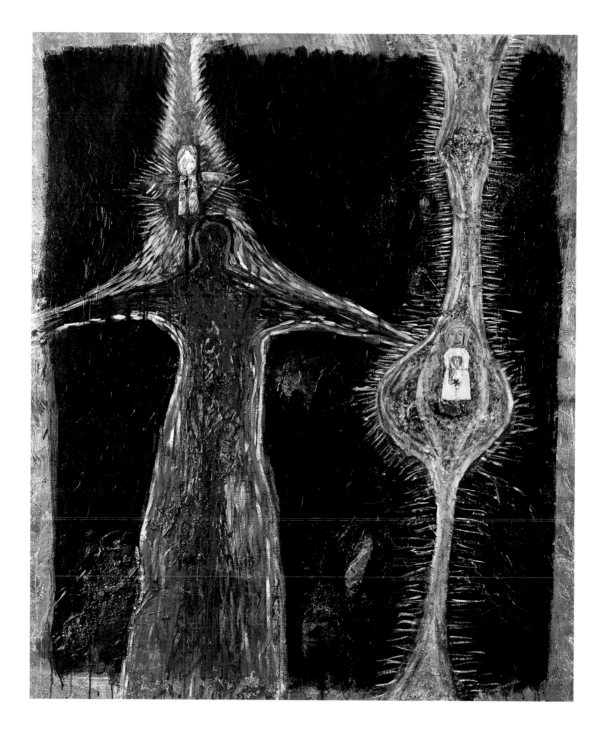

PLATE 54
*The Wounded Healer, **Resurrection #1**, 1991*
acrylic, gold leaf, handmade dolls, and mixed media on canvas
72 × 60 in.

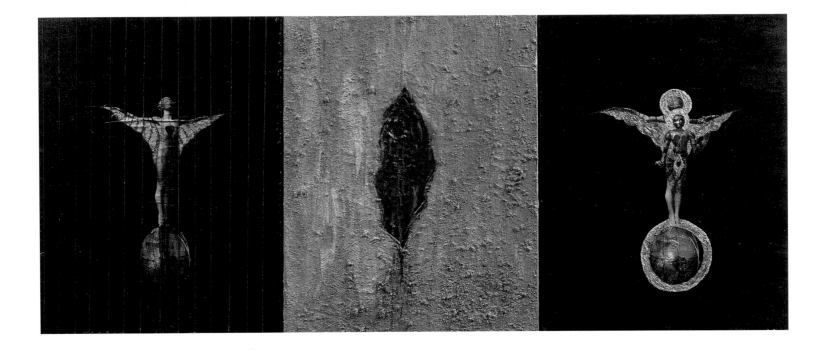

PLATE 55
The Wounded Healer, **Choice: Love or Fear #1**, 1991
acrylic, gold leaf, earth, string, and mixed media on canvas
20 × 48 in.

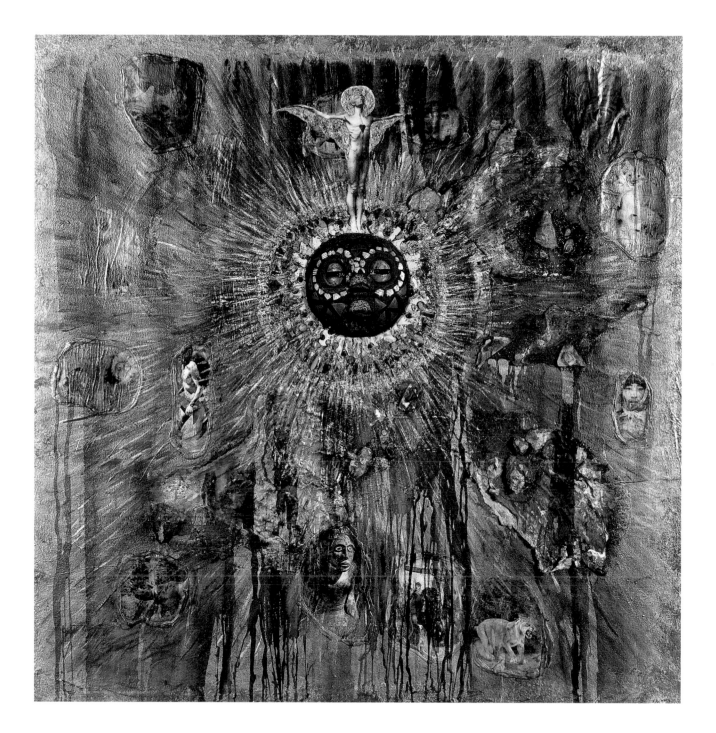

PLATE 56
The Wounded Healer, **Healing Our Sacred Wounds #12**, 1992
acrylic, gold leaf, glass, African mask, and mixed media on canvas
48 × 48 in.

PLATE 57
A Verse for the Eleventh Hour, **The Second Coming: Fragment #1**, 1993
acrylic, gold leaf, and mixed media on handmade paper
18 × 23 in.
Collection of Eva and Eric Jungermann, Phoenix

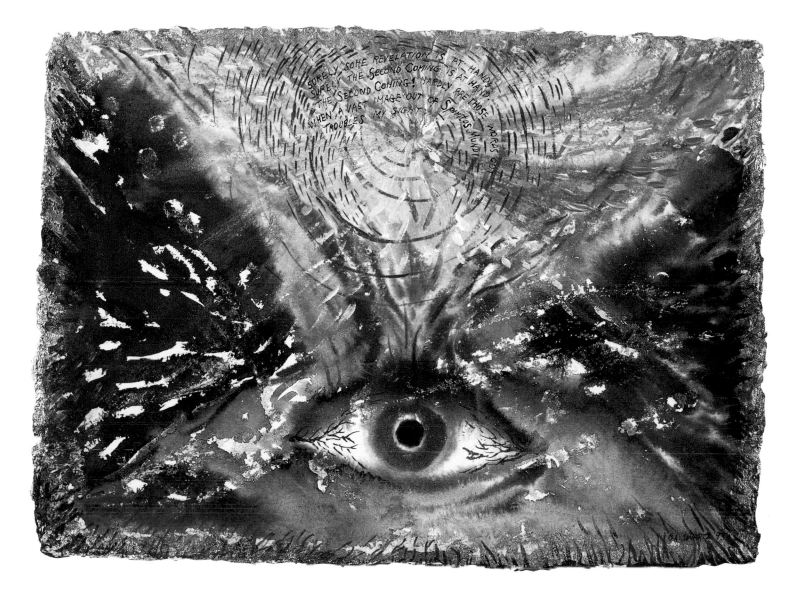

PLATE 58
A Verse for the Eleventh Hour, **The Second Coming: Fragment #3**, 1993
acrylic, gold leaf, and mixed media on handmade paper
18 × 23 in.

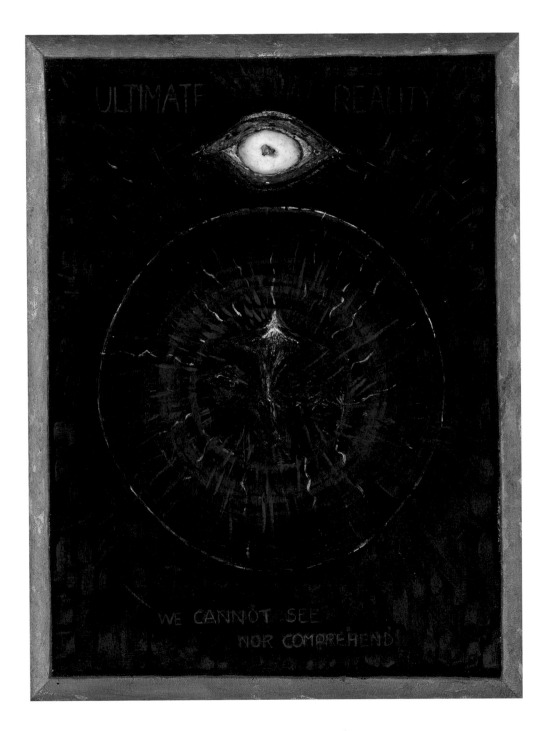

PLATE 59
A Story for the Eleventh Hour, **Beginning***, 1993
acrylic, sliced geode, gold leaf, silver leaf, and mixed media on shaped canvas
40 × 30 in.
Collection of John Haworth, New York

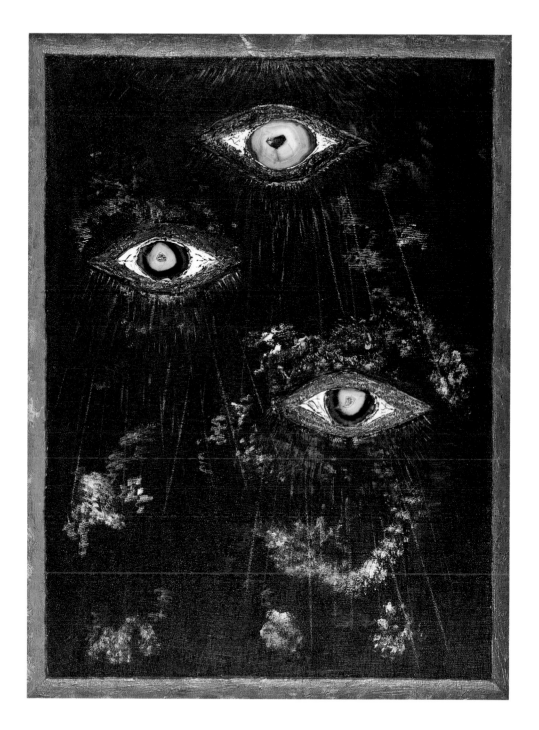

PLATE 60
A Story for the Eleventh Hour, **Coalescence**, 1993
acrylic, sliced geode, gold leaf, silver leaf, and mixed media on shaped canvas
40 × 30 in.
Collection of Diane and Gary Tooker, Paradise Valley, Arizona

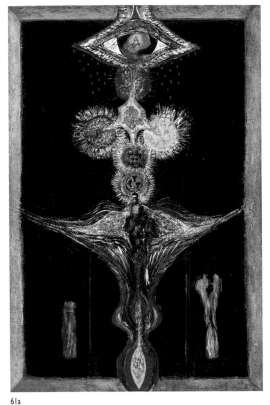

6la

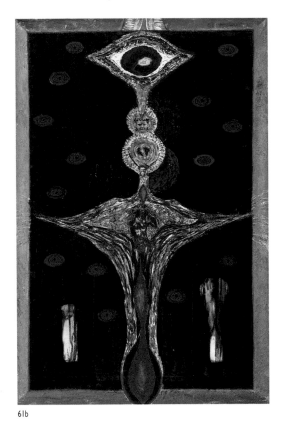

6lb

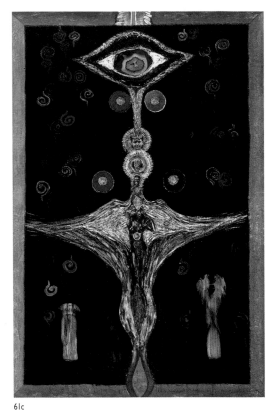

6lc

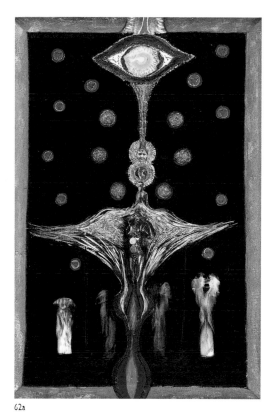

62a

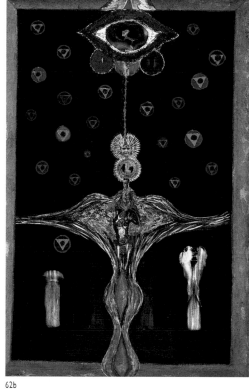

62b

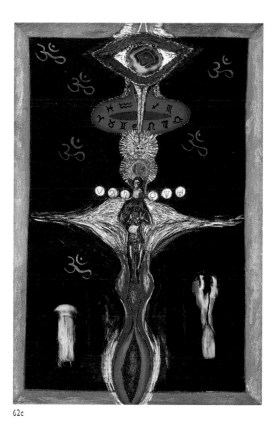

62c

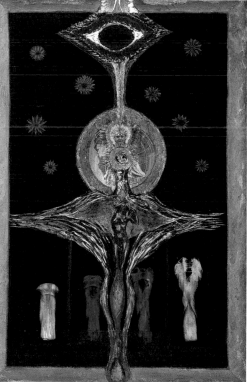

62d

PLATE 62a
A Story for the Eleventh Hour,
A Personal Story: Maturity, 1993
acrylic, sliced geode, gold leaf, silver leaf,
and mixed media on shaped canvas
36 × 24 in.

PLATE 62c
A Story for the Eleventh Hour,
A Personal Story: Integration, 1993
acrylic, sliced geode, gold leaf, silver leaf,
and mixed media on shaped canvas
36 × 24 in.

PLATE 62b
A Story for the Eleventh Hour,
A Personal Story: Initiation, 1993
acrylic, sliced geode, gold leaf, silver leaf,
and mixed media on shaped canvas
36 × 24 in.

PLATE 62d
A Story for the Eleventh Hour,
A Personal Story: Transformation, 1993
acrylic, sliced geode, gold leaf, silver leaf,
and mixed media on shaped canvas
36 × 24 in.

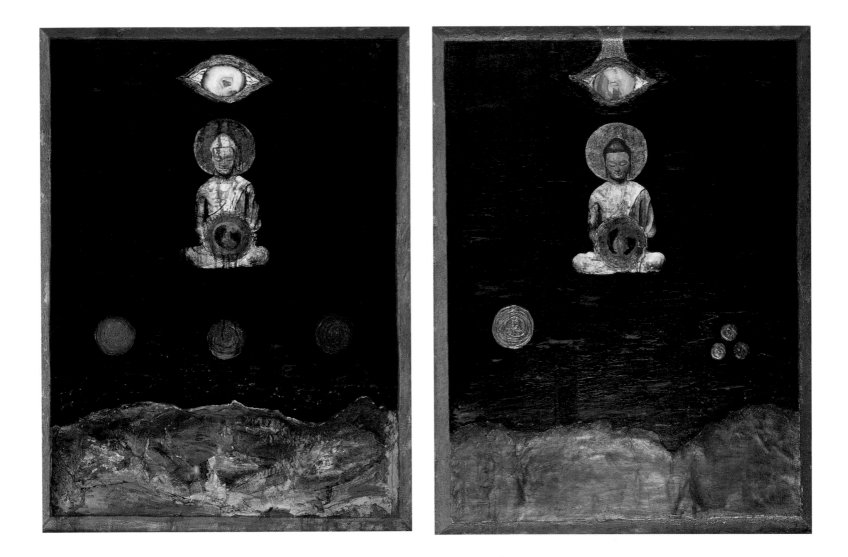

PLATE 63
A Story for the Eleventh Hour, **And the lotos rose, quietly, quietly**, 1993
acrylic, sliced geode, gold leaf, silver leaf, and mixed media on shaped canvas
48 × 36 in.

PLATE 64
A Story for the Eleventh Hour, **A white light still and moving**, 1993
acrylic, sliced geode, gold leaf, silver leaf, and mixed media on shaped canvas
48 × 36 in.
Collection of Marion Rockefeller Weber, San Francisco

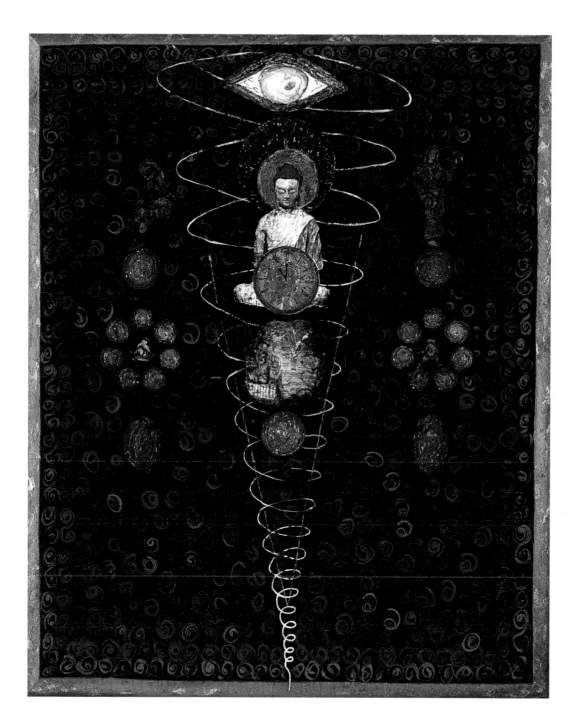

PLATE 65

A Story for the Eleventh Hour, **The Return: Encountering the Spiral at the Eleventh Hour**, 1993
acrylic, sliced geode, gold leaf, silver leaf, and mixed media on shaped canvas
60 × 48 in.

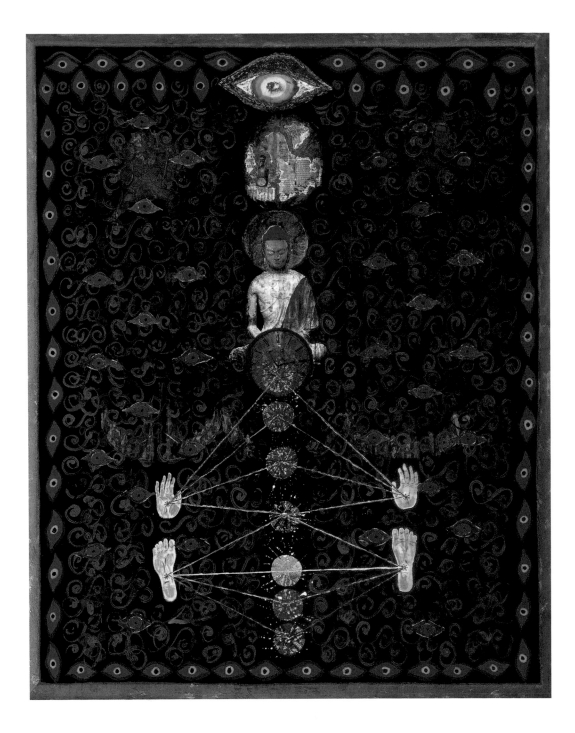

PLATE 66
A Story for the Eleventh Hour, **The Return: Charging the Species at the Eleventh Hour**, 1993
acrylic, sliced geode, gold leaf, silver leaf, and mixed media on shaped canvas
60 × 48 in.

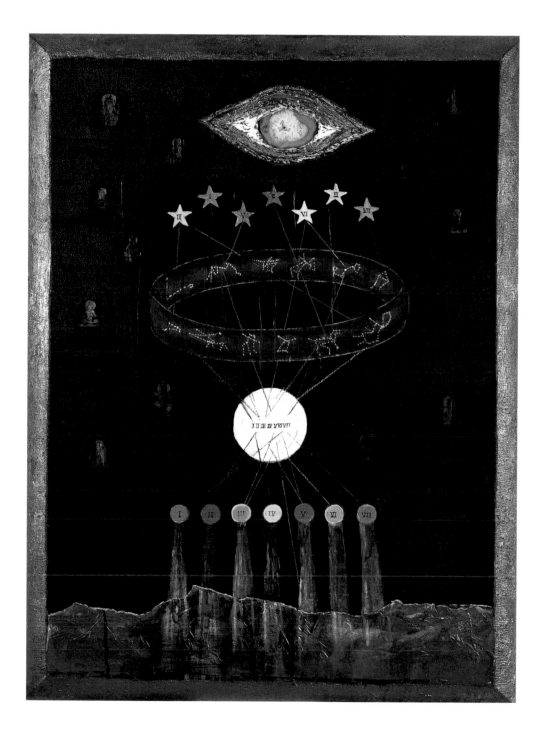

PLATE 67
A Story for the Eleventh Hour, **Reconciled among the Stars**, 1993
acrylic, sliced geode, gold leaf, silver leaf, and mixed media on shaped canvas
40 × 30 in.
Collection of Mary and Douglas Jordan, Paradise Valley, Arizona

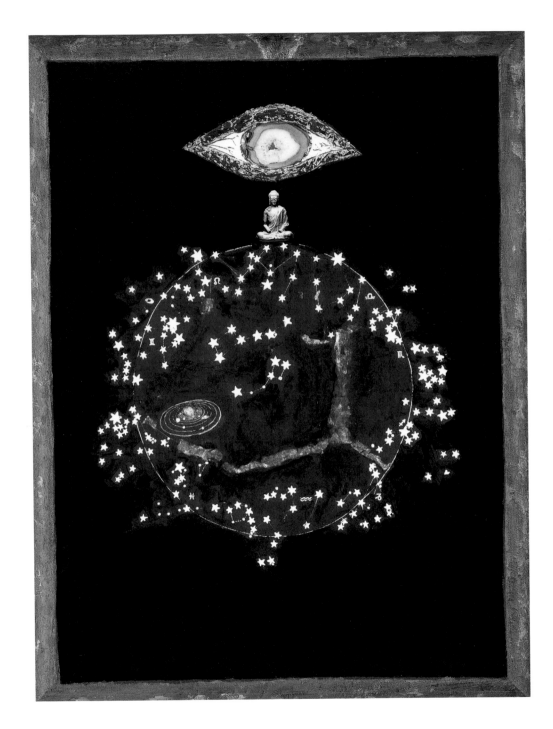

PLATE 68
A Story for the Eleventh Hour, **Shantih shantih shantih**, 1993
acrylic, sliced geode, gold leaf, silver leaf, and mixed media on shaped canvas
40 × 30 in.
Collection of Darrel LaDra, Red Hook, New York

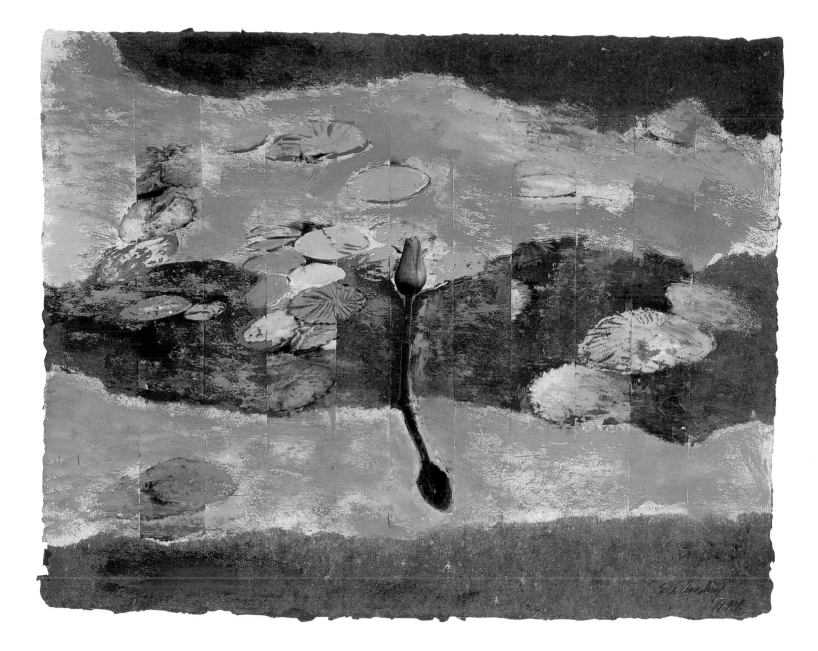

PLATE 69
The Lotus as Metaphor, **Shadow of the Lotus**, 1994
acrylic and mixed media on handmade paper
18 × 24 in.

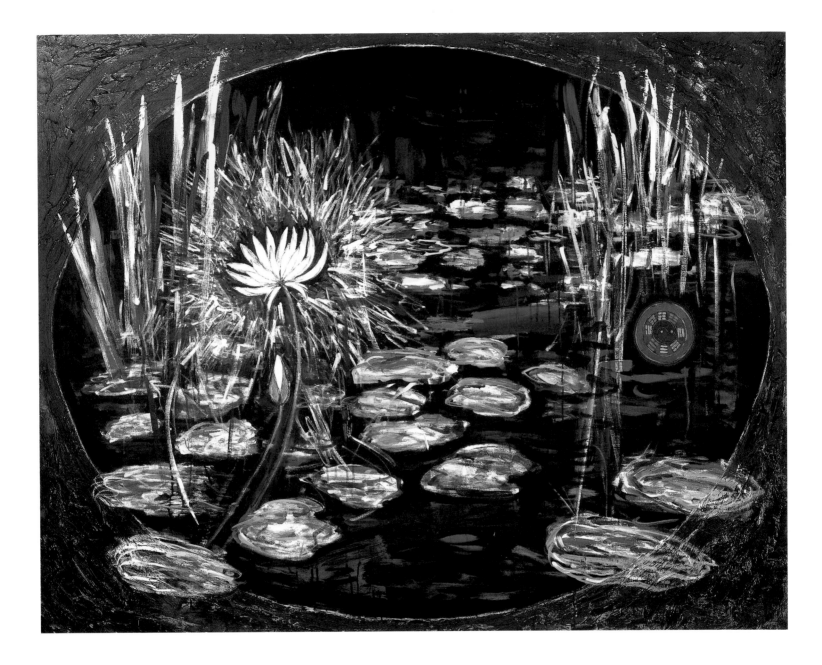

PLATE 70
The Lotus as Metaphor, **Twenty-two Petaled Lotus**, 1994
acrylic on canvas
48 × 60 in.
Collection of Parker Smith, Charlotte, North Carolina

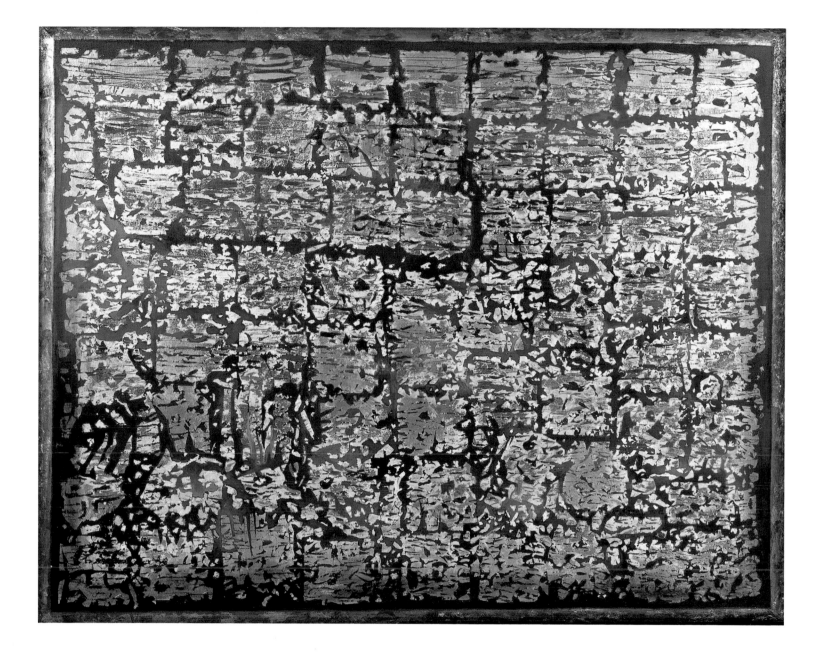

PLATE 71
Shen Qi, **#2**, 1996–97
acrylic, gold leaf, and mixed media on shaped canvas
48 × 60 in.
Collection of Lisa Tear, La Jolla, California

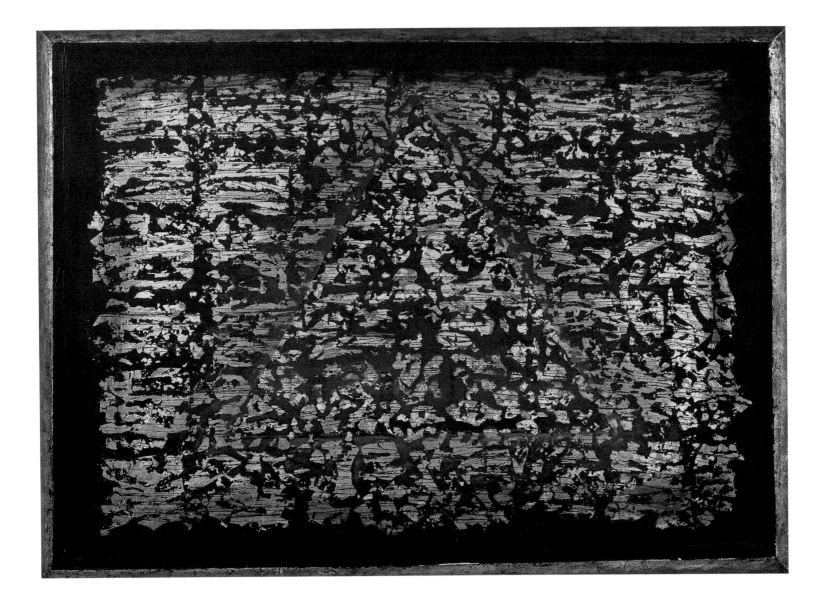

PLATE 72

Shen Qi, **Tetragrammaton #2 (with ultramarine line)**, 1997

acrylic, gold leaf, and mixed media on shaped canvas

36 × 48 in.

Collection of the Scottsdale Museum of Contemporary Art, Scottsdale, Arizona

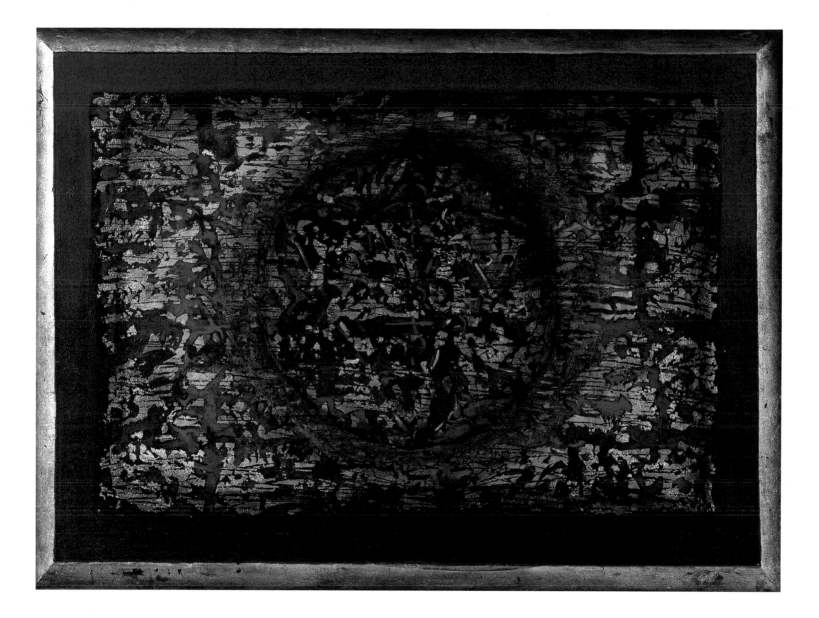

PLATE 73
*Shen Qi, **The 32 Paths of Wisdom #1**,* 1997
acrylic, gold leaf, and mixed media on shaped canvas
30 × 40 in.
Collection of Diane and Gary Tooker, Paradise Valley, Arizona

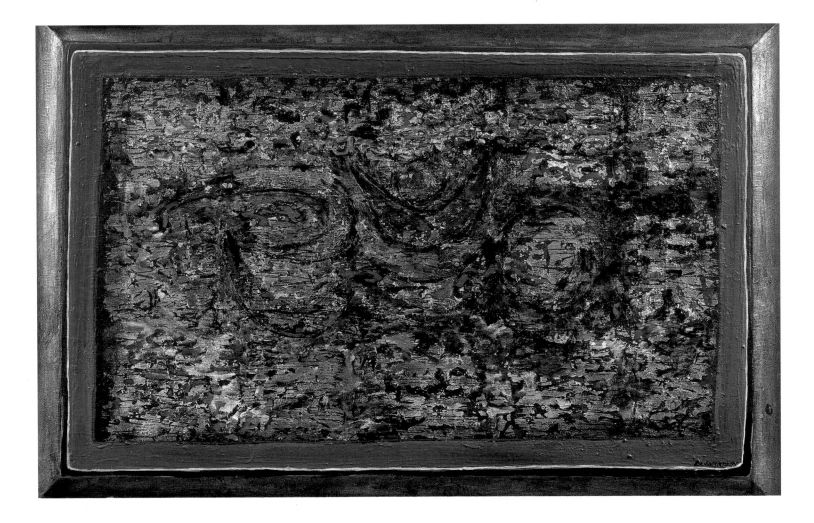

PLATE 74
Shen Qi, **Om #1 (vermilion)**, 1997
acrylic, gold leaf, and mixed media on shaped canvas
24 × 36 in.

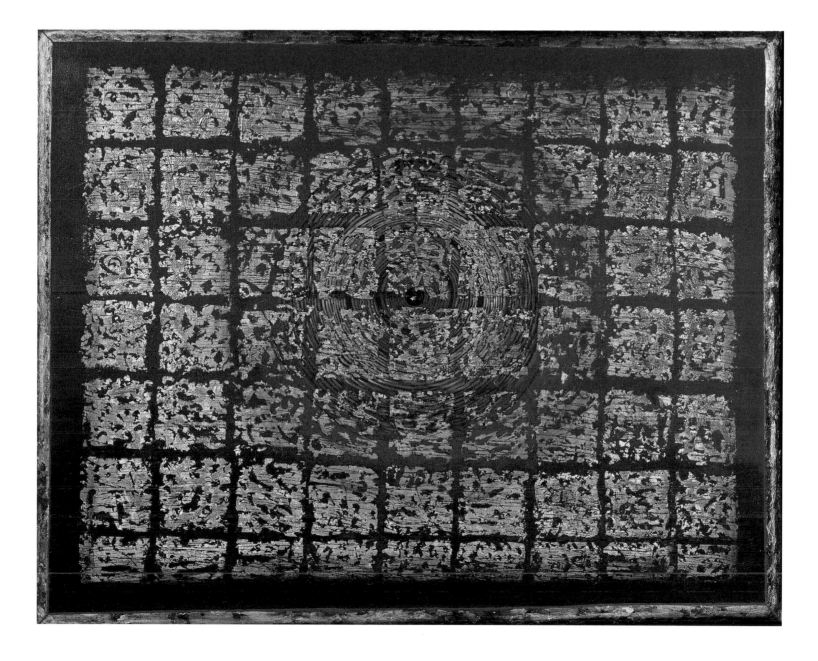

PLATE 75

Shen Qi, **The Cabalistic Scheme of the Four Worlds #1**, 1997

acrylic, gold leaf, and mixed media on shaped canvas

48 × 60 in.

Collection of Carole and Jerry Vanier, Scottsdale, Arizona

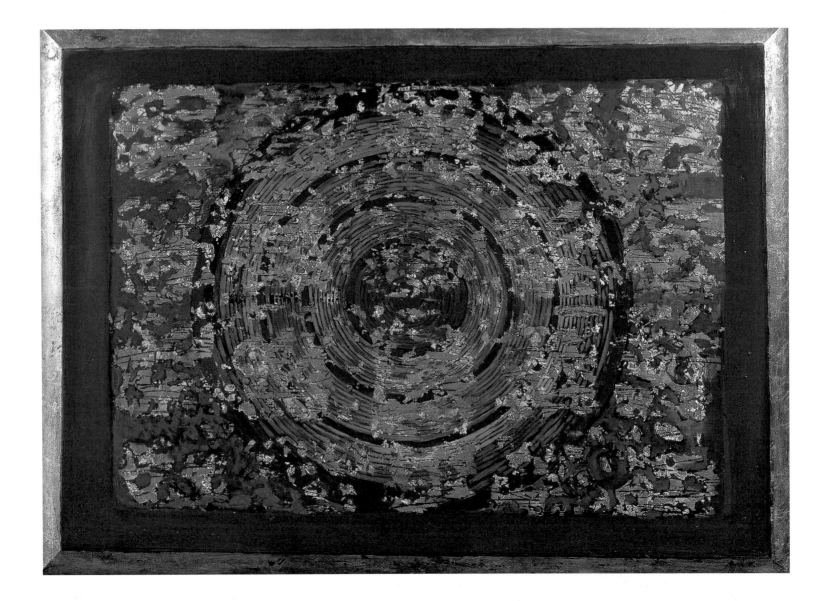

PLATE 76
*Shen Qi, **The Cabalistic Scheme of the Four Worlds #4**, 1997*
acrylic, gold leaf, and mixed media on shaped canvas
30 × 40 in.
Collection of the Scottsdale Museum of Contemporary Art, Arizona

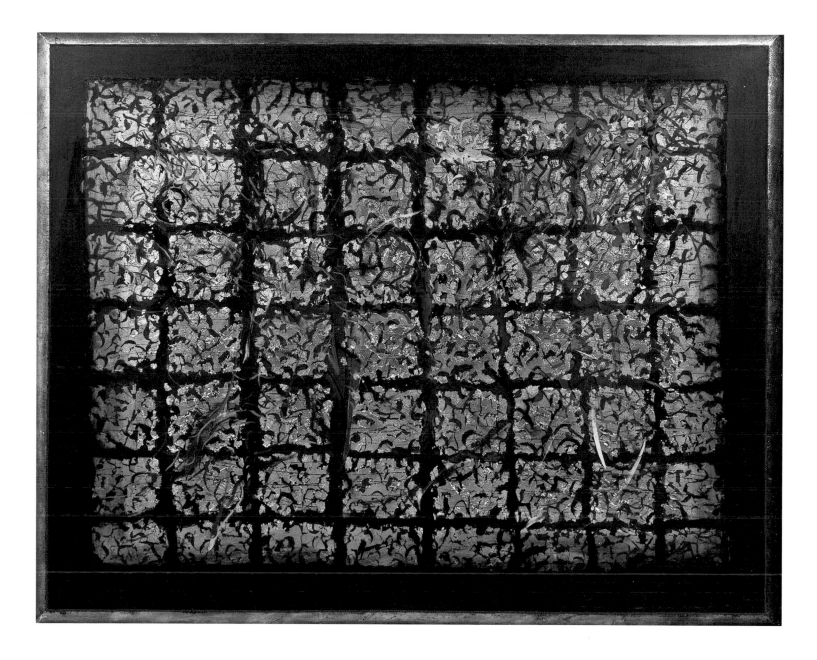

PLATE 77
Shen Qi, **Om Mani #4 (cobalt blue)**, 1998–99
acrylic, gold leaf, and mixed media on shaped canvas
48 × 60 in.

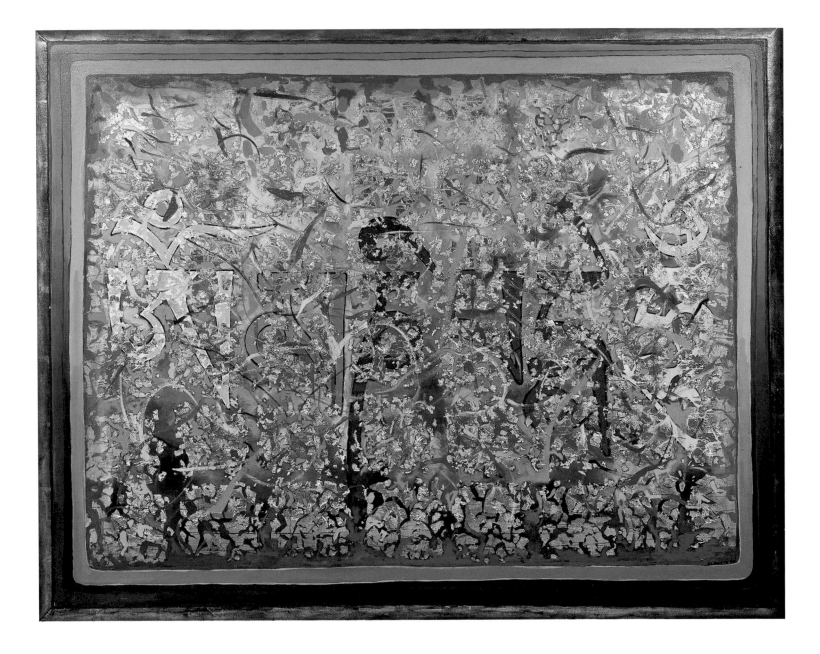

PLATE 78
Shen Qi, **Om Mani #5 (pale green)**, 1999
acrylic, gold leaf, and mixed media on shaped canvas
48 × 60 in.

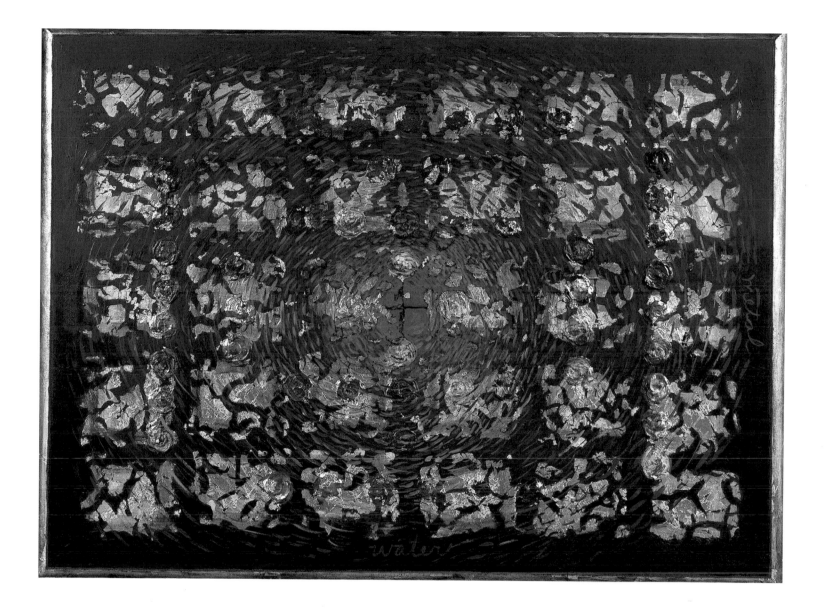

PLATE 79
*States of Change, **#3 (cobalt blue)**, 1999*
acrylic, gold leaf, and mixed media on shaped canvas
36 × 48 in.
Collection of Jeffrey Scult, San Francisco

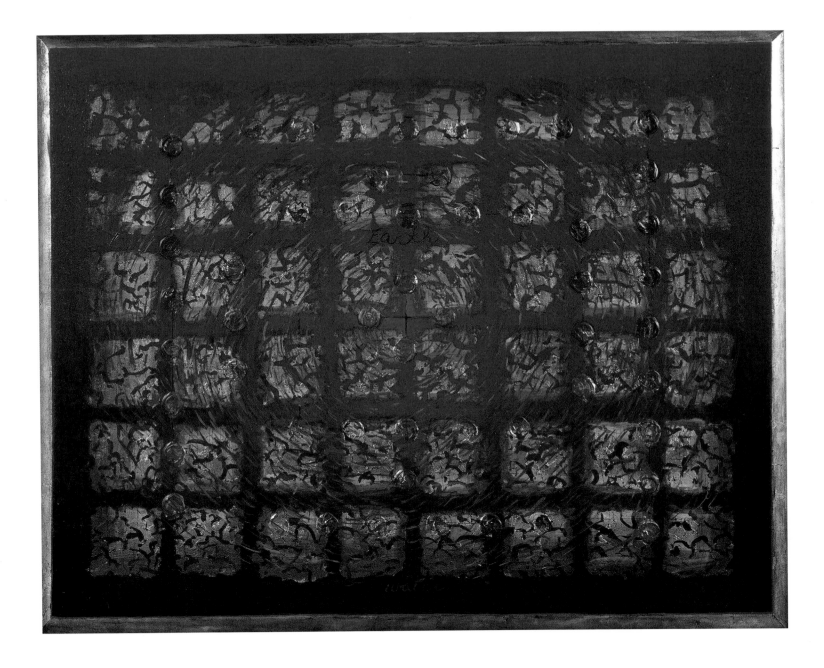

PLATE 80
*States of Change, **#4 (cadmium red deep)**,* 1999
acrylic, gold leaf, and mixed media on shaped canvas
48 × 60 in.
Collection of Ursula and Stephen Gebert, Chiaroscuro Gallery, Santa Fe

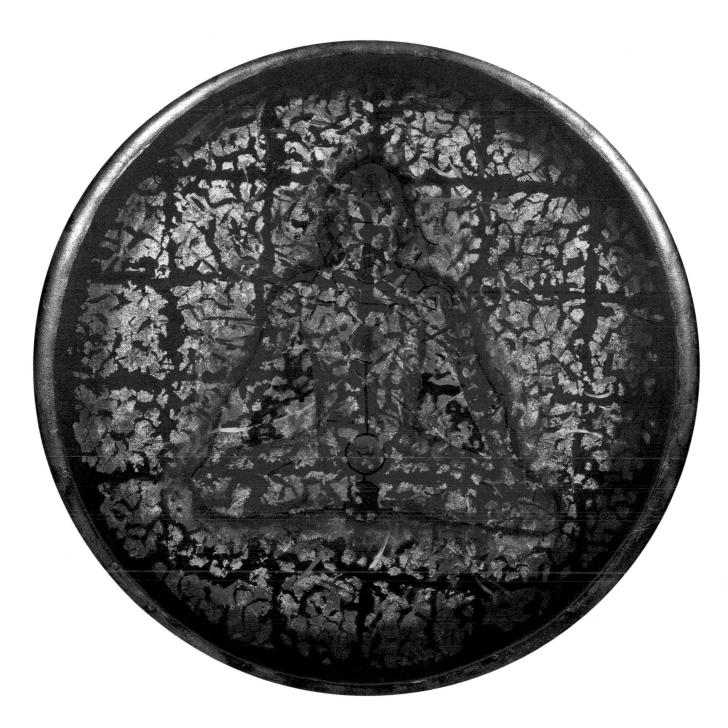

PLATE 81
States of Change, **Ten Sefiroth #1 (alizarin crimson)**, 1999
acrylic, gold leaf, and mixed media on shaped circular canvas
diam.: 40 in.

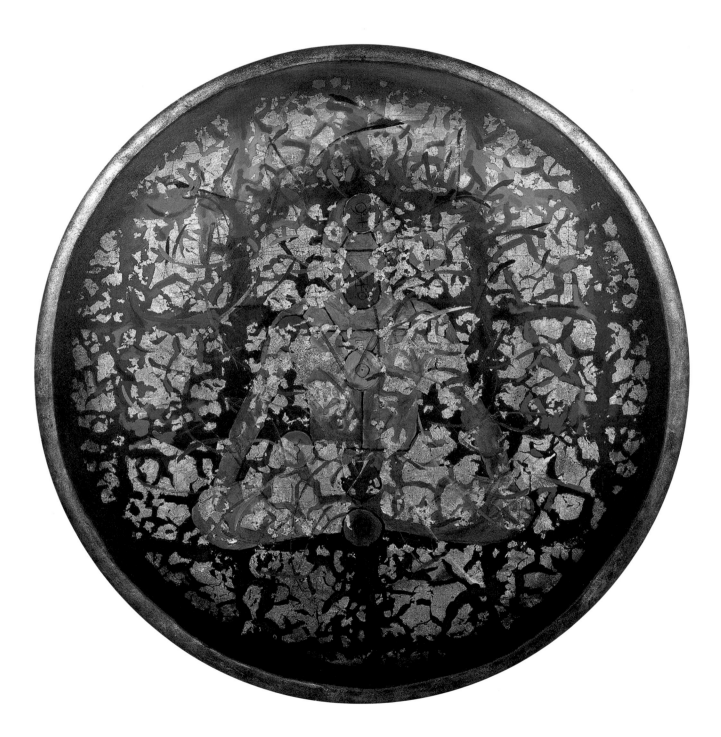

PLATE 82
States of Change, **Ten Sefiroth #4 (pale gray)**, 1999
acrylic, gold leaf, and mixed media on shaped circular canvas
diam.: 40 in.
Collection of Skirball Cultural Center and Museum, Los Angeles

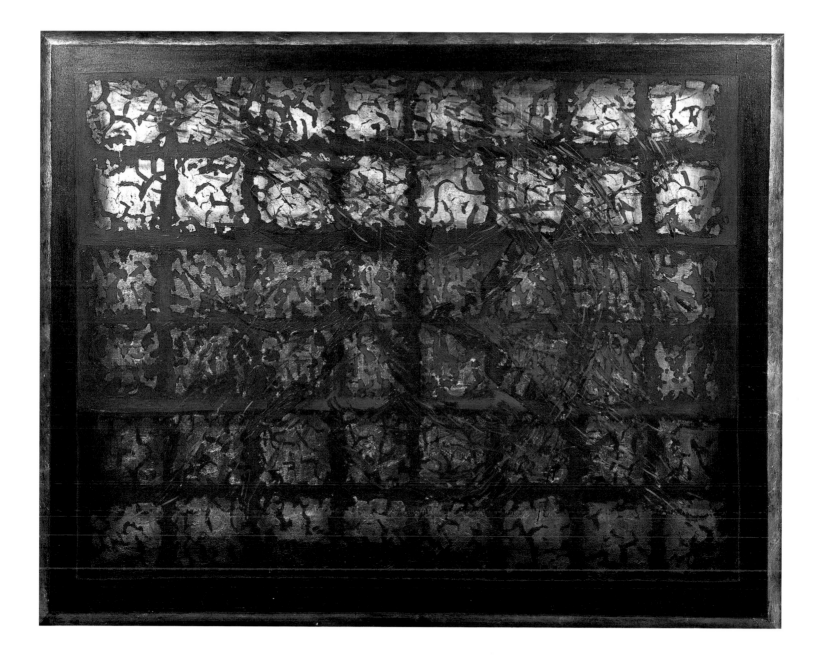

PLATE 83
States of Change, **Eternity #2 (Three Aspects)**, 1999
acrylic with silver leaf, gold leaf, copper leaf, and mixed media on shaped canvas
48 × 60 in.
Collection of Diane and Gary Tooker, Paradise Valley, Arizona

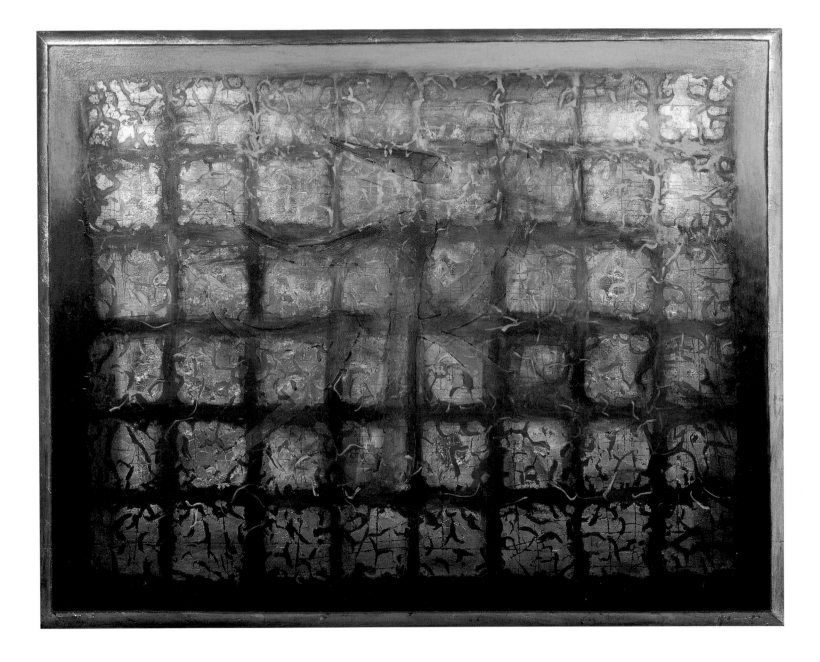

PLATE 84
States of Change, **Eternity #4 (The Mystery)**, 1999
acrylic, gold leaf, and mixed media on shaped canvas
48 × 60 in.
Collection of Marilyn and Donald Hollis, Paradise Valley, Arizona

Chronology

The three Ames children, left to right: Bruce, Sylvia, and Beth.

1936

Born Beth Ellen Ames, February 5, New York City, the third child of Dorothy Andres Ames and Maurice U. Ames (brother, Bruce, b. 1929; sister, Sylvia, b. 1932).

Mother encourages Beth's creativity by providing her with lessons in drawing, painting, dancing, singing, and piano.

Beginning when Beth is about ten, an aunt, Rachel Andres, gives her lessons in classical piano and watercolor.

1948

Begins receiving weekly figure-painting lessons at Art Students League and visiting the Museum of Modern Art.

1949

Passes entrance exam to attend High School of Music and Art, New York.

Left to right: the artist's maternal grand-mother, Sophie Andres, the artist's mother, Dorothy Andres Ames; and her aunt Ricky Andres.

The Ames family, 1953. Left to right: Sylvia (sister), Bruce (brother), Beth, Maurice (father), and Dorothy (mother).

1954

Enters College of Home Economics (now College of Human Ecology), Cornell University.

At Cornell, meets and is introduced to literature about the healing aspects of creative expression by professor Frances Wilson Schwartz of the Child Development department; as a result of her influence, decides to become an art teacher.

Edith Wachenheim (left) and Beth painting in Denmark, summer 1956.

On Schwartz's recommendation, reads *The Biology of the Spirit* (1955) by Edmund Sinnott. His thesis, that all growth is purposeful and that spiritual growth is vital, becomes an important part of her personal philosophy.

1956

Serves as arts-and-crafts director of a Catskills summer camp.

Graduates from Cornell; remains for another semester to assist Schwartz and to audit a modern-poetry class that emphasizes the writing of W. H. Auden and T. S. Eliot.

Spends summer months visiting museums in England, France, Italy, Denmark, and Switzerland.

Begins teaching English, poetry, and art at PS 80 junior high school in the Bronx.

1958

Begins night classes (mostly studio) in art education at New York University,

working in oil in semiabstract manner on canvas.

Frances Wilson Schwartz dies of cancer at age thirty-nine, leaving Beth her papers and personal library.

Begins experimenting with watercolor.

1959

Switches to watercolor exclusively.

Receives M.A. in art education from New York University.

December 27, marries attorney Melvin Jay Swartz; couple moves to Phoenix.

1960

Paints cityscapes recalling the view from the window of the apartment where she grew up and landscapes inspired by the poetry of e. e. cummings and T. S. Eliot.

Begins teaching at Yavapai Elementary School, Scottsdale.

1962

Begins teaching at Kaibab Elementary School, Scottsdale.

1963

Joins with other local artists (Barbara Bennett, Ray Fink, Eugene Grigsby, Rip Woods, and Muriel Zimmerman-Magenta) to form an artists' cooperative.

1964

Stops full-time teaching to devote more time to painting.

Begins teaching in extension division of Arizona State University art depart-

ment. Develops arts-and-crafts program for elementary-school teachers in conjunction with university program.

1965

Serves as consultant to Volunteers in Service to America (VISTA) and Head Start federal government programs, giving lectures on creativity and leading courses in watercolor for preschool teachers.

1966

Summer, takes painting and lithography classes at Instituto de Allende, San Miguel de Allende, Mexico. Produces first lithograph.

1967

April 27, daughter, Julianne, is born.

1968

Begins working with acrylic on paper, using a larger format, and moves from realism into abstraction.

1970

Becomes interested in the subject of synchronicity after reading Anelia Jaffe's book about Carl Jung, *The Myth of Meaning* (1970). Begins employing synchronistic combination of action and response in her work.

Becomes active in a community-based group that lobbies Phoenix-area businesses to hire more minority women.

April 1, son, Jonathan, is born.

Rafting trip down the Colorado River leads to work reflecting her new sense of

connection with nature. Also develops a body of work that relates women to the earth, including such paintings as *Let the Heavens Say She Must #1* (1970) and *She Is Joined to the Soul of Stone* (1970).

Begins experimenting with collage and layering after seeing watercolors by John Marin at Los Angeles County Museum of Art. Creates works utilizing this process, such as *Dawn in the Grand Canyon* (1970) and *Opening Her New Wings at Dusk* (1971).

1971

Helps form a group of women artists, The Circle, who will work and exhibit together until 1975. Members include Carol Colburn, Darlene Goto, Mary Joyce Norton, and Arlene Scult.

Spends summer in San Miguel de Allende taking classes at Instituto de Allende; experiments briefly with pouring stains of color on canvas.

Transcendental meditation and growing knowledge of color theory through study with artist Dorothy Fratt lead her to create *Meditation* series (1971–73).

1973

Produces *Projected Power* series.

1974

June, attends conference in Buffalo, New York, sponsored by the Creative Problem Solving Institute. Meets George T. Lock Land, author of *Grow or Die: The Unifying Principle of*

Transformation (1973). Land's theories will have great impact on her thinking and work.

Fall, begins studying Zen Buddhism.

Undertakes four series relating to the elements: *Umi* (Japanese for "water") (1974), *Air* (1974–76), *Flight* (1974–75), and *Prana* (Sanskrit for "spiritual energy") (1974–75). Also begins *Earthflow* series (1974–76).

Begins fire works. Groups of work reflecting this process will include *Smoke Imagery* series (1977), *Cabala* series (1977), *Mica Transformation* series (1977), and *Colly's Dream* series (1982).

1976

January, attends lecture about human growth given in Phoenix by Elisabeth Kubler-Ross during a symposium on death and dying.

Mother suffers heart attack; in response, Swartz creates *I Love Mommy* series.

October, travels to Israel with husband.

Attends lecture by critic Lucy Lippard on women artists whose work deals with ritual, including Judy Chicago, Geny Dignac, and Mary Beth Edelson.

1977

Attracted by the use of fire as a medium and as a way of dealing with death, produces *Smoke Imagery* series.

Begins exploring conceptual and aesthetic possibilities of mutilating

paper, then ordering, disordering, and reordering it. *Fire and Ice* series (1977), *Mica Transformation* series (1977), *Torah Scroll* series (1977–78), and *Cabala* series (1977) exemplify this ritualized approach to painting.

Begins studying the Cabala.

Creates *Cabala* series.

Named "Master Teacher" by Arizona State Department of Public Instruction.

Receives educational grant from Arizona Commission on the Arts and Humanities for *Inquiry into Fire*.

1978

February, *Inquiry into Fire* opens at Scottsdale Center for the Arts.

March visit to Rothko Chapel, Houston, inspires her to create a spiritually oriented exhibition environment.

July, one of four Arizona artists invited to participate in *The First Western States Biennial Exhibition* (opens at Denver Art Museum, March 1979).

Begins *Sedona* series (1978–80), incorporating earth from Arizona's Sedona–Red Rock area.

1979

Spring, collaborates with Sandy Kinnee, Colorado Springs, on works utilizing serigraphy, glitter, and earth; learns handmade-paper techniques.

August, serves as artist-in-residence

at Volcano Art Center, Hilo, Hawaii. Collects sand there that she will use in *Black Sand Beach* series.

Begins *Black Sand Beach* and *Green Sand Beach* series (1979–80) after returning to Arizona.

Fall, produces *Sedona and Hawaii* silkscreen series with Joy Baker, Southwest Graphics, Scottsdale.

1980
Produces *Monument Valley* series.

April, travels to Israel; visits ten historic sites connected to female figures in biblical history; starts *Israel Revisited* series.

August, serves as artist-in-residence at

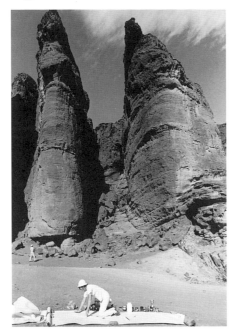

Swartz at King Solomon's Pillars, southern Israel, April 1980.

"The Awesome Space: The Inner and Outer Landscape" conference, Sun Valley Art and Humanities Center, Sun Valley, Idaho.

1981
Produces *Illuminated Manuscript* and *Buried Scroll,* and *Ten Sites* series.

February and April, travels to Alexandra Soteriou's Atelier du Livre, Bergen, New Jersey; learns to make paper from imported Chinese raw-flax fibers and uses it that year in *Rock Forms*, *Red Rock*, and *Blue Rock* series.

June, rafting trip down the Colorado River; begins large, free-form pieces for *New Landscape Rituals.*

Completes *Tree of Life*, ten-part, eighteen-foot-high work.

September, finishes *Israel Revisited* and debuts it that month at The Jewish Museum, New York.

Completes *Ten Sites Series.*

1982
January–June, builds new studio in her Paradise Valley home.

Creates *Colly's Dream* series in homage to her friend and neighbor Colly Soleri, the late wife of architect Paolo Soleri.

Meets artist James Turrell and visits Roden Crater.

Summer, does her final two major fire works on commission from the Phelps Dodge Corporation.

Studies shamanic practice with Michael Harner (author of *The Way of the Shaman* [1980]) and Navajo shaman-artist David Chethlahe Paladin as well as Indian medicine practice with Preston Monongye; integrates the healing process into her art.

1983
Attends eight-day experiential workshop, "Shamanic Healing, Journeying, and the Afterlife," Esalen Institute, Big Sur, California, led by Michael Harner.

The Swartz family, October 1983. Left to right: Jonathan, Beth, Melvin, and Julianne.

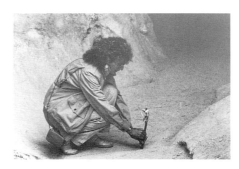

Swartz performing a ritual before viewing the cave paintings at Grotte de Font de Gaume, July 15, 1983.

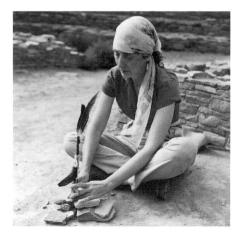

Swartz performing a ritual at sacred Indian site, Chaco Canyon, New Mexico, summer 1983.

Begins *A Moving Point of Balance*.

Returns to working on canvas.

June 17–27, member of "Southwest Pilgrimage, 1983," sponsored by Four Winds Circle.

July, travels to France. Visits megaliths, Carnac, Brittany coast, with artist Linda Farnsworth. The sites influence the seven paintings that will comprise *A Moving Point of Balance*.

1984

Mary Carroll Nelson's book *Connecting: The Art of Beth Ames Swartz* published.

April, divorced from Melvin Swartz.

December, David Chethlahe Paladin dies. Leaves his medicine wheel to Swartz; it becomes an integral element of all installations of *A Moving Point of Balance*.

Preston Monongye and Swartz, Scottsdale, Arizona, 1984.

Begins *Night Vision* series.

Experiences a vision while undergoing psychosynthesis (a type of therapy formulated by Robert Assagioli) with therapist Penelope Young. Vision inspires the final three chakra paintings in *A Moving Point of Balance*.

1985

Completes *A Moving Point of Balance*.

Receives Governor's Award, Outstanding Women of Arizona—Women Who Create.

July, travels to Canada for debut of *A Moving Point of Balance* at Nickle Art Museum, University of Calgary, Alberta. Medicine man performs ceremony at opening.

1986

Begins *Trans-Illumination* series of healing portraits.

Reads Theodor Schwenk's *Sensitive Chaos: The Creation of Flowing Forms in Water and Air* (1965). Later interprets

Schwenk's concepts in *A Story for the Eleventh Hour* (1993).

1987

Summer, organizes "Transformative Artists Conference and Workshop," Rim Institute, Payson, Arizona.

July, spends a month in Pietrasanta, Italy, creating experimental sculpture and visiting artists' studios.

Begins studying healing stones collected in Arizona; these become integral elements in *Alchemy* (1987) and *Celestial Visitations* (1987–88) series. Latter series inspired by her mother's fatal illness and by Adin Steninsaltz's *The Thirteen-Petaled Rose: A Discourse on the Essence of Jewish Existence and Belief* (1980).

1988

Co-founds International Friends of Transformative Art (IFTA), a nonprofit organization that provides grants for artists involved in spiritual and ecological endeavors.

March 13, completes *The Angel of Deliverance, #5 (Celestial Visitations* series). Mother dies the next day.

June, visits archaeological sites in Greece; inspired by goddess figures.

October, performance artist Rachel Rosenthal presents piece at University of Arizona Museum of Art, Tucson, inspired by *A Moving Point of Balance*.

1989

Reads Thomas Berry's *The Dream of the*

Earth (1988) and produces *Dreams for the Earth* series.

August 27, father dies.

1990
October, delivers keynote speech, "Art and Healing" conference, New Harmony, Indiana.

1991
Begins dividing her time between New York and home in Paradise Valley.

Begins *Healing Our Sacred Wounds* series.

October, speaks at "Art as a Healing Force" symposium, Stinson Beach, California.

1992
Moves to New York City.

February, *A Moving Point of Balance* exhibited at first MedArt International Congress, New York.

May, meets art dealer and writer John D. Rothschild in New York.

With Rothschild, creates the nonprofit Culture Care Foundation, whose goal is to support cultures that exhibit positive social values.

Begins *A Verse for the Eleventh Hour* series (1992–93).

1993
Begins *A Story for the Eleventh Hour* series.

October, serves on panel at "The Sacred and the Arts" conference, New York.

1994
Receives Flow Fund Award from the Rockefeller Family Fund. Uses the award monies to support the Culture Care Foundation's Sacred Souls Project.

February, serves on panel for "Art, Earth and Medicine: A Healing Approach" session at College Art Association annual conference, New York.

June, resigns from IFTA board of trustees to focus on involvement with the Culture Care Foundation.

December, travels to Jakarta, Indonesia, to honor first four recipients of Sacred Souls Award.

Produces print series inspired by *A Story for the Eleventh Hour*.

1995
Diagnosed with chronic fatigue immune deficiency syndrome (CFIDS).

December, moves back to Arizona to focus on health.

1996
Celebrates sixtieth birthday with healing ceremony.

Introduced to Shen Qi and begins *Shen Qi* series (1996–99).

1997
Cabalistic images begin appearing in *Shen Qi* series.

1998
January, long-term installation of *A Moving Point of Balance* begins at Arizona Cancer Center, Tucson.

Reads *Experiencing the Kabbalah* (1997) by Chic Cicero and Sandra Tabatha Cicero.

1999
Begins *States of Change* series.

November 26, marries John D. Rothschild in Los Angeles.

2000
Joins Cabala study group.

Begins experimenting with gold grids on circular canvases.

July, serves as faculty member at Anderson Ranch, Snowmass Village, Colorado; teaches "Painting Your Own Mythology" class.

Travels to New York, Paris, Malta, Greece, and Turkey. Especially moved by Tarxien and Ggantija temples in Malta.

October, begins three-year course in Jewish history, ethics, and traditions at the Jewish Federation, Phoenix.

2001
March, receives Governor's Arts Award in recognition of significant contributions to the arts of Arizona.

Exhibitions and Collections

Selected Solo Exhibitions

1966
Galerias Glantz, Mexico City

1967
Martin Gallery, Scottsdale, Arizona

1969
Martin Gallery, Scottsdale, Arizona

1970
Rosenzweig Center Gallery, Phoenix

Memorial Union Gallery, Arizona State University, Tempe

1971
Galeria Janna, Mexico City

Martin Gallery, Scottsdale, Arizona

1972
Memorial Union Gallery, Arizona State University, Tempe

Grady Gammage Auditorium, Arizona State University, Tempe

1975
Pavilion Gallery, Scottsdale, Arizona

1976
Acrylic on Paper, Attitudes Gallery, Denver

Bob Tomlinson Gallery, Albuquerque

1978–79
Beth Ames Swartz: Inquiry into Fire, Scottsdale Center for the Arts, Arizona. Traveled to: Springfield Art Museum, Missouri, and Frank Marino Gallery, New York

Artel Gallery, Albuquerque

Jasper Gallery, Denver

1979
Elaine Horwitch Galleries, Scottsdale, Arizona

Earth / Sunlight / Fire, Ellen Terry Lemer, Ltd., New York

1980
Elaine Horwitch Galleries, Scottsdale, Arizona

1981
New Landscape Rituals, Frank Marino Gallery, New York

Jewish Community Center, Rockville, Maryland

1981–83
Israel Revisited, Jewish Museum, New York. Traveled to: University of California, Irvine; Skirball Museum, Hebrew Union College, Los Angeles; University of Arizona Museum of Art, Tucson; Judah Magnes Museum, Berkeley, California; Art Museum of Southeast Texas, Beaumont; Albuquerque Museum

1982
Fire / Earth Paintings, Sun Valley Center for the Arts and Humanities, Idaho

Elaine Horwitch Galleries, Scottsdale, Arizona

Coconino Center for the Arts, Flagstaff, Arizona

J. Rosenthal Fine Arts, Chicago

1983
Art Resources Gallery, Denver

Deicas Art, La Jolla, California

Elaine Horwitch Galleries, Santa Fe, New Mexico

1984
Beth Ames Swartz: Selected Works, 1970–1984, Elaine Horwitch Galleries, Scottsdale, Arizona

DuBose Gallery, Houston

The Gallery, York, Pennsylvania

J. Rosenthal Fine Arts, Chicago

1985
Beth Ames Swartz: Selected Works, 1975–1985, ACA Galleries, New York

1985–90
A Moving Point of Balance, Nickle Art Museum, University of Calgary, Alberta. Traveled to: Multicultural Arts Center, San Diego; Woodbridge Conference Center, Snowmass Village, Aspen, Colorado; University of Arizona Museum of Art, Tucson; Coconino Center for the Arts, Flagstaff, Arizona; Newhouse Center for Contemporary Art, Staten Island, New York; Salt Lake Art Center, Utah; Palm Springs Desert Museum, California; University Art

Museum, Arizona State University, Tempe

1986
Beth Ames Swartz: Trans-Illumination Series, Elaine Horwitch Galleries, Scottsdale, Arizona

The Gallery, York, Pennsylvania

1988
Elaine Horwitch Galleries, Scottsdale, Arizona

1988–89
Return of the Chalice, New Gallery, Houston

1989
Elaine Horwitch Galleries, Palm Springs, California

Plaka Art Gallery, Athens, Greece

1990
Elaine Horwitch Galleries, Scottsdale, Arizona

Towson State University Museum, Towson, Maryland

1991
The Cincinnati Art Gallery, Cincinnati

Tilden/Foley Gallery, New Orleans

1992
Artefino Galleries, Charlotte, North Carolina

1994
A Story for the Eleventh Hour, E. M. Donahue Gallery, New York

1995
The Lotus as Metaphor, Joy Tash Gallery, Scottsdale, Arizona

1996
A Story for the Eleventh Hour, Phoenix Gallery, Santa Monica, California

1998
Shen Qi Series, Joy Tash Gallery, Scottsdale, Arizona

Shen Qi Series, Donahue/Sosinski Art, New York

1999
Shen Qi Series, KL Fine Arts, Inc., Highland Park, Illinois

2000
Beth Ames Swartz: States of Change, Vanier Galleries on Marshall, Scottsdale, Arizona

2002
Reminders of Invisible Light: The Art of Beth Ames Swartz, 1960–2000, Phoenix Art Museum

Beth Ames Swartz: Selected Works, 1960–2002, Herbert F. Johnson Museum of Art, Cornell University, Ithaca, New York

Visible Reminders, Vanier Galleries, Scottsdale, Arizona

New Work, Chiaroscuro Gallery, Santa Fe

Selected Group Exhibitions

1965
Arizona Annual, Phoenix Art Museum

1966
Los Robles Gallery, Palo Alto, California

Cave Creek Gallery, Arizona

Casa Grande Arts Festival, Arizona

Alhambra Invitational, Phoenix

1967
Scottsdale Artists League, Arizona

Phoenix Little Theatre Gallery

1968
First Watercolor Biennial, Phoenix Art Museum

Arizona Artist's Guild, Phoenix

Alhambra Invitational, Phoenix

Arizona Annual, Phoenix Art Museum

1971
Tucson Fine Arts Festival

1972
Casa Grande Arts Festival, Arizona

1973
Student Union Gallery, University of Arizona, Tucson

1974
Ninth Annual Southwestern Invitational, Yuma, Arizona

Joslyn Art Museum, Omaha, Nebraska

Eight State Biennial, Western Colorado Center for the Arts, Grand Junction

1975
Arizona/Women '75, Tucson Art Museum

Dimensions '75, Glendale Community College, Arizona

64th Annual Exhibition, Texas Fine Arts Association, Laguna Gloria Museum of Art, Austin

Southwestern Regional Arts Festival, Tucson

1976
Four-State Watercolor Biennial, Albuquerque Museum

Arena National Competition, New York

Sally Caulfield Gallery, Binghamton, New York

Looking at an Ancient Land, Museum of Fine Arts, Santa Fe

1977
Southwestern Invitational, Yuma, Arizona

Four Corners Biennial, Phoenix Art Museum

Janus Gallery, Los Angeles

1978
Expanded Image on Paper, Memorial Union Gallery, Arizona State University, Tempe

Works on Paper, Gargoyle Gallery, Aspen, Colorado

Works on Paper, A.D.I. Gallery, San Francisco

1979–80
The First Western States Biennial Exhibition, Denver Art Museum. Traveled to: National Collection of Fine Arts, Smithsonian Institution, Washington, D.C.; San Francisco Museum of Modern Art; Seattle Art Museum

Biennial 1979, Phoenix Art Museum

1980
Ten Take Ten, Colorado Springs Fine Arts Center

Aspects of Fire, Frank Marino Gallery, New York

1980–81
Gallery Group, Frank Marino Gallery, New York

1981
Gallery Group, Ellen Terry Lemer Ltd., New York

Arcosanti Festival, Arizona

Paper: Surface and Image, Robeson Gallery, Rutgers University, New Brunswick, New Jersey

1981–82
Arizona Invitational, Scottsdale Center for the Arts, Arizona

Artists in the American Desert (traveling exhibition organized by Sierra Nevada Museum of Art), Salt Lake Art Center, Utah; Leigh Yawkey Woodson Art Museum, Wausau, Wisconsin; Arapaho College, Littleton, Colorado; Palm Springs Desert Museum, California;

University of Arizona Museum of Art, Tucson; Arkansas Arts Center, Little Rock; Laguna Gloria Art Museum, Austin, Texas; Kaiser Center, Oakland, California; Fresno Art Center, California; Sierra Nevada Museum of Art, Reno, Nevada

1982

Nature as Metaphor, organized by National Women's Caucus for Art, New York (in conjunction with College Art Association annual meeting)

1983

Women in Art, Tempe Fine Arts Center, Arizona

Artists of the Rockies and the Golden West Retrospective, Sangre de Cristo Art Center, Denver

Selected Works on Paper from the Permanent Collection, National Museum of American Art, Washington, D.C.

Handmade Paper, Eve Mannes Gallery, Atlanta

Exchange of Sources, Expanding Power, University Art Museum, California State University, Long Beach

The Southwest Scene, Brentwood Gallery, St. Louis

1984

Cheney Cowles Memorial Museum, Spokane, Washington

The Olympian Spirit, Senior Eye Gallery, Long Beach, California

1986

The Artist as Shaman, Women's Building, Los Angeles

1987

Artists of the Western States Biennial, Elaine Horwitch Galleries, Palm Springs, California

New Sacred Art: Prayers for Peace, White Light Gallery, New York

1988

The Transformative Vision, Newhouse Center for Contemporary Art, Staten Island, New York

1989

Phyllis Weil and Co., New York

Revelations: The Transformative Impulse in Recent Art, Aspen Art Museum, Colorado

1990

American Women Artists, Knoxville Museum of Art, Tennessee

1991

Sacred Spaces, Chelsea Center, East Norwick, New York

Art as a Healing Force, Bolinas Museum, California

1992

Dreams and Shields: Spiritual Dimensions in Contemporary Art, Salt Lake Art Center, Utah

1993

Sacred Arts Symposium, New York

Summer Show, E. M. Donahue Gallery, New York

1994

Body and Soul: Contemporary Art and Healing, De Cordova Museum and Sculpture Park, Lincoln, Massachusetts

1994–95 Premier Exhibition, Joy Tash Gallery, Scottsdale, Arizona

1995

New Paintings and Prints, Cortland Jessup Gallery, Provincetown, Massachusetts

Modern Icons, Reicher Gallery, Barat College, Lake Forest, Illinois

1996

Summer Group Exhibition, Joy Tash Gallery, Scottsdale, Arizona

1997

Pools of Light, Donahue/Sosinski Gallery, New York

2000

Images of Nature, Phoenix Art Museum

Faculty Exhibition, Anderson Ranch, Snowmass Village, Colorado

The Works of Modern Jewish Artists, Sylvia Plotkin Judaica Museum, Scottsdale, Arizona

2001

A Century of Arizona Women Artists, Desert Caballeros Western Art Museum, Wickenburg, Arizona

Eight Women Artists, Bernstein Display, New York

Selected Public Collections

Albuquerque Museum

Arizona Cancer Center, University of Arizona, Tucson (long-term loan)

Arizona State University Art Museum, Tempe

Art Museum of Southeast Texas, Beaumont

The Brooklyn Museum, New York

Denver Art Museum

Everson Museum of Art of Syracuse and Onondaga County, Syracuse, New York

Hebrew Union College–Jewish Institute of Religion, Skirball Museum, Cincinnati Branch

Herbert F. Johnson Museum of Art, Cornell University, Ithaca, New York

The Jewish Museum, New York

Joslyn Art Museum, Omaha, Nebraska

Museum of Fine Arts, Santa Fe

Phoenix Art Museum

San Francisco Museum of Modern Art

Scottsdale Center for the Arts

Scottsdale Museum of Contemporary Art

Skirball Cultural Center and Museum, Los Angeles

Smithsonian American Art Museum, Washington, D.C.

Towson State University, Towson, Maryland

Tucson Museum of Art

University of Arizona Museum of Art, Tucson

Yuma Art Center, Arizona

Selected Corporate Collections

American Republic Insurance Company, Des Moines, Iowa

Arizona Bank, Phoenix

Betty Ford Center of the Eisenhower Medical Center, Rancho Mirage, California

Byzantine Hotel, Rethymnon, Crete

Canyon Ranch, Tucson

Central Bank of Colorado, Denver

Doubletree Inns, Phoenix

Empire Savings and Loan, Denver

Home Petroleum, Denver

Houston Oil and Minerals, Denver

IBM Corporation, Endicott, New York

Madison Green, New York

Midlands Federal Savings Bank, Denver

Mountain Bell Telephone Company, Denver

National Bank of Arizona, Scottsdale

Performing Arts Theater, Calgary, Alberta

Petro Lewis Corporation, Denver

Phelps Dodge Corporation, Phoenix

Phoenix Sky Harbor International Airport

Prudential Life Insurance Company, Newark, New Jersey

Rockresorts, Rockefeller Plaza, New York

Rothschild Fine Arts, Inc., Paradise Valley, Arizona

Subaru Corporation, Denver

Temple Solel, Paradise Valley, Arizona

United Bank, Denver

Valley National Bank, Phoenix

Western Savings, Phoenix

William Feldman and Associates, Los Angeles

Selected Bibliography

Arizona/Women '75. Exh. cat. Tucson, Ariz.: Tucson Art Museum, 1975.

"Artist Brings Unique Vision to Charlotte Showing." *Charlotte (N.C.) Jewish News*, February 1992.

"Artists among Us: Beth Ames Swartz Speaks Out." *Focus on Art* (spring 1997): 15.

"Artist's Theme: Rebirth by Destruction." *Volcano Gazette* (Hilo, Hawaii), June–July 1979, 4.

Austin, April. "Art's Longing for 'Connectedness.'" *Christian Science Monitor*, October 4, 1996.

Avrutick, Sharon. "An Artist Looks at Her Heritage." *Museum Magazine* 2, no. 4 (September–October 1981): n.p.

Azon, Gary. "Healing Art." *Downtown*, no. 339 (February 16–March 2, 1994): n.p.

Baigell, Matthew. "Art and Spirit: Kabbalah and Jewish-American Artists." *Tikkun* 14, no. 4 (July–August 1999): 59–61.

Beaudin, Victoria. "Artist's Work Depicts Heavenly Inspiration." *Scottsdale Daily Progress—Weekend*, May 6, 1988.

"Beth Ames Swartz, 'Inquiry into Fire.'" *Arizona Artist Magazine* (fall 1977): 3–4.

Beth Ames Swartz: Inquiry into Fire. Exh. cat. Scottsdale, Ariz.: Scottsdale Center for the Arts, 1978. Introduction by Melinda Wortz.

"Beth Ames Swartz at Frank Marino Gallery." *Artworld*, February–March 1979, n.p.

"Beth Ames Swartz Calls Her New Series 'Trans-Illumination.'" *Scottsdale (Ariz.) Daily Progress*, April 4, 1986.

Beth Ames Swartz, 1982–1988. Exh. cat. for *A Moving Point of Balance*. Scottsdale, Ariz.: A Moving Point of Balance, Inc., 1988. Introduction by John Perreault.

Blumenthal, Carol. "From Gallery to Garden: The Greening of Art in New York." *Whole Earth Dreams* 1, no. 2 (July 1991): 1–2.

Body and Soul: Contemporary Art and Healing. Exh. cat. Lincoln, Mass.: De Cordova Museum and Sculpture Park, 1994. Introduction by Rachel Rosenfeld Lafo, Nicholas Capasso, and Sara Rehm Roberts.

Brown, Carol Osman. "Artists 'Set up' Shop," *Phoenix Gazette*, March 10, 1963.

———. "Artist Captures Creativity," *Phoenix Gazette*, December 12, 1964.

Bucklew, Joan. "Ten Artists in New Valley Group Display Their Work." *Arizona Republic* (Phoenix), April 7, 1963.

Carde, Margret. "Balancing Act: Latest Work of Beth Ames Swartz Set in Quiet, Healing Environment." *Phoenix Metro Magazine*, May 1987, 68–70.

———. "Beth Ames Swartz: Celestial Visitations." *Artspace* 12, no. 3 (summer 1988): 20–22.

———. "Dreams for the Earth." *Design Spirit* (winter 1991): 36–42.

Cecil, Sarah. "New York Reviews: Beth Ames Swartz." *Art News* 81, no. 2 (February 1982): 174.

Cembalest, Robin. "The Ecological Art Explosion." *Art News* 90, no. 6 (summer 1991): 96–105.

Chafee, Katharine. "The Fiery Art of Beth Ames Swartz." *Straight Creek Journal* (Boulder, Colo.), June 22, 1978.

Clurman, Irene. "Ten Works of Ten Artists Reveal Vital Insights." *Rocky Mountain News* (Denver), July 17, 1977.

———. "On Fiber Work, Flapping Wings and Flamed and Frozen Paper." *Rocky Mountain News*, March 25, 1979.

———. "Molded, Folded, Torn, Painted Works of Art." *Rocky Mountain News*, May 20, 1979.

Condon, Scott. "Woodbridge Hosts Artist's Experiment." *Snowmass (Colo.) Sun*, June 26, 1986.

Cooper, Evelyn S. "Seven Transformative Paintings Aim for Heart, Not Head." *Arizona Republic* (Phoenix), December 29, 1989.

Cortright, Barbara. "The Look of Nature, the Flow of Paint." *Artweek*, May 3, 1975, 4.

———. "The Signatory Aspects of Prometheus." *Artspace* 2, no. 2 (winter 1978): 10–15.

———. "Fire as Process and Image." *Artweek*, February 25, 1978, 16.

Costa, Robert. "Beth Ames Swartz: Substantiating Belief." *Cover Arts Magazine* 8, no. 3 (March 1994): 13.

Dicker, Kiana. "Art That Transforms: Mysticism Merges with Healing in Beth Ames Swartz's Canvases." *Scottsdale (Ariz.) Daily Progress*, October 5, 1989.

"Disorder Transforms Her Multimedia Art." *Ketchum Roundup* (Sun Valley, Idaho), August 21, 1980.

Dixon, Michael. "A Search for the Spirit." *Phoenix Home and Garden* 19, no. 3 (January 1999): 66–73.

Donnell-Kotrozo, Carol. "Beth Ames Swartz." *Arts Magazine* 54 (February 1980): 11.

———. "Mixing Her Media Does the Trick for Beth Ames Swartz." *Scottsdale (Ariz.) Daily Progress—Weekend*, February 1, 1980.

———. "Beth Ames Swartz: Elaine Horwitch Galleries." *Artforum* 22 (November 1983): 84–85.

Douglas, Olivia W. "Beth Ames Swartz: E. M. Donahue." *Art News* 93, no. 5 (May 1994): 161.

Durnford, Alice. "Works Capture Spirit of Jewish Women." *Beaumont (Tex.) Journal,* April 4, 1983.

Erlich, Robbie. "Beth Ames Swartz: Frank Marino Gallery." *Arts Magazine* 53 (May 1979): 40.

The First Western States Biennial Exhibition. Exh. cat. Denver: Western States Art Foundation, 1979. Introduction by Joshua C. Taylor.

Folliott, Sheila. "Expanding Powers." *Artweek*, March 19, 1983, 6.

Fressola, Michael. "Fresh Visions in Art and Film: New Age Art at the Newhouse." *Staten Island Advance*, March 1, 1988.

———. "'Moving Point' Stirs the Spirit." *Staten Island Advance*, March 26, 1989.

Gablik, Suzi. *The Reenchantment of Art.* New York: Thames and Hudson, 1991, 155–57.

Gadon, Elinor W. *The Once and Future Goddess: A Symbol for Our Time*. New York: Harper and Row, 1989, 245–46, 248.

Hait, Pam. "Women and Art: A Retrospective." *National Forum* (fall 1981): 16.

Hale, Douglas. "Teachers Open Gallery." *Arizona Republic* (Phoenix), March 3, 1963.

Hardaway, Francine. "The Valley's Gift to the World." *New Times Weekly* (Phoenix), August 26–September 1, 1981, 27.

Heinberg, Richard. "Cloning the Buddha." *The Quest* 87, no. 4 (July–August 1999): 59–61.

Henderson, Barbara. "Beth Ames Swartz." *A Magazine of the Fine Arts* 2, no. 15 (April 1976): 34–41.

Horwitz, Barbara. "Jewish Artist Expresses Healing Experience." *Jewish United Fund News*, June 1999, 22.

Israel Revisited. Exh. cat. Scottsdale, Ariz.: Beth Ames Swartz, 1981. Introduction by Harry Rand.

James, Anne Michael. "Art Explodes in Snowmass." *Aspen (Colo.) Daily News*, June 20, 1986.

————. "Art as Healing: Ancient Purpose Remembered." *Choice and Connections '88 and '89*. Boulder, Colo.: Human Potential Resources, Inc., 1987.

Jennings, Jan. "Artist Aims for Emotional Responses." *(San Diego) Tribune*, May 8, 1986.

Katherine, Anna. "Four Elements Become Artist's Ritualistic Style." *Albuquerque Journal*, July 3, 1983.

————. "Exploration of Elemental Forces: Beth Ames Swartz." *Artlines* 5, no. 8 (October 1983): 16–17.

Kingsley, April. "West Meets East." *Newsweek*, August 20, 1979, 79.

Klein, Eleanore. "The Friendly Universe of Beth Ames Swartz." *Today's Arizona Woman*, January 1990, 28–29.

Krapes, Shelley. "A Painter's Way with Paper." *Fiberarts* 9 (July–August 1982): 19–20.

Landman, Roberta. "At Home with Beth Ames Swartz." *Phoenix Home and Garden* 29, no. 11 (September 2000): 62–63.

Lawson, Kyle. "Artist Fires Creative Elements." *Phoenix Gazette*, March 19, 1980.

Lippard, Lucy. *Overlay: Contemporary Art and the Art of Prehistory*. London: Pantheon, 1983, 266–67.

Locke, Donald. "Beth Ames Swartz at Elaine Horwitch, Scottsdale, Arizona." *Artspace* 4, no. 2 (winter 1980): 44–45.

————. "Beth Ames Swartz at Elaine Horwitch Galleries, Santa Fe." *Artspace* 7, no. 3 (summer 1983): 76.

Lugo, Mark-Elliott. "Tradition Is Exhibit 'Journey's' Point of Departure." *(San Diego) Tribune*, April 10, 1986.

McEntire, Frank. *Dreams and Shields: Spiritual Dimensions in Contemporary Art*. Exh. cat. Salt Lake City: Salt Lake Art Center, 1992, 34–35, 90, 118–19.

McKinnon, Karen. "Beth Ames Swartz Brings Rebirth to Her Work by Daring Destruction." *New Mexico Independent* (Albuquerque), March 31, 1978.

Maietta, Vince. "Creative Business Techniques Keep Area Artists from Starving." *Business Journal* (Phoenix), April 24, 1989.

Maschal, Richard. "Between Fire and Earth, Beth Ames Swartz Finds Art." *Charlotte (N.C.) Observer*, February 9, 1992.

Miles, Candice St. Jacques. "The Art of Beth Ames Swartz: A Connective Manifesto." *Arizona Magazine* (weekly supplement to *Arizona Republic*, Phoenix), April 21, 1985, 12–13, 16–17.

Miller, Jim. "A Painter's Picture of Perfect Health." *University of Calgary Gazette*, June 12, 1985.

Mills, J. "Earthflows at Attitudes." *Denver Post*, April 11, 1976.

Montini, Ed. "Layers, Pieces of Art and History Merge into a Lifetime's Work." *Arizona Republic* (Phoenix), October 5, 1980.

"'A Moving Point of Balance' at the Multicultural Arts Gallery." *San Diego Metropolitan*, April 1986, n.p.

"A Moving Point of Balance." *Aspen (Colo.) Flyer*, July 18, 1986.

Nelson, Mary Carroll. "Beth Ames Swartz." *Artists of the Rockies and the Golden West* 6, no. 4 (fall 1979): 60–63.

———. *Connecting: The Art of Beth Ames Swartz*. Flagstaff, Ariz.: Northland Press, 1984. Introduction by Harry Rand.

"Newsroom of the Republic Quite 'Arty.'" *Arizona Republic* (Phoenix), March 31, 1963.

Noriyuki, Duane. "Multi-Media Show at Woodbridge." *Aspen (Colo.) Times*, June 19, 1986.

Perlman, Barbara. "Gallery Hopping." *Arizonian*, November 24, 1967.

———. "Artist Charts New Beginnings in Work." *Scottsdale (Ariz.) Daily Progress*, June 15, 1977.

———. "Rites of Fire and Transformation." *Arizona Arts and Lifestyle* 1, no. 4 (winter 1980): 34–41.

———. "Arizona: Varied, Energetic and Exciting." *Art News* 79, no. 10 (December 1980): 148–49.

———. "Arizona's Surprising Women Artists." *Arizona Arts and Lifestyle* 3, no. 4 (winter 1982): 28–30.

Perreault, John. "Western Omelet." *Soho Weekly News* (New York), July 26, 1979.

———. "Impressions of Arizona." *Art in America* 69, no. 4 (April 1981): 35–45.

———. "Just Deserts." *Soho Weekly News* (New York), October 13, 1981, 49.

———. "The Transformative Vision: A Critic Analyzes the Spiritual Impulse That Informs Great Art and a Contemporary Exhibition." *Design Spirit* 2, no. 1 (winter–spring, 1990): 15–19.

Peterson, William. "Show's Paintings by Beth Ames Swartz Address Special Moments of Life." *New Mexico Independent* (Albuquerque), September 17, 1976.

———. "Reviews: Beth Ames Swartz." *Artspace* 1, no. 1 (fall 1976): 33.

———. "Review of 'Ten Take Ten' Exhibition." *Artspace* 2, no. 1 (fall 1977): 38–39.

———. "Reviews: Colorado Springs Fine Arts Center: 'Ten Take Ten,'" *Artspace* 2, no. 1 (fall 1977): 38–39.

Petrovsky, Fred. "Beth Ames Swartz: On the Cutting Edge." *Scottsdale Scene*, May 1984, 68–71.

Price, Max. "Colliding Forces Work to Create Excitement." *Denver Post*, July 22, 1983.

"Prints and Photographs Published," *Print Collector's Newsletter* 26, no. 3 (July–August 1995): 103–8.

Pyne, Lynn. "Beth Ames Swartz: New and Glittering." *Phoenix Gazette*, March 10, 1984.

———. "Artist Approaches Life from a Different Angle." *Phoenix Gazette*, April 20, 1988.

Rand, Harry. "Some Notes on the Recent Work of Beth Ames Swartz." *Arts Magazine* 56 (September 1981): 92–96.

Raven, Arlene. "Beth Ames Swartz: A Story for the Eleventh Hour." *Village Voice*, February 16, 1994, 88–89.

Reed, Mary Lou. "Beth Ames Swartz's Stylistic Development, 1960–1980." Master's thesis, Arizona State University, 1981.

———. "A Vital Connection: Artist and Topography." *Woman's Art Journal* 2, no. 2 (fall–winter 1981–82): 42–45.

Revelations: The Transformative Impulse in Recent Art. Exh. cat. Aspen, Colo.: Aspen Art Museum, 1989. Essay by John Perreault.

Rigberg, Lynn. "Beth Ames Swartz at Elaine Horwitch Galleries, Scottsdale." *Artspace* 6, no. 3 (summer 1982): 73.

Rothschild, John D. *A Story for the Eleventh Hour*. Exh. cat. New York: E. M. Donahue, 1994. Introduction by Berta Sichel.

———. *Beth Ames Swartz: The Lotus as Metaphor*. Exh. cat. Scottsdale, Ariz.: Joy Tash Gallery, 1995.

————. "Beth Ames Swartz: States of Change." Essay. Scottsdale, Ariz.: Vanier Galleries on Marshall, 2000.

Rubin, David S. "In Search of the Shekinah." *Artweek* 13 (February 13, 1982): 3.

Sacred Spaces. Exh. cat. Ronkonkoma, N.Y.: SunStorm Arts Publishing for Chelsea Center, Muttontown, N.Y., 1991. Essay by Roxana Marcoci.

Samuels, Michael. "Art as a Healing Force." *Alternative Therapies* 1, no. 4 (September 1995): 38–40.

Savini, Marcos. "Arte vestida de verde." *Jornal de Brasilia* (Distrito Federal), May 3, 1992.

Seidel, Miriam. "The Wounded Healer." *New Art Examiner* 20, no. 8 (April 1993): 32.

————. "Beth Ames Swartz at E. M. Donahue." *Art in America* 82, no. 11 (November 1994): 131.

————. *Beth Ames Swartz: The Shen Qi Series.* Exh. cat. New York: Donahue/ Sosinski Art, 1997.

Snyder, Jodie. "Fine Art as Healing Art: Valley Artist Hopes Work Helps Cancer Patients." *Arizona Republic* (Phoenix), January 12, 1998.

Stevens, Lianne. "Viewers Get the Picture at San Diego Art Experience." *Los Angeles Times*, April 19, 1986.

Szeremy, Eniko. "Of Introspection and Airbrushes," *Rocky Mountain Journal* 26, no. 29 (April 7, 1976): 43.

Ten Take Ten. Exh. cat. Colorado Springs: Colorado Springs Fine Arts Center, 1977, 27–29.

Walton, Kelly. "With Love, From Beth: Art That Heals." *City Life* (Scottsdale, Ariz.), March 14, 1984, 34.

————. "Beth Ames Swartz to Open New Show at Elaine Horwitch Gallery." *City Life*, March 26, 1986, 35.

Whitney, Fitzgerald. "Feminine Spirituality in Judaism." *Los Angeles Times*, May 15, 1982.

Wilson, Mike. "Buddha, Saint of the Christian Church." *The Quest* 86, no. 11 (winter 1998): 30.

Wortz, Melinda. "The Fire and the Rose." *Artnews* 77 (April 1978): 10.

Yearwood, Pauline Dubkin. "Art That Heals: Kabbalah Images Enhance Artist's Abstract Works." *Chicago Jewish News*, May 14–20, 1999, 4–5.

Young, Joseph. "Beth Ames Swartz: On a New Journey." *Scottsdale (Ariz.) Daily Progress —Weekend*, March 6, 1984.

Zelenko, Lori Simmons. "Vernissage." *L'Officiel / USA Holiday* (fall 1979): 28–30.

Films

The New Art of the American West. New York: Dick Young Productions, 1979. Features six artists included in *The First Western States Biennial.*

An Odyssey. Misdee Chauncey, producer. Channel 10 TV, Phoenix, October 1980. Ten-minute color film documenting *Israel Revisited.*

Photograph Credits

Alexei Afonin, plates 59–66, 68–70

AR3 Photography, plate 4

Peter Bloomer, page 15 top, plates 2, 3, 6, 8, 14,
 16, 18, 20–30, 32, 34, 36–38

Linda Bryant, page 137 left

Diane Colligan, plate 46

Kim Cornelison, frontispiece

James Cowlin, pages 14, 30

Linda Enger, pages 136 right above, 137 center

Linda Kilgore, page 136 right below

Courtesy of the Nickle Arts Museum, plate 39

Yaël Rosen, pages 33, 136 left

J. Keith Schreiber, plate 33

Robert Sherwood, page 13, plates 1, 5, 7, 12, 13,
 15, 17a, 17b, 19, 40–45, 47–52, 54, 55, 71–84

Craig Smith, pages 15 bottom, 16 top, plates 9–
 11, 31, 35, 53, 56–58, 67